D0863028

PAINTING IN PASTELS

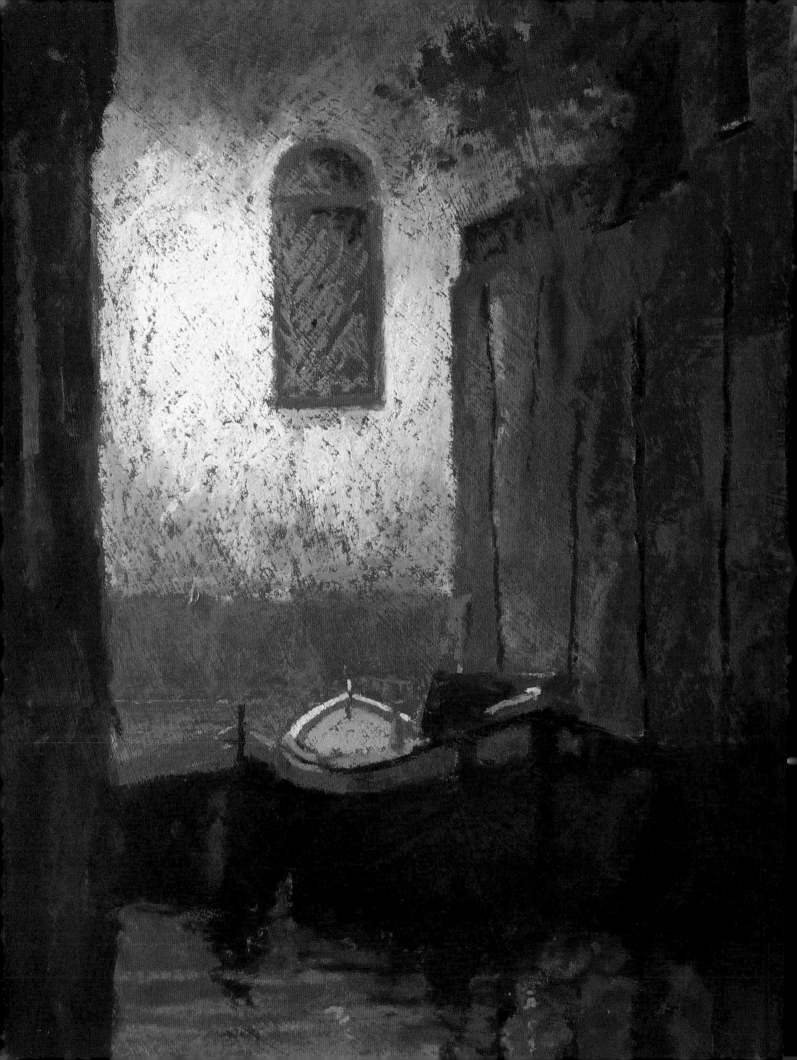

PAINTING IN PASTELS

Robert Brindley RSMA

THE CROWOOD PRESS

BOCA RATON PUBLIC LIBRARY
BOCA RATON, FLORIDA

First published in 2010 by
The Crowood Press Ltd
Ramsbury, Marlborough
Wiltshire SN8 2HR

www.crowood.com

© Robert Brindley 2010

All rights reserved. No part of this publication may be reproduced or transmitted in any form
or by any means, electronic or mechanical, including photocopy, recording, or any information
storage and retrieval system, without permission in writing from the publishers.

British Library Cataloguing-in-Publication Data
A catalogue record for this book is available from the British Library.

ISBN 978 1 84797 198 2

Front cover: *Autumn/The Hermitage Near Whitby* 28 x 33cm (11in x 13in)
Frontispiece: *Golden Light/Venetian Nocturne* 23 x 28 cm (9in x 11in)

Acknowledgements
I wish to thank Byron Howard for writing the foreword. Special thanks to all my family,
especially my wife Liz, for her invaluable assistance in the writing of this book.

Typeset by Kelly-Anne Levey
Printed and bound in Singapore by Craft Print International

CONTENTS

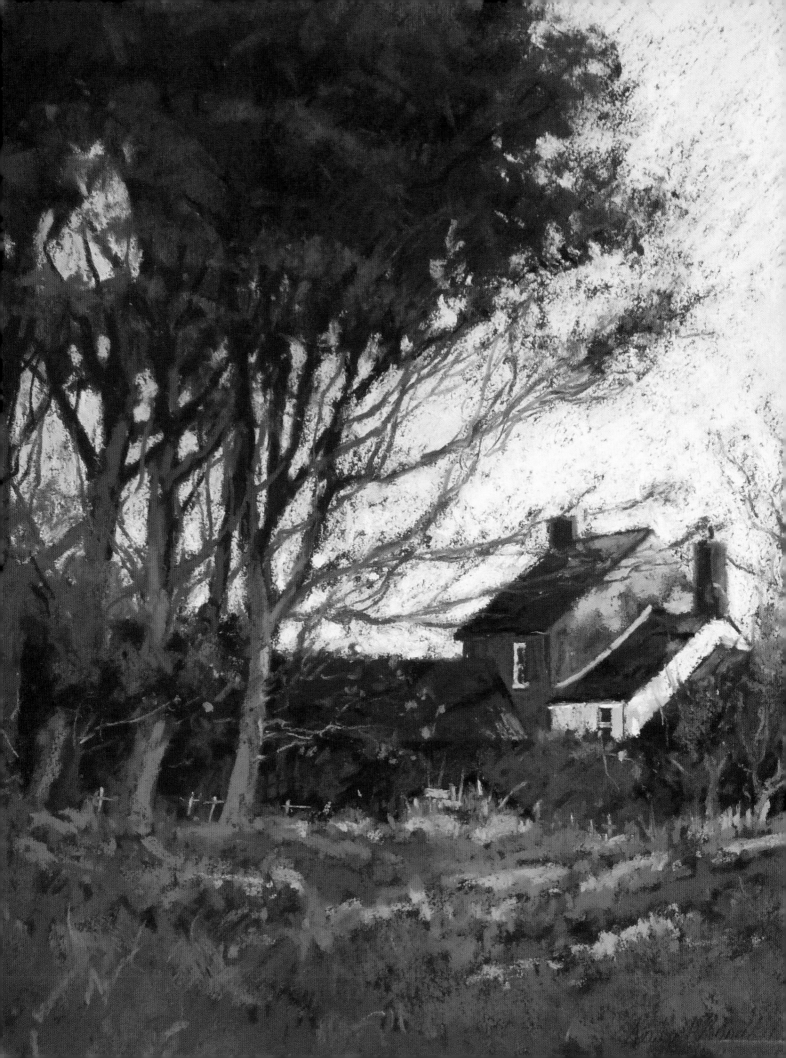

FOREWORD

Coloured powder, bound to form a stick? What possibilities for aspiring or established artists to engage in creative image making!

Robert Brindley opens up an intriguing and masterful range of opportunities in painting with pastels, the most instant of colour applications. His creative ability, developed through experienced observation and channelled through a highly perceptive analysis of his chosen subject, displays a remarkable authority across the full compass of pastel technique.

He presents for us, the viewer, an astonishing orchestration of pastel painting and mark making, creating a wonderment of light, shade and depth. His captivating passages of smoothed pastel glow in the warmth of soft focused sunlight, alternating with serene, cool atmospheric distances, evoking space and a sense of mystery.

The visual tension he creates across the picture plane is often a foreground overlaying of intense electric brilliance, dextrous dashes, telling darks – expressive exuberance with the courage of the moment, held together with draughtsmanship and understanding.

He offers us a colour symphony of moods, magic and mastery of the medium, the creative manipulation of coloured dust.

Byron Howard, Master Sculptor, Travis Studio

OPPOSITE PAGE:
Autumn/The Hermitage Near Whitby, 28 x 33cm (11in x 13in).

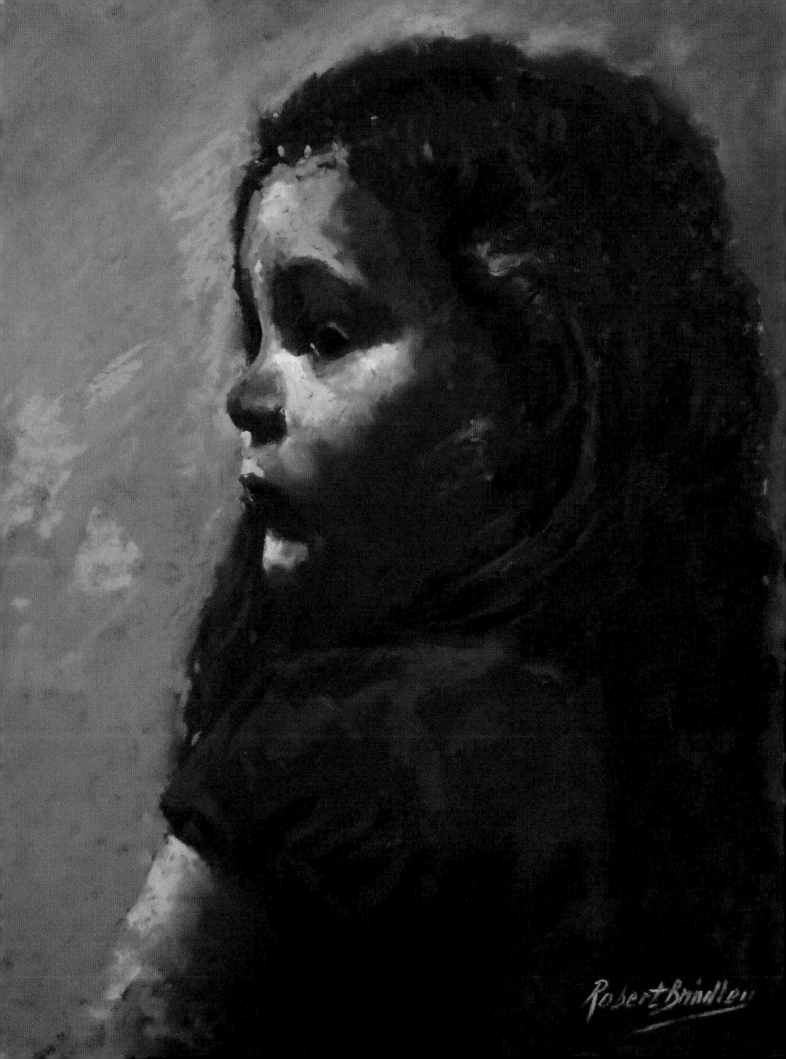

INTRODUCTION

The novice paints the leaves; the master suggests the tree.

Anonymous

Pastels are an exciting, versatile medium, ideal for painting, sketching and drawing. They provide the artist with a larger range of instant, vibrant colour than the other painting mediums. Their immediacy when drawing, combined with their richness of colour, make pastels perfect for experimentation and personal expression, either for rapid studies or finished pieces of work. In addition to all these factors, the amount of materials required is less than for oils or watercolours.

Soft pastels are made of pure, powdered pigment, bound together with a carefully measured amount of resin or gum (just sufficient to hold the pigment together), then moulded into stick form. Oil pastels are similar but bound together with an oil medium. Because pastel sticks are made in this way, they are the purest form of applying pigment to a surface. This purity of pigment produces paintings of distinctive strength of colour and luminosity.

In recent years the popularity of pastel painting has grown significantly. There are many reasons for this resurgence; however, I feel that the irresistible range of mouth-watering, pure colours available, coupled with the flexibility of the medium are the primary reasons. Pastels can be worked in a variety of ways, producing paintings depicting soft atmospheric conditions through to bold statements of full colour and imaginative design, where the characteristics of the medium can be fully exploited.

The selection, motivation and interpretation of any subject are of paramount importance to the success of any piece of work, and the use of pastel as your selected medium will allow you unlimited freedom when considering these factors.

OPPOSITE PAGE:
Holly, 30 x 25cm (12 x 10in).

Versatility

Being such a versatile medium they are an ideal choice for painting a wide variety of subject matter, such as landscape, still life and portrait painting, to name a few.

Landscape

Artists have always drawn and painted the landscape; perhaps it's natural to want to capture the beautiful scenery that surrounds us. Landscapes are nearly always at their most appealing during the hour after sunrise and the hour before sunset, but these are also the times when the light is changing the fastest. With their wide range of ready made, vibrant colours, to represent brilliant skies, glowing suns and vegetation bathed in early morning or late afternoon light, pastels offer the artist the ability to capture a scene before the light completely changes.

Bright colours or dark ones, sparkling clarity or misty atmosphere, landscape, still life, portrait – I haven't met a subject, style or mood yet that can't be portrayed beautifully in pastel.

Dave Beckett

Still Life

Typically, a still life painting will feature objects such as flowers, fruit, china or other items, arranged to form an interesting group. Successful paintings in this genre are achieved by careful consideration of the way the light falls and illuminates each object within the group. Your ability to observe and reproduce light convincingly is paramount when painting any subject matter; however, this is especially important for reproducing the subtlety of reflected light found in many still life subjects.

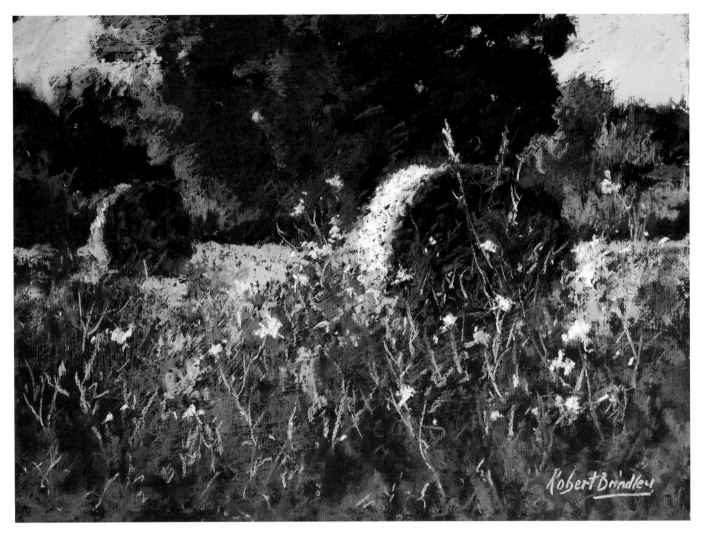

Hay Bales, 38 x 30cm (15 x 12in).

Portrait

Before the invention of photography, the only way to get a permanent representation of yourself was to commission an artist. Since the advent of the camera things have changed dramatically and most people have dozens of photographs of themselves. Despite this, portraits remain a firm favourite among sitters and artists alike. As in landscape painting, the immediacy of pastel is also beneficial for portraits. They allow you to capture a likeness quickly, before the sitter gets bored. Layering and blending techniques are perfect for representing soft, translucent skin tones. Having all your colour and tonal options at hand, rather than having to mix them, makes selecting the right ones far easier.

A Brief History of Pastel Painting

Dry pigments made from natural materials were used by early cave-dwellers well before records were kept. Chalk had long been used as a drawing medium. However pastels or chalk, compressed into stick form in many colours, only became available to artists in the late fifteenth century.

Pastels gradually became an established painting medium in the sixteenth to eighteenth centuries as more artists used this form of pastel crayon to produce colour sketches or studies for larger oil paintings. During this time, some artists began to experiment with pastels as a new standalone medium; their subtlety and speed of application developed virtuosity previously unseen.

From that time the medium has grown in popularity and developed far beyond the earlier methods employed. Many of the Impressionists were inspired by the works of Degas, Manet and Toulouse-Lautrec, who popularized the medium by experi-

menting with the use of different techniques such as linear strokes on top of blended pastel and many more, producing impressionistic works of brilliance and intensity. Degas, in particular, was probably the most influential pastel painter of his time, using an extensive range of techniques and effects; in an attempt to create luminosity, he experimented with cross-hatching, and combined pastel convincingly with virtually every other medium.

As pastels have no oil binder, they do not yellow or crack as oil paintings do. Consequently they have very little need of restoration. The purity of pigment and freshness of soft pastel paintings held in collections worldwide confirms the longevity of the medium.

This book is based on my personal observations and experience, covering materials, subject selection, techniques, the characteristics of pastel and their importance when *plein air* painting.

The book is organized according to subject matter with chapters dedicated to landscape, coastal scenery, interiors, still life, the figure and more.

To supplement these chapters I have included in-depth step-by-step demonstrations, each with a particular theme, to illustrate the process of producing a painting using pastels.

At the end of most chapters there is a section 'In the Spotlight' where I offer the assessment of a completed painting, discussing my reasons for selecting the subject, the motivation, interpretation and finally an evaluation of the completed work, giving particular attention to any weaknesses and possible subsequent corrections if required, and an analysis of the benefits to be gained from this process.

Paintings are, most importantly, a means of communicating your ideas to others without the use of words. I hope that some of the information given in the following pages will help you to succeed in this vital process.

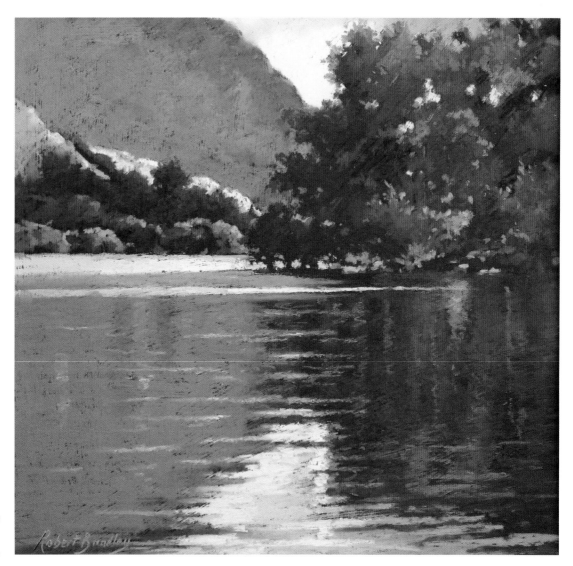

Reflections/ Derwentwater, 36 x 36cm (14 x 14in).

MATERIALS AND EQUIPMENT

The painting *Scuola Tintoretto/Venice* was undertaken as a demonstration painting for an art society and painted on black Hermes sandpaper. The subject was selected to illustrate how a dark ground could be used to enhance the drama of vibrant colour. The painting was developed from the photograph *Colours of Venice*.

Photograph *Colours of Venice*.

OPPOSITE PAGE:
Scuola Tintoretto/Venice, 25 x 36cm (10 x 14in).

Materials for Starters

The choice of materials and equipment available for the pastel artist is enormous and could easily be daunting to the beginner. The following basic list of materials is intended for those who would like to try painting with pastels on a reasonable budget. It is important, however that you always buy the best quality that you can afford.

Pastels are so forgiving.
Gaye Adams

A Limited Range of Pastels

The first consideration should be given to the selection of a limited range of colours. There are many manufacturers of pastels, often offering slightly different colour palettes and varying degrees of hardness/softness. Most manufacturers make starter sets of 24, 36 or 72 pastels tailored for general work, landscape and portrait. These sets should prove to be quite adequate for beginners, and further colours can be purchased separately as needs demand. The following manufacturers make well-matched starter sets of excellent quality at a reasonable price.

Rembrandt
Rembrandt pastels are a little harder than other manufacturers', but are an ideal choice for most beginners. Half sticks are available, offering good value for money.

Unison
Unison pastels are superb and can be purchased in several combinations of grouped sets.

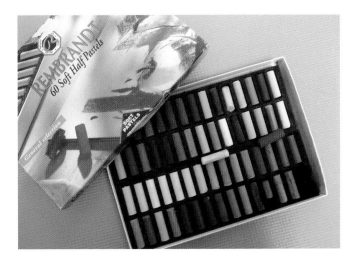

General selection: 60 half stick soft pastels by Rembrandt.

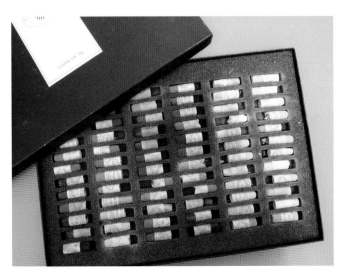

Landscape set: 72 soft pastels by Unison.

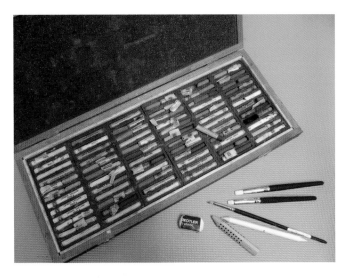

Landscape set: 72 soft pastels by Rowney.

Daler-Rowney
Daler-Rowney soft pastels are available in several sets and offer excellent value for money.

Conte, Rexel Derwent, Carbothello and Faber Castell Pitt
A small selection of pastel pencils would be useful for drawing out and accurate detailing. No more than ten or twelve should be needed unless you intend to produce entire paintings with them.

Pastel Paper or Board

The following papers and boards should prove suitable for the beginner:
Hermes fine sandpaper: an excellent paper for bold, expressive mark making.
Art Spectrum Colourfix: textured boards and papers available in sixteen colours.

The direct, colourful nature of pastel is ideal for capturing the qualities of immediacy, spontaneity and sparkle

Patricia Greenwell

Other Essentials
- A soft, easy to clean eraser: either a kneaded putty eraser or a plastic eraser by Staedtler are recommended.
- A roll of artist's masking tape.
- A copious supply of kitchen towels.
- A box of Wet Wipes or similar, for keeping your hands clean.

Materials for the more Experienced Pastellist

Further materials and equipment will eventually be needed by the beginner and the more advanced painter. Consideration can now be given to a broader selection of materials which will enable the more experienced pastellist to experiment further with the medium.

A Wider Range of Pastels

As a pastel painter you will have your own preferred brands of pastel; however, whether you are relatively new to the medium or more experienced, the following suggestions may prove useful.

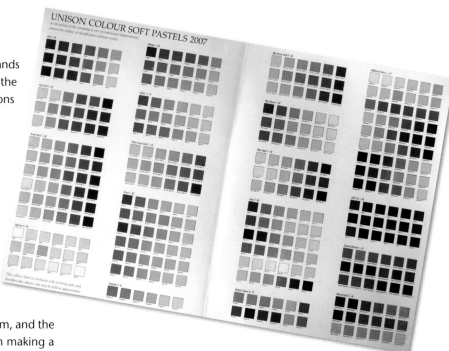

Unison colour chart.

Unison

John Hersey's handmade pastels are considered by many pastellists to be one of the finest brands available. Unison offer a range of almost four hundred different colours and shades in sets of eighteen sticks. They are sold either individually or in colour coordinated sets giving you the opportunity to add colours as and when you need them (see Unison colour chart).

The pastels are available in two sizes: 50mm × 15mm, and the larger Jumbo sticks which are 75mm × 20mm. When making a selection from this range, it is worth noting that generally, as the number increases, the pastel gets lighter.

Sennelier

These very fine pastels are also categorized in harmonious groups and sets, usually of five to eight sticks. The sticks are smaller than the Unison pastels; however being smaller makes it sometimes easier to find edges for detail work.

Schminke

Once again these high quality pastels come in a range of around four hundred shades. They contain the very finest colours combined with a minimum of binders. Schminke use a colour code for denoting their pastels: D denotes that the pastel is a pure colour; B that the colour is mixed with black; and H, M and O mixed with white. For example, Ultramarine Deep comes in the following sequences: 63D, 63B, 63H, 63M and 63O.

Rembrandt

This range of pastels has been developed over the course of a century and in collaboration with practising artists. Their softness ensures that the pigment transfers effectively to the paper and at the same time the pastel stick maintains its integrity without crumbling or turning to dust. Each colour has its own number, for example Yellow Ochre 227. In the case of the pure colour the number is followed by the figure 5. The darker colour (mixed with black) is indicated by 227.3 and the lighter graduations by 227.7, 227.9 and 227.10.

Art Spectrum

In recent years this Australian manufacturer has produced a range of very fine papers and soft pastels. The pastels produce a rich, velvety bloom much valued by pastellists. The range is once again extensive, being produced in half and full sticks and available in many carefully selected boxed sets. Each colour is given a number, preceded by a coded letter: D=darkest, N=dark, P=pure pigment, T=tint, V=very tinted and X=extra tinted.

Daler-Rowney

This range of pastels, both hard and soft, has provided artists with a quality product for many years, and today they are widely used and considered by many pastellists as one of the finest brands on the market. Each soft pastel is given a unique name and reference number and is available in four shades: for example Autumn Brown 1=TD2011, Autumn Brown 2=TD2012, Autumn Brown 3=TD2013, Autumn Brown 4=TD2014. The sticks are approximately 12mm × 65mm in size.

Hard pastels are often used for drawing out and also for positive mark making at any stage of the painting process (these techniques will be fully discussed later). The hard pastels made by Daler-Rowney are available in a relatively small range of colours; however they do produce a sketching set of twelve pastels and a very useful set of twelve greys. Both these sets are worthy of consideration should you prefer your initial drawing to be retained, either partially or entirely, in the completed painting.

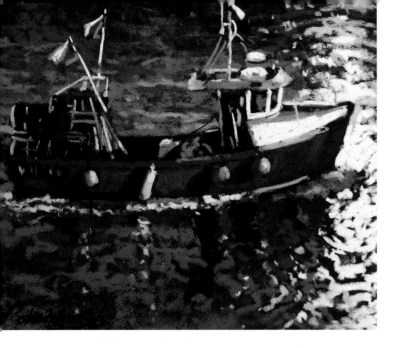

The Red Boat/Whitby Harbour, 20 × 15cm (8 × 6in).

Pastel Supports

To enable you to fully express yourself and to produce a successful pastel painting it is vital to have a thorough knowledge of the supports (papers and boards) available to you. These days the variety and choice is extensive. Only fifteen or twenty years ago your options would have been limited to three or four papers: a flour paper (resembling very fine sandpaper) and one or two coloured boards (some of which were not even lightfast). Any variations to these commercially available products were created by pastel artists looking for additional texture and colour to exploit the full character of pastels.

Artists today are extremely fortunate having ready-made surfaces available to them which allow full expression and personal interpretation. In addition to these ready-made supports, textured primers are available in a large range of colours. Dry additives can also be purchased and added to an acrylic primer giving a variety of textural surfaces.

The following suggestions should give you a basis for experimentation, which is necessary to any artist's development.

Art Spectrum Colourfix Papers

This Australian paper is wonderful to work on and is available in fifteen colours plus white. The sheets are Canaletto watercolour paper, ready primed with Colorfix Fine Tooth pastel primer and are acid free, lightfast and fully permanent. This primed surface provides positive tooth to hold extra colour and extra layers, allowing more pastel, charcoal or pencil on your work and less on the floor. Up to ten layers of pastel can be put down. No need for fixative. Weight: 300gsm/140lb; Size: 50 × 70cm/20 × 27in.

The manufacturer also produces two further versions of this paper, with primed surfaces which are waterproof, allowing further scope for experimentation:

Colourfix Supertooth: a heavyweight 500gsm hot pressed watercolour paper ready primed with Colorfix Supertooth pastel primer, having approximately 50% more tooth than the regular version.

Colourfix Plein Air Board: an archive quality 2mm white board ready primed with Colorfix Fine Tooth pastel primer, 45 × 35cm, with an image area 40 × 30cm, allowing a 25mm white margin; available in nine colours, plus white.

Art Spectrum Colourfix Primers

These primers are available in fourteen shades, plus clear, and are the same as used on the Colourfix papers. This quick drying, fine tooth, acid free, acrylic primer bonds solidly to practically any clean surface: paper, canvas, card, ply, plastic, glass and metal. The colours can be mixed/blended and are lightfast, permanent and non-toxic. They come in 259ml pots.

Hermes Fine Sandpaper

Available in black or grey, unmounted or mounted on stiff board. This paper is available in two grades, P400 and P500, and the uncut sheet size is 30 × 20cm. The paper is available mounted on boards from 30 × 20cm down to 7.5 × 11cm. This excellent paper is waterproof, lightfast and is ideal for the artist who loves to use bold, expressive mark making.

Snowy Evening/Egton, 30 × 25cm (12 × 10in).

Hermes black P500 sandpaper was used for the painting *Snowy Evening/Egton*. The dark ground worked perfectly to accentuate the drama in this scene. Very little pastel was used in the shadowy areas of the painting, just enough to suggest texture and subtle colour change.

The Red Boat/Whitby Harbour was painted on grey Hermes P400 sandpaper which had been painted over its entire surface with a bright red acrylic paint. This coloured ground and abrasive surface proved to be extremely useful when painting this subject. Quite a substantial area of the finished piece of work is the coloured ground. When treating a board or paper with a different coloured ground, be sure to apply the colour very thinly (as in a watercolour wash); this will ensure that you do not clog the tooth of the paper, allowing you to use full pressure on your positive marks without loss of adhesion.

Sennelier Pastel Card

This very popular 350gsm card is ideal for pastel, soft lead pencil and charcoal work. The card is manufactured using fine, pH neutral vegetable flakes and cork; the flakes are hand applied, resulting in an abrasive board which produces a velvety, smooth uniform effect. This card can be purchased in three sizes and five different colours plus Antique White. Sennelier also manufacture papers and pads of various sizes in a wider range of thirteen colours plus Antique White.

Canson Mi-Teintes Paper

This range of pastel paper has a natural textured surface for the artist preferring to work on a fairly traditional paper ground. The paper is 160gsm and with a 45% cotton content and is produced in thirty-five colours plus a Soft White.

Further Recommended Supports

The following manufacturers also offer a comprehensive range of coloured papers and cards in many textured finishes. Over a period of time you may decide to try as many of them as possible to determine which surface suits your method of working:

Fisher 400 Art Paper: 360gsm, buff coloured, water resistant, paper with a good tooth supplied in 70 × 51cm sized sheets.

Fabriano Ingres: a popular, wood free, 160gsm paper with two deckle edges and a fine linen texture, available in a varied range of colours.

Fabriano Tiziano: a 40% cotton rag, acid-free, 160gsm paper with an excellent range of colours.

Others: Daler-Rowney Murano, Hahnemuhle and Schmincke Sansfix are further excellent papers and cards.

Easels

Whether you decide to work inside or outdoors, consideration should be given to purchasing a good sturdy easel. It is possible to work without an easel in the studio providing that you can raise the painting into a vertical position to allow the pastel dust to fall freely away from the surface. A French easel similar to the one illustrated is ideal for indoor or outdoor work. These easels have a wonderful flexibility and can be set up in numerous positions, enough to suit any artist's needs. They are rigid, robust and have plenty of storage space for all the necessary materials.

Should you require a more robust studio easel for painting larger works you should have no problems selecting a suitable one from the variety available from many manufacturers.

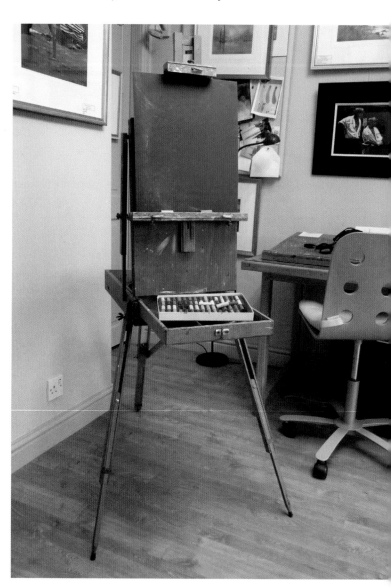

French easel.

Useful Equipment

- A blending stump, tortillon (a paper stump made of rolled-up blotting-paper or soft thick paper), hog oil painting brush or plasticized colour blender.
- A razor blade or craft knife for the removal of small mistakes.
- Thin rubber gloves: an increasing number of pastellists wear gloves to protect their skin from becoming dry.
- Fixative: the use of fixative is a contentious matter and will be discussed in depth later.

Surface Preparation

If you decide to prepare your own surfaces or use pastels in conjunction with another medium the following materials should be considered:

Papers: a variety of NOT (cold-pressed) or Rough (hot-pressed, HP) watercolour papers.

Primer: large tub of inexpensive white acrylic paint for priming boards; a household acrylic primer is quite adequate for this purpose.

Brushes: several medium–large acrylic or oil painting brushes for treating boards. For large surfaces a No.1 or 2 decorator's brush is adequate. Remember not to use expensive brushes on heavily textured, abrasive grounds. Using them only once for this purpose will ruin them for painting purposes.

Straight edge: a metal straight edge and self-healing mat for cutting boards.

Inks: a small selection of Indian or acrylic inks for drawing or underpainting your surface.

Acrylics: a limited range of acrylic paints, once again for tinting or underpainting; unless you decide to be quite adventurous with colour, three primary colours will suffice as expensive colours will only be wasted.

Texture paste: often useful for providing various textures to your boards; there are many available, including texture paste by Daler-Rowney, and fine-tooth pastel ground or a coarser pumice gel, both by Golden.

The preparation of boards and using pastel in conjunction with other mediums will be discussed in depth in Chapter 3.

Selecting a Range of Colours

Along with the techniques and skills required to produce a successful pastel painting, you will need to develop a feeling for how the pastel will behave on the paper, how the different tints work with each other and most importantly an understanding of basic colour theory.

You may find that the starter sets discussed earlier cope adequately for all you want to paint. However, other artists may feel restricted and decide to expand their colour range. Many artists have an extensive selection of different shades numbering in the hundreds, especially those who paint a variety of subject matter such as portraits, interiors and landscapes.

Colour is personal to each and every artist, and the following suggestions are intended for those having limited experience, who may find the selection of a range of colours from the hundreds available a daunting task.

The most common mistake made when starting to paint with pastels is to buy too many different colours, some of which you will never use. Starter sets are fine for the beginner and those wanting to paint a limited variety of subject matter. However, if you wish to develop your paintings and tackle a wider range of subject matter, the selection of your own palette of colours will prove advantageous and far better than buying a ready-made set. By doing this you only buy what you need.

The pastels selected should be limited to a range of warm and cool colours from each of the primaries and secondaries, a few earth colours, a few greys, and finally a black and a white (see colour chart). A good starting point is to look at what is available and select one mid tone example from each of the primaries and secondaries. At the outset try making your selection from the following: a warm red, cold red, orange, warm yellow, cold yellow, warm green, cold green, warm blue, cold blue, warm violet and cold violet. By selecting the second or third darkest of any tint from the colours listed above you will have ten basic, mid-tone pastels.

Consideration can now be given to expanding this set to include dark and light versions of these colours, providing you with a wider tonal range. Generally speaking, most manufacturers produce a colour and then a range of lighter and darker tints from this colour. They create the lighter tones by adding kaolin (China clay) or chalk to the pigment; darker shades are created by the addition of a black pigment such as carbon black. At this time it is worth mentioning that some colours, in particular yellow, only really come in light and mid tones. Select a light and dark tone to complement your original colours, bearing in mind that you will not need a dark version of the cool yellow and orange. Pick the darkest pastel from the range, and for the light value take the lightest or second lightest. You should now have a set of twenty-eight pastels.

RIGHT:
*Proprietary purpose-made box
with 72 landscape pastels.*

The earth colours can now be selected. The following are all you should need initially: a warm and cool earth brown, together with their lighter and darker tints: Yellow Ochre or Gold Ochre and a Burnt Sienna would be ideal. The greys can be selected in the same way as the earth colours by choosing a warm and cool grey, together with their light and dark tints. This range of earth and grey pastels can be expanded as needs demand.

With regard to the black and white pastels: you probably won't use a black pastel very often, but a good black is always useful for achieving a good, strong dark accent when used in conjunction with your other darker pastels. White will be of more use, especially for accents where you may have chosen the second lightest light in your colour set. A good soft white is essential for all highlights; Unison, Sennelier and Schminke make good soft whites, ideal for accents and highlights.

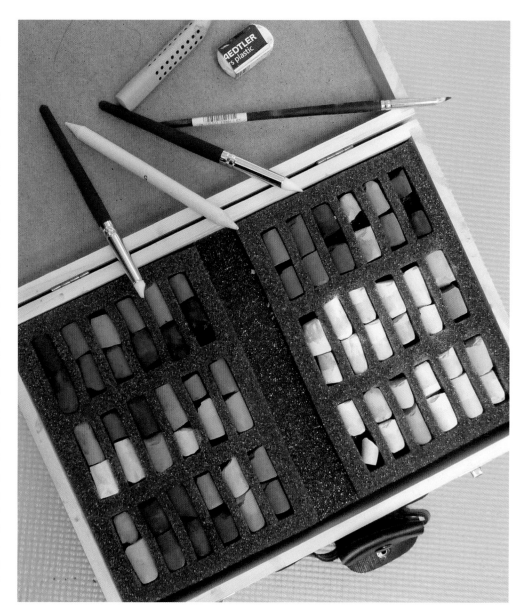

Storing Pastels in the Studio

Most artists will have their own favoured method of storing their pastels. Many will retain the flat boxes they were supplied in, thus maintaining some sort of order. It's a good idea to break the pastel sticks in half before starting to use them. Although many artists may not like to destroy the look of their precious new pastels, there are benefits to be gained from doing this: your original stick, with its label can be left untouched, enabling you to re-order easily when the used section runs low; and you will be able to use the pastel easily, using either the tip, for a fine mark, or the full width of the stick for covering large areas, without being hampered by the paper sleeve. The pieces of pastel being used can be kept alongside the unused sections in the box, or a new box can be used for the working pastels.

Boxes containing the working pastels can be any suitable shallow tin available; the pastels can be kept clean and separate by sitting them on a bed of ground rice. Boxes such as this can be used for each colour grouping (yellows, reds, blues) or all the pastels can be kept together in one box. This decision will depend on how well organized you want to be with your storage.

Should you prefer to store the working pastels in a more organized way, many art shops will let you buy – or in some cases give you – used boxes complete with their foam divisions. The rigid card boxes used by Unison are ideal for this purpose.

Another alternative is to purchase purpose-built boxes, of which there are many available, such as the one shown here.

IN THE SPOTLIGHT

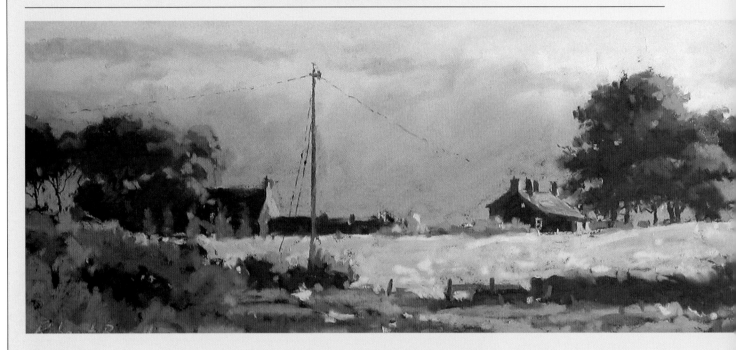

ABOVE:
The Rape Field/Aislaby,
30 × 13cm (12 × 5in).

RIGHT:
The Rape Field/Aislaby 1,
16 × 13cm (6½ × 5in).

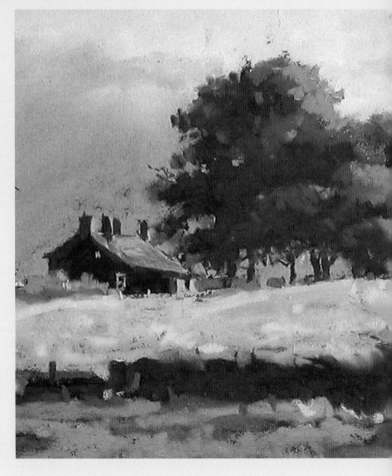

The painting *The Rape Field/Aislaby* was a rapid sketch undertaken whilst running a workshop in the village of Aislaby in North Yorkshire. The immediate attraction to the subject was the wonderful, bright yellow colour of the rape field in conjunction with the prominent and perfectly composed trees and buildings on the horizon line.

Evaluation

Bearing in mind that this was a quick sketch, executed in around half an hour, the majority of the painting is fairly successful. The main fault however, lies with the composition. In the heat of the moment, with time ticking away, not enough consideration was given to deciding which group of trees and buildings to paint. Instead of allowing more time for reflection, the scene was painted far too literally. The resultant painting therefore has no focal point. To make matters worse there is no lead in, which leaves the viewer wondering whether to settle on the trees to the left or right hand side of the painting.

This is a common error and is often referred to as the mantelpiece. The two groups of trees in this painting are

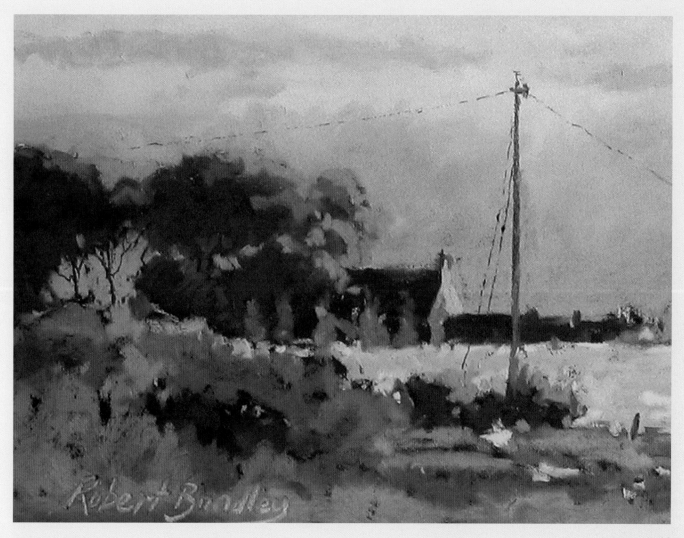

The Rape Field/Aislaby 2, 13 × 13cm (5 × 5in).

positioned similarly to candlesticks on a mantelpiece. Be wary of this situation; it is usually obvious, as in this case, however, on many other occasions it may be less noticeable.

Possible Remedies

Fortunately, in this case, the remedy was quite straightforward. By cropping the painting in the correct place, two smaller paintings were created, both having far better design resulting in successful focal points (see *The Rape Field/Aislaby 1* and *The Rape Field/Aislaby 2)*. This fortunate outcome is extremely rare; two for the price of one can't be bad.

Comments

In this particular instance there was a positive outcome; however, complacency must never be allowed to set in. You will probably continue to make errors throughout your time as a painter, sometimes repeating the same error. Remember, however, that you are involved in a constant learning process, and not everything sinks in first time, especially if you are hampered by lack of time or other issues. Never despair; we all suffer from human failings and must accept that we are not always as finely tuned in from one day to the next.

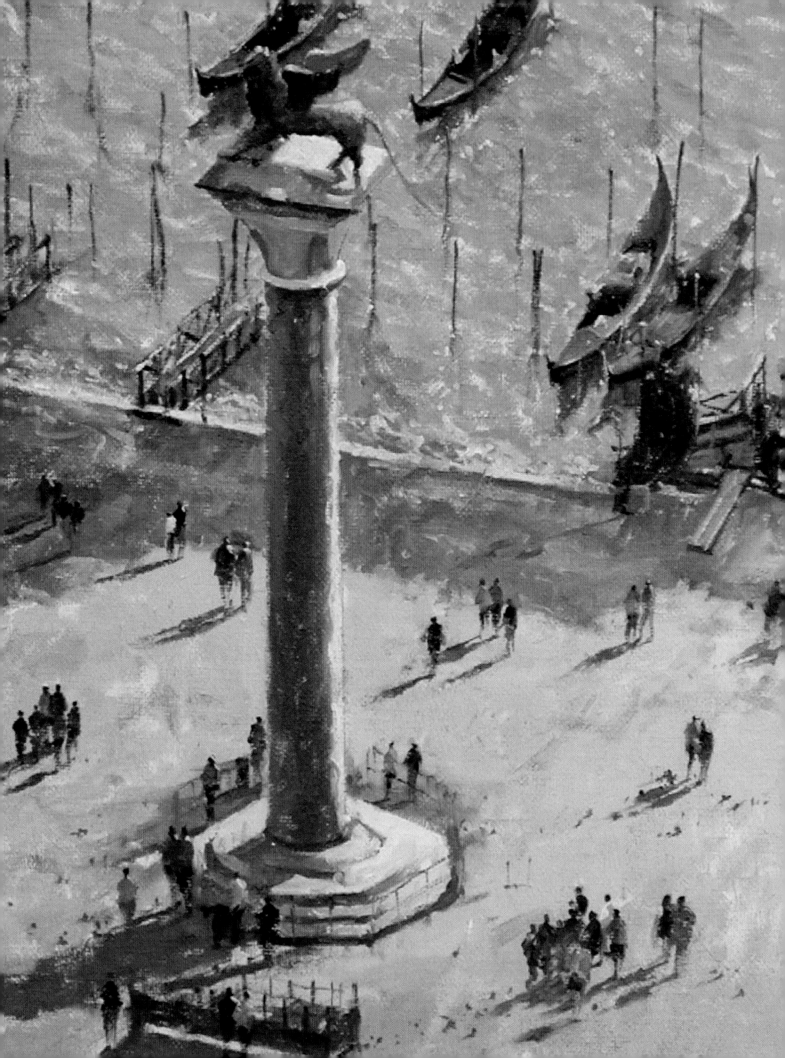

GETTING STARTED

The painting *View from the Campanile Tower/Venice* shows the gondola moorings alongside the Piazzetta San Marco, on the Grand Canal. This breathtaking view, depicted in bright, early morning light, makes a wonderful subject for a pastel painting.

The Characteristics of Pastels

Pastel is a special medium to work with. Its characteristics offer the artist immense scope when tackling any kind of subject matter. They work equally well for the beginner as they do for the more experienced painter. If you are trying pastel for the first time you will be rewarded with the progress to be made within a relatively short space of time and will also appreciate the scope offered by this wonderfully expressive medium.

There is a widely held belief that pastel is best suited to subject matter where strong, vibrant colours are encountered in conjunction with quite heavily textured surfaces. There may be some justification for this view; however, this book will cover a diverse range of subject matter, some requiring bold use of colour and texture and others requiring subtlety, gentle colour and little or no texture at all, thus illustrating the responsive, flexible characteristics of the medium.

It is time to dispel the misconception that pastel is a fragile, impermanent medium. This is certainly not true; in fact, pastels are the easiest paintings to preserve and protect. Oils over the years crack and have a tendency to darken, and watercolours fade and suffer from foxing due to inferior papers.

The painting *Towards Rum and Eigg from Arisaig* was painted with a limited palette of colours on a sheet of grey Hermes fine sandpaper and illustrates perfectly how a more subtle approach can be adopted using pastels.

OPPOSITE PAGE:
View from the Campanile Tower/Venice, 30 × 40cm (12 x 16in).

RIGHT:
Towards Rum and Eigg from Arisaig, 25 × 28cm (10 x 11in).

Inspiration and Motivation

All artists will have different motives and objectives, which gives their work the necessary individuality and energy. Many artists are motivated and influenced by the commercial aspect of the subject matter and may have developed a style and colour palette which has proved successful for them in the market place. Others respond quite differently, producing paintings of great variety with regard to subject matter, colour selection and mood and atmosphere. Although both the above approaches are valid and very much of personal choice, the second option demands much more from artists who strive to express themselves freely

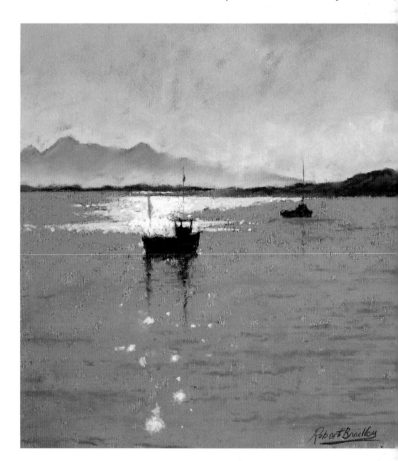

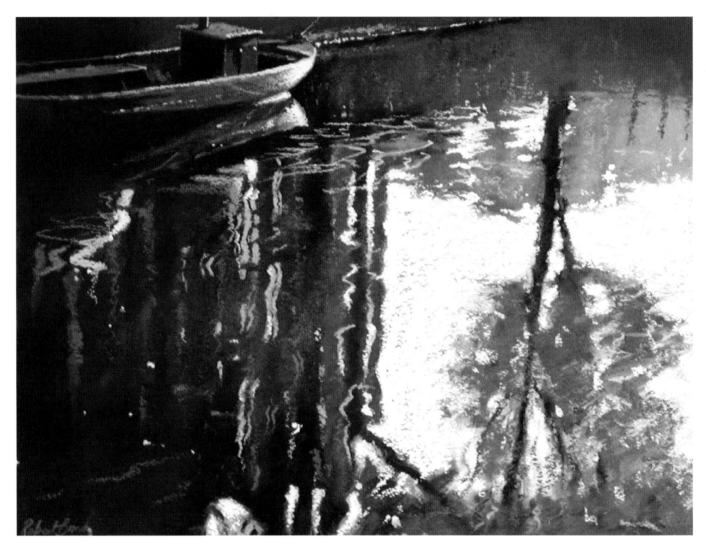

Canal Reflections, 40 × 33cm (16 × 13in).

in the desire to communicate their ideas and feelings to the viewer. There is no doubt that an exhibition of work displaying variety, expression and emotion will be rewarded with a positive response from all who attend. Painting has always been a shared experience; for the artist there should be a satisfaction from a painting which not only fulfils its aims on a personal level but at the same time captures the interest, emotions and imagination of others.

The inspiration for any painting originates with the excitement or emotion created when a subject is observed for the first time. This reaction, which is nearly always immediate, may be triggered by a number of factors, such as a particular mood, atmosphere, colour or light effect. Subject matter may often be quite ordinary; however, all that is needed to generate excitement or emotion is the presence of one of the aforementioned factors. The painting *Canal Reflections* deals with the wonderful reflections in the still waters of the canal. In essence this is a very

ordinary subject; however, a limited palette of colours was used, and a high horizon line employed, to capture the reflections on the placid water surface. This pastel was painted on black Hermes fine grade sandpaper which had been underpainted with a Burnt Sienna wash of acrylic paint.

Inspiration can manifest itself in many unexpected ways and often results in an irresistible desire to paint the subject, which when combined with good observation and interpretation is likely to ensure the eventual success of the work. At other times inspiration comes from unexpected sources which don't always have an immediate impact. On some occasions a little vision is required to transform a promising subject into a workable image. For instance the subject could have all the compositional strengths but may lack the quality of light, colour or mood necessary for a successful painting. In these instances experience, together with a sound ability to recall similar subjects from the past, becomes a real asset.

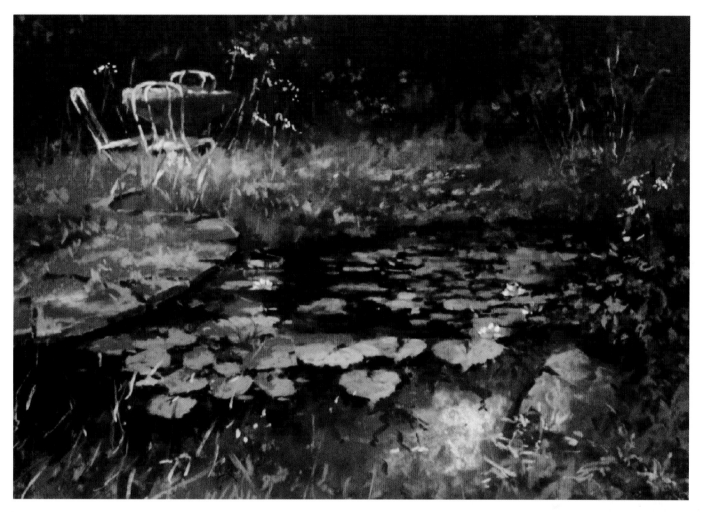

The Lily Pond, 50 × 35cm (20 × 14in).

To fully benefit from your inspiration, whichever form it comes in, either immediate and exhilarating or less obvious, train your mind to be as receptive as possible. Consider a wide variety of subject matter; look for unusual subjects and never reject outright a subject that may be incomplete in one or two essential elements. In so many instances this type of subject matter, which requires a little more input, will prove to be one of your successes.

Composition

The term composition refers to the placement or arrangement of the elements in a painting. A successfully composed piece of work is achieved where the various elements relate to each other and to the whole, resulting in a harmonious design that is aesthetically appealing and stimulating. A satisfying composi-

I find a single focus in the scene and then play everything off that one thing.

Kenn Backhaus

tion is vitally important to communicate your ideas and feelings to the viewer, and therefore it is essential that you spend time composing the elements carefully before you begin to paint. An essential compositional element in any painting is a strong focal point as it attracts the viewer's eye to the centre of interest. A successful focal point is often accompanied by a simple, uncluttered composition, as illustrated in *The Lily Pond*, where the viewer's eye is drawn to the focal point (the table and chairs) via the lily pads and the arc of the paving. In this particular painting the focal point is strengthened by surrounding the lightest light by the darkest dark.

A balanced and well-composed painting can be achieved by adhering to the compositional guidelines regarding the golden section, a mathematical proportion accepted by Renaissance artists as having particular aesthetic and artistic significance. This theory suggests that any significant feature within a painting, such as a figure or major tree, is best positioned approximately two-fifths of the way across the picture. However, many of today's artists are more liberated and compose their paintings free from the restraints of the old masters, preferring to follow in the footsteps of Van Gogh, Gauguin and Matisse, where composition was based more on intuition.

Lines as a Compositional Device

Literal lines do not exist in nature but are the optical phenomena created when surfaces curve away from the viewer. Nonetheless, line-like shapes are considered important, as they create a visual path which enables the eye to move through the painting. For example, mooring posts, masts and rigging can be used to dramatic effect as a compositional device.

In the painting *Towards the Sea/Alnmouth*, the verticals of the trees together with the various diagonals created by the field boundaries create a visual path through the painting.

Towards the Sea/Alnmouth, 30 × 30cm (12 × 12in).

Less obvious lines can be created, intentionally or not, which influence the direction of the viewer's gaze. These could be adjacent areas of differing colour or contrast, such as where the beach meets a harbour wall, rocks or seaweed. Lines may be exaggerated or created for this purpose. The use of too many lines however will suggest chaos and may conflict with the mood the artist is trying to evoke. Lines in a painting contribute to both mood and linear perspective, giving the illusion of depth. Oblique lines convey a sense of movement, and angular lines generally convey a sense of dynamism and possibly tension. Lines can also direct attention towards the main subject of the picture or contribute to organization by dividing it into compartments.

To help illustrate these points further, study the following paintings.

Drinks by the Pool
Vertical and angled lines contribute to creating a visually exciting composition. The oblique line of the balustrade takes the viewer's eye deep into the painting and then across to the focal point, the seated figures.

Sand Snipe/Penzance
The use of strong vertical lines, in conjunction with an unusual format, work extremely well in this painting. Height and grandeur have been accentuated in this tall, slender composition. The viewer's eye is forced to travel through the centre of the painting to the large sun-struck bow of the main boat. Tightly angled, convergent lines help to create a dynamic, lively image. Curved lines are generally used to create a sense of flow within an image, and they are also generally more aesthetically pleasing. Compared to straight lines, curves ensure a greater dynamic influence in a painting.

Picnic in the Meadow
The composition for this painting is strengthened by the use of the following devices:
- A foreground shadow keeps the eye within the picture plane.
- The focal point has been strengthened, creating maximum impact by using high contrast and enhanced detail around the picnic table.
- The picnic table and chairs are positioned on or around the golden section.
- The outside edges of the painting are rendered simply and almost out of focus, ensuring that there are no major distractions away from the focal point.

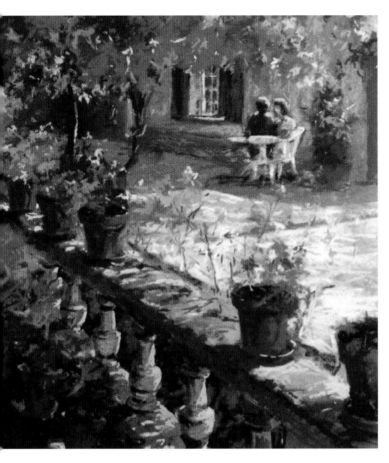

Drinks by the Pool, 45 × 53cm (18 × 21in).

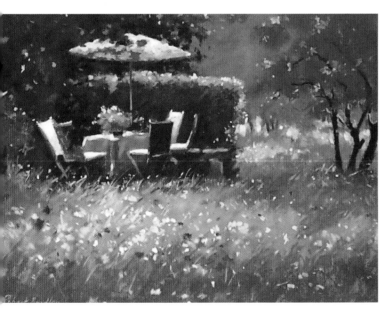

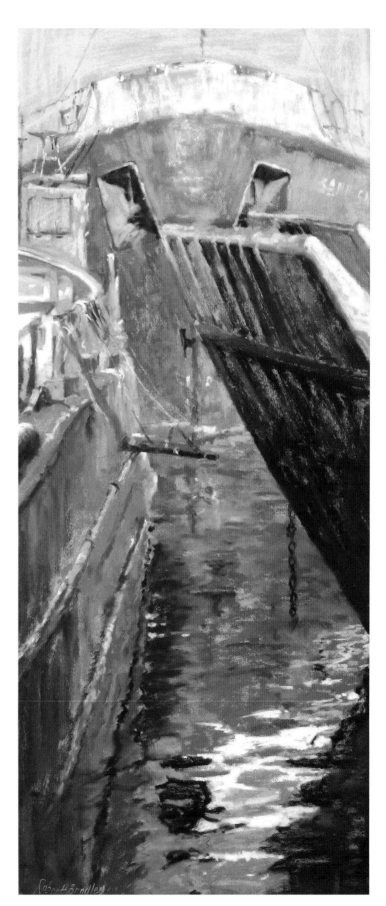

ABOVE:
Picnic in the Meadow
40 × 30cm (16 × 12in).

RIGHT:
Sand Snipe/Penzance
23 × 60cm (9 × 24in).

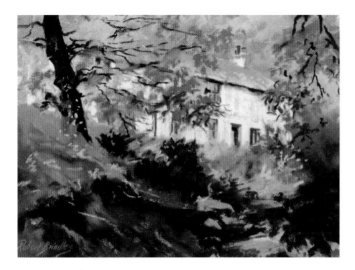

Streamside Cottage/Seatoller, 23 × 20cm (9 × 8in).

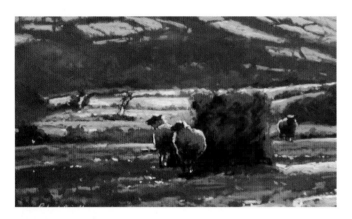

January Snow/North Yorkshire Moors 1, 30 × 20cm (12 × 8in).

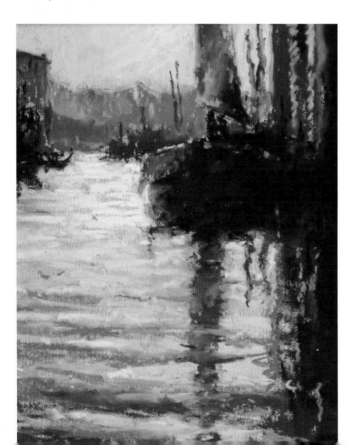

Compositional Devices

There are numerous compositional layouts; however the following five examples are amongst the most widely used. They may seem obvious, but notice that there is often a combination of layouts used in any one of the examples.

The Diagonal Layout

Streamside Cottage/Seatoller is a typical example of the diagonal layout. The dark, broken line used for the top of the bank of the stream leads the viewer's eye into the painting. Whenever you decide to use this layout be careful not to let the diagonal line run out near the top of the painting. A strong shape, a vertical or some other element to stop the eye travelling out of the picture can be used to prevent this occurring. In this painting the white cottage, aided by the branch and foliage in the top right-hand corner have resolved the problem.

The L Layout

The sketch *January Snow/North Yorkshire Moors 1* illustrates the L layout. This shape is a very common compositional format and can be used in four different ways by rotating the L. (See the Inverted L composition below). A larger, more considered, studio version of this painting is included later in this chapter.

The Inverted L Layout

The painting *Venetian Reflections* illustrates how the L shape layout can be adapted successfully by inverting the L.

The S/Zig Zag Layout

Never make the S/Zig Zag layout too obvious. The shape should flow smoothly through the picture plane, taking the viewer on a leisurely stroll, not a roller coaster ride. The painting *Colours of Tuscany* illustrates how this layout can be used subtly and with greater effect if the S/Zig Zag shape is lost and found as it weaves its way through the picture. The tall cypress trees act as a vertical foil to the layout by cutting through the shape.

Radial Lines with Lead-In

Radial lines are an extremely useful compositional device. Any combination of lines at various angles can be used, but remember to keep everything simple. The painting *Morning Light/*

LEFT: *Venetian Reflections*, 25 × 18cm (10 × 7in).

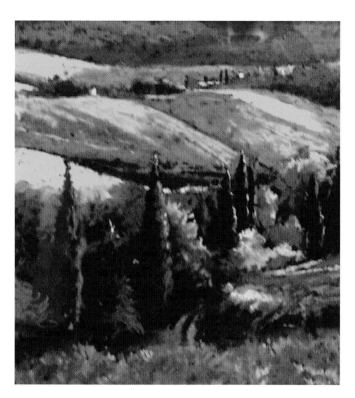

Morning Light/Morston Quay, 37 × 25cm (14½ × 10in).

ABOVE:
Colours of Tuscany
30 × 35cm (12 × 14in).

RIGHT:
Moorings on the Dordogne
35 × 48cm (14 × 19in).

Morston Quay uses the water's edge and the river banks to provide a variety of diagonal and radial lines, resulting in a strong, convincing lead-in.

O Layout

The painting *Moorings on the Dordogne* loosely illustrates the use of the O compositional layout. The river bank and overhanging foliage combine well to frame the centre of interest. It is worth noting that this painting relies on the strong diagonal of the river bank to lead the viewer into the painting, thereby using the Diagonal layout in addition to the O layout.

Experiment with all of these suggested layouts, either individually, or by using combinations of more than one. Never be afraid to experiment with the design and composition of your work.

I usually have an immediate recognition of the potential image, and I have found that too much concern about matters such as conventional composition may take the edge off the first inclusive reaction.

Ansel Adams

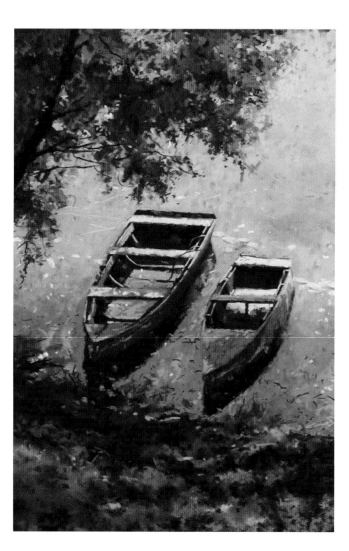

Light and the Illumination of the Subject

Light influences everything and is the primary stimulus for virtually all painters. The way in which light illuminates the everyday scene is almost impossible to capture and remains a constant challenge for all artists. Subsequently, bearing this fact in mind, the aim should be to interpret these light effects as convincingly as possible by creating paintings that reflect the light effect in conjunction with harmony, tone and colour.

Light is transient and presents itself in many different ways, creating excitement, mood, atmosphere and emotion – all very difficult elements for you to transmit via your painting.

The stunning light effect that you may love to paint often disappears far too quickly and the magic dissipates along with it. When painting *plein air* you must learn to accept this as normal, especially when painting in this country. Your development will depend on accurate observation and your ability to make quick decisions and to record information in conditions of changing light.

The Colour of the Light

One of your most important considerations when selecting individual colours is the temperature of the light (its bias towards one colour or another). The light that falls on any scene unites everything within that scene producing total harmony.

For you to be able to reproduce a harmonious, convincing version of the scene, it's vital that you learn to analyse the temperature of the light to determine what effect it has on all the local colours in front of you. Identifying local colour is relatively simple; for example we all know that grass is green and the door in front of you is red and so on. However you will need to look beyond these more obvious colours and try to determine the colour of the light and how it subtly affects everything it illuminates.

Probably the best way of observing shifts in the temperature of the light is to place a white board outside, where it can easily be viewed from the house. Place it in a position where it will receive a moderate amount of light throughout the day. Notice how the colour change of the white alters at different times of the day. This experiment can be repeated by placing the board in shade and comparing the differences.

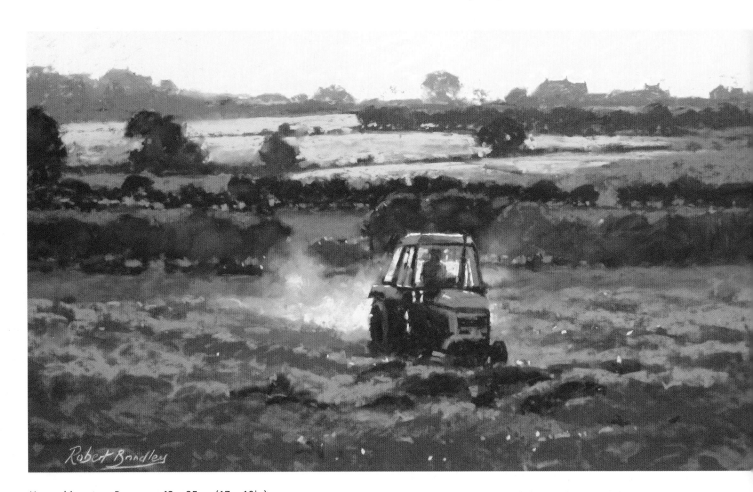

Haymaking near Ruswarp, 43 × 25cm (17 × 10in).

These changes can be observed throughout the year, noting how the colours change not only on a day-to-day basis, but more importantly how they change from season to season. Apply everything you have learnt to your pastel painting by choosing a selection of colours that lean towards the colour of the light. For example, an evening light may have a pink or orange bias which would dictate that a warmer green would need to be selected for grass or foliage, together with warmer versions of every colour in the scene.

To make the selection of colours easier, firstly decide on the colour of the light. Let's say that the light has been identified as a warm, pale orange; select a range of tones, from dark to light, that represent this colour. Six tones would be plenty. You will now be able to add a small amount of the correct value to each area of the painting.

The painting *Haymaking near Ruswarp* illustrates how the temperature of the light, a yellow/orange, influenced the selection of colours. A warm, umber board was used to harmonize the painting. Note how the sky, trees, fields and even the tractor contain varying degrees of the colour of the light.

Light, Mood and Atmosphere

The ability to capture mood and atmosphere in a painting reveals a rare talent. Only a few extremely talented painters have the ability to reproduce this element at will. For most painters it remains a hit and miss affair with many failures and few successes.

To achieve any success in capturing mood and atmosphere in your work you will need to assess the quality of the light and how it influences the masses, tones, colour and edges. Quite often an atmospheric subject has reduced detail and colour in conjunction with simplified masses and areas of tone with little contrast and only soft, gradual transitions. The edges may also appear to be generally soft with the exception of the ones in and around the focal point. The painting *Evening towards San Georgio/Venice* has all the above elements, vital to the creation of an atmospheric painting. Although there is no exact solution or formula available, observing all the above elements and the quality of the light should prove invaluable when trying to achieve both mood and atmosphere and recession in your paintings.

The path or direction of light in your paintings is also an important factor for you to consider. The direction of side lighting, low lighting or back lighting can be used creatively to ensure good design and composition. A light source, such as full sunlight, can serve to highlight texture or interesting features. Strong, low light creates long shadows offering wonderful opportunities for design and composition. The strong direct illumination in *Tuscan Glow* helps to highlight the texture, details and colour so important to the successful rendering of this subject.

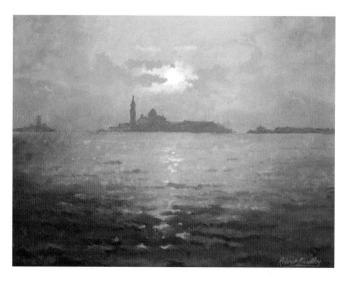

Evening/Towards San Giorgio/Venice, 35 × 27cm (14 × 11in).

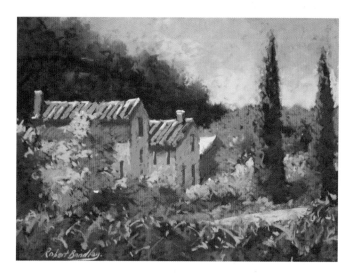

Tuscan Glow, 40 × 33cm (16 × 13in).

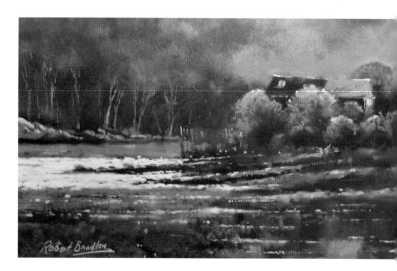

Misty Morning/River Esk/Whitby, 30 × 25cm (12 × 10in).

Autumn/High Street/Burford, 38 × 25cm (15 × 10in).

A diffused light source has the opposite effect, reducing texture and simplifying features and detail. The small painting *Misty Morning/River Esk/Whitby* was painted from rough pencil sketches and photographic reference made on a cold January morning. The relatively diffused light source reduces the details of the background trees.

Side lighting can on some occasions be dramatic and may offer you the opportunity to use the direction of the light, and resulting shadows, to guide the viewer's eye to a particular area of the painting.

Low, side lighting, found when painting early in the morning or in the evening, produces wonderful long shadows which could prove extremely useful when composing your paintings. The low, side lighting in *Autumn/High Street/Burford* casts a long shadow from behind the avenue of trees on the right, across the verge and footpath. (Note the warm and cool colour changes in this shadow, and also how the shadow is darker close to the trees, getting progressively lighter as it moves further away). The light has also created areas of wonderful warm light on the side of the cottages. Warm light has also been used along the diago-

nal line formed by the hedge and footpath on the left-hand side drawing the viewer directly into the painting.

When composing with light and recreating various light effects, it is worth remembering that winter light will produce long shadows, however they will invariably be more subtle in terms of tone and intensity of colour than summer shadows.

When considering light, tone must also be taken into account as the two go almost hand in glove; for instance, the tone of any object will be dependent upon the light at that time. You should also be aware of the contrasts of light and dark by asking yourself how light is the shape against that dark? And vice versa. By answering these questions you will be gaining an understanding of the importance of tone, and at the same time developing a true understanding of light and its effect on tone. The importance of tone in all paintings will be discussed later in this chapter.

Before leaving the topic of light, it may be useful to discuss briefly the importance and advantages of dull lighting conditions. Many painters prefer painting well-illuminated subjects and sometimes are convinced that these lighting conditions make the best paintings. There may be an element of truth

behind these views; however, if you are concerned primarily with capturing the subtleties of tone and colour created by low light and dull conditions, you will reap the benefits of constant light, together with additional time to complete your work. Should you require convincing of the value of working in flat light, seek out and study the paintings of Bruce Mulcahy, RSMA. Bruce is one of the few genuine *plein air* painters of our time, working entirely in front of the subject and capturing all aspects of the landscape in all seasons and conditions.

centuries, often exaggerating diffusion and colour temperature to increase the effect.

Basically all you need to bear in mind when painting convincing distances is to follow simple rules: make things cooler (bluer), lighter in value, and a little softer as they recede.

The painting *January Snow/North Yorkshire Moors 2* shows how the distance has been treated using cooler, lighter and softer tones. This painting was developed in the studio from the sketch shown earlier in this chapter.

Aerial Perspective

There are two types of perspective that artists use when painting and drawing. Aerial perspective could be described as the use of gradations in colour, tone and definition to suggest distance. The other, linear perspective, is a method of portraying objects on a flat surface so that the dimensions shrink with distance. The parallel, straight edges of any object follow lines that eventually converge on the horizon at infinity. Typically this point of convergence will be located somewhere along the horizon and is called a vanishing point. The use of parallel lines which converge on the horizon is a valuable aid when trying to convey depth in your work. You may find it easier to understand this by thinking of aerial perspective as a means of creating a believable distance between objects in your paintings.

How you observe the effect of aerial perspective depends on your relationship to the objects viewed and the relative distance involved. Generally, the heavier the atmosphere, the more pronounced the effect. When viewing your subject from a lower elevation with a higher level of moisture in the air it is easier to see the effect. Conversely, the drier the atmosphere, and the higher the elevation, the less apparent it becomes.

When observing anything in nature, we are influenced by two elements: the warm sun, the basis of all light, and the cool veil of atmosphere that surrounds the earth. The earth's atmosphere cools and diffuses the warm light from the sun, producing a flat, even light over broad areas. Objects that are a great distance away appear both lighter and cooler than nearer objects because of the amount of atmosphere between them and you. Artists have used aerial perspective to create distance in their paintings for

Major Shapes and Tonal Masses

A composition can be helped enormously by the observation and use of major shapes and tonal masses. Well-observed shapes and masses form the building blocks for many paintings, once again ensuring that the viewer is subconsciously led into the painting. Try to squint your eyes when looking at the subject; you will be more able to isolate shapes and tonal masses. The more you squint, the less light enters your eyes and the image becomes simpler in every aspect. In time, this process will become almost second nature.

When working from a digital photograph, try converting the image into greyscale on the computer as an aid to identifying tones and masses. The same process can be used if you take a photo of your final painting; by eliminating the influence of colour and unnecessary detail, you can reveal the major masses and most important shapes.

January Snow/North Yorkshire Moors 2, 50 × 38cm (20 × 15in).

Should you ever have a problem with composition, return to geometry and theory to help you work things out. You may find the following suggestions helpful when composing your paintings:

A Strong Focal Point

A strong focal point is an essential requirement for any composition; the focal point can be made more effective by increasing the tonal contrast and/or including more detail in the immediate area around the focal point. At the same time consider reducing the tonal contrast and detail around the outer edges of your painting.

The Golden Section

Place significant features such as major verticals, horizontals and in particular the focal point, on the golden section.

Using Light

Light is probably the most important element of any subject and more than likely what attracted you to the subject in the first place, so use the light to compose your painting.

Using Linear Features

Look for, exaggerate or create linear features, which provide movement and at the same time lead the viewer's eye into the painting.

Masses and Tonal Shapes

Use the major masses and tonal shapes to compose your painting.

The painting *The Blue Boat/Aldeburgh* employs a few of the above suggestions to achieve a successful composition. The size of the boat in conjunction with the strong colours used creates a

The Blue Boat/Aldeburgh, 43 × 30cm (17 × 12in).

powerful focal point. The viewer's eye is led into the painting by the two areas of rough grass in the foreground (they act almost like stepping stones), moving on to the boat and then progressing even further into the painting along the shallow diagonal of t he edge of the beach.

Subject Selection

For many artists subject selection is a major problem area. Although subject selection in many ways is driven by inspiration, as previously discussed, there are other factors which prevent artists from being able to settle on a suitable subject.

Lack of Confidence

Many artists have a large store of reference material to choose from, yet they remain indecisive over subject selection and always seem to tackle the simpler subjects that they are more confident with. This lack of confidence, unless confronted and eradicated, will only frustrate and stifle the creative process and the path to improvement. If this is the case, you may have to tackle the problem in a positive way. Try to gradually wean yourself off the easy subjects by telling yourself that it will be impossible for you to progress by working from a position of safety. Your progression as an artist will be ensured by taking a few risks and stretching your abilities. Remember no pain, no gain.

To begin taking these vital steps, make a commitment to paint at least one difficult subject in every three paintings carried out. Be confident in the knowledge that, although many of these paintings will not prove to be a winner, you will have learnt far more from one failed painting than dozens of successes where you have not taken risks or stretched yourself. Once you have established such a routine over a period of time, you will begin to reap the rewards. There is nothing better for encouraging further improvement, linked with a new-found confidence, than producing successful works based on more demanding subject matter.

Remember that confidence feeds confidence, and painting, once you have mastered the basics, is all about practice in harness with confidence in your ability. After a suitable period of time you may decide to force the issue by attempting two out of every three paintings which may offer you a challenge. Eventually this problem will no longer exist, and you will find yourself selecting your next painting based purely on the excitement created by the subject matter. Some days you will find yourself painting the simple subject again, but this time the decision will have been made for the correct reasons.

Too Much Reference Material

Too much reference material can, in some instances, overwhelm the inexperienced painter, and making a decision on what to paint becomes a real problem. The solution to this common problem is simple.

Structure in any working environment has always been of vital importance, and it is especially useful to artists. Create yourself a very simple filter system by having a hit list of your favourite images to hand – twenty to thirty images/subjects at any one time should be sufficient. This list can be created or adjusted in any free time by working your way through your reference material. Put to one side some of the subjects that excite you and at the same time satisfy the criteria for making a good painting. Discard all the surplus material for the present time; these can be reassessed again at a later date. Should you have more than twenty or thirty subjects, thin them down further. You are now left with a much smaller selection of subject matter from which decision making will become much easier. A word of caution however – never allow the number of images to creep beyond thirty; otherwise you will return to your old indecisive ways.

A maximum number of thirty images should be sufficient to allow for the ever changing response to any image at any one time. One day you might be quite overwhelmed by a particular subject; however, the next day you may find it rather ordinary. Having a reasonable number of images for consideration at any one time should enable you to select an image that ticks all the boxes on that particular day.

Should you paint in more than one medium, a similar system can be employed for each one; in fact some images may be considered for several different media.

Insufficient Reference Material

Other artists have insufficient reference material to work from and subsequently suffer from a lack of inspiration. Once again, this problem can be reduced by adopting some simple methods.

Wherever you go, take with you a small sketch book and a camera. If you don't already do this you will be amazed at how much reference material can be gathered in a relatively short period of time. Just think of the number of times that you observed a stunning light effect or subject and your camera/sketch book was at home. Never find yourself in a situation like this again; be disciplined and be well prepared.

Another excellent spur for inspiration is to build a library of art books. Should you particularly like an artist's work, a book or DVD may be all you need to fire your inspiration.

The Evaluation of the Subject

The most common problem with subject selection however seems to be the evaluation of the subject with regard to the following important factors: viewpoint (the location from which the subject is observed), focal point, composition (which includes the focal point in conjunction with a good lead-in), colour, tone and the illumination of the subject.

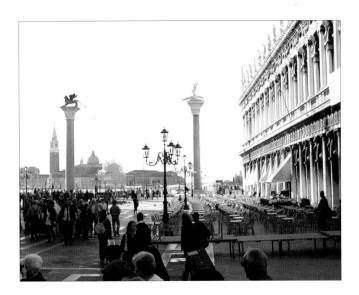

Photograph *The Piazzetta/San Marco Venice.*

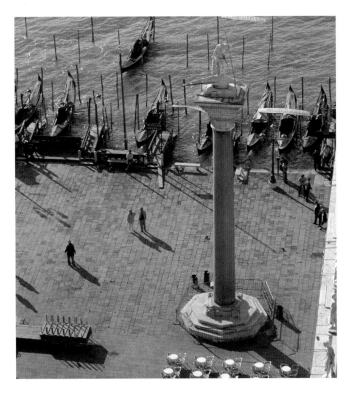

Photograph *High Aspect/Piazzetta San Marco.*

The selection of the best position to paint from is vital to the success of any painting. Rushing into painting any promising subject without giving due consideration to the viewpoint will often result in disappointment. By viewing the subject from different angles and elevations, you may produce a more aesthetically appealing subject with added drama and excitement. Viewing a subject from a different viewpoint influences not only the elements within the picture but also the viewer's interpretation of the subject. You may find that sitting, standing, or moving several feet to the left or right makes a tremendous difference to the composition.

The photograph *The Piazzetta/San Marco/Venice* was taken from quite a low viewpoint and is a sound subject. However, compare it with the painting *View from the Campanile Tower* on page 22 and the photograph *High Aspect/Piazzetta San Marco*, both of the same location but offering far more from the point of view of both drama and composition. The painting in particular illustrates perfectly how the artist can interpret the same subject matter quite differently by changing the viewpoint. This is of course an extreme example; however, it does illustrate the value of taking your time when evaluating any new painting location.

In some instances a subject can be far more effective and have more impact when viewed from close quarters. The painting *Tractor and Fishermen's Huts/Skinningrove* illustrates how radical cropping has been used to eliminate extraneous detail, allowing the red tractor to fill the frame. The viewer can now be fully engaged with the colour and texture within this exciting subject.

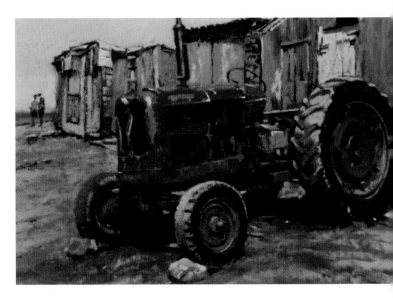

Tractor and Fishermen's Huts/Skinningrove, 38 x 30cm (15 x12in).

Tone

The use of accurate tonal values is essential to the success of any painting. Tonal problems are probably the most common, and in some cases the only, fault in a failed piece of work.

The truth is that small errors in drawing, composition and the accurate use of colour are not necessarily going to result in a failed painting. However, the slightest inaccuracy in tonal relationships or tonal values should be considered a major flaw in the work. For example, maybe you are not satisfied with one of your completed paintings; you know that something is not working with certain elements. Sometimes you may be finding it difficult to make one particular feature stand out against another or you may be lacking definition in certain areas of the work. In situations such as this, always consider your tonal values. Work around the painting assessing local comparisons of tone, asking yourself repeatedly, Is this light enough, or dark enough against the surrounding values? If the answer is no, then you will have to make the necessary adjustments. In some instances, this local adjustment highlights other areas where the values are also incorrect and adjustments will need to be made accordingly. It is certainly true that one small inaccuracy often reveals others; after all, any one small area is part of the whole and will subsequently have a real bearing on the entire painting.

Colour gets the glory and value does the work.

Richard McKinley

What is tone and why is it important to painting? Also how does tone relate to colour? Quite simply tone in painting terms means how dark or light a colour is. Once we have decided this we can then ask ourselves: what is the colour or hue? Tone and colour should always be considered separately, as the strength and visual attraction of some colours is overpowering, and subsequently it is easy to misinterpret their tone.

All colours have a tonal value, and subsequently each individual colour produces a huge tonal range which is dependent on how light or dark these are. You should also be aware that tone is relative, and how dark or light it is often depends on what it's surrounded by. For example, a tone that appears very light when surrounded by a substantially darker one may appear quite dark when placed against a much lighter one.

Irrespective of colour the range of tones in nature, from the darkest dark to the lightest light, is infinite and could never be replicated by the painter.

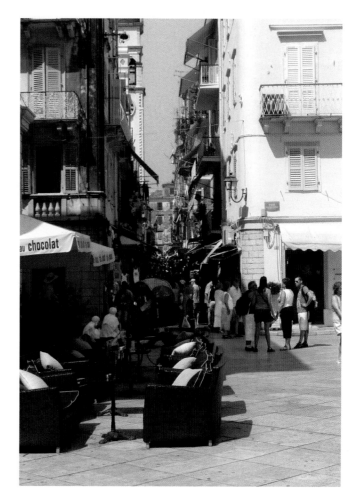

Photograph, *Old Corfu Town.*

The black and white, tonal photograph *Old Corfu Town* illustrates the full range of tones present in everything we see. From this photograph it is easy to understand how an artist could never come close to reproducing all of them. The range of tones that can be reproduced by the painter is limited by the characteristics and properties of each individual colour; for instance, lighter hues such as yellow, will produce a smaller range of tones than a darker colour such as red.

For painting purposes the artist has to drastically reduce and simplify the tonal range.

A simple sketch can be made using as little as three tones – a dark, medium and light – as illustrated in the sketch *Agios Gordios Beach/Corfu*, which was made on a pad of Sennelier grey felt sketching paper, using three blue/grey Conte pastel pencils and white gouache to enhance the buildings. The subject was simplified greatly for the purpose of producing a rapid on-site sketch, which can be seen from the photograph of Agios Gordios Beach. The photographic reference, together with this small sketch are all that would be required for developing a studio painting at a later date.

Sketch *Agios Gordios Beach.*

Photograph *Agios Gordios Beach/Corfu.*

Experiment with this method to produce your own small tonal sketches; start with the darkest tone and finish with the lightest. Should you decide that you want to introduce further tones, just expand the range to, say, five or more tones. Without the distraction of colour you will begin to handle tone confidently.

To take your experimentation a step further, still use the three basic tones, but add three tones of another colour. Finally, make a series of simple tonal paintings using even more colour. You may start with subtle, colourful greys and finish with strong vibrant colours. Tonal sketches such as these will be an invaluable aid to your understanding of the relationship between tone and colour.

In practice, a more realistic number of tones for the development of a successful painting would be eight or thereabouts. However, for each painting produced, the tones required would rarely incorporate the full range of eight, from dark to light. For example, adopting a tonal range of 1 to 8, if you paint an overcast or hazy morning scene you would need a more limited range of tones: probably only tones 2 to 4 would be required. Conversely, on a bright, sunny day, you may need to have the complete range of tones available.

To assist the evaluation of tone when working from life it may prove useful to view the subject through a piece of red or green plastic mounted in a simple homemade cardboard viewer or plastic photographic slide holder. Red has its limitations but generally works well for most outdoor situations, as many landscapes are saturated with green, blue and grey. When the subject is viewed through the red plastic, colour is reduced and a monochromatic image can be observed.

When you are working on a subject with bright reds and oranges, green plastic could be used. Hold the viewer up to scrutinize both the scene and your painting in order to compare the relative value range. Though far from 100 per cent accurate, these exercises may prove helpful in reducing the stimulation of colour and focusing your attention on tone. With practice, you will gradually be able to assess value without any aids.

Boats/Corfu Old Town Harbour, 25 × 25cm (10 × 10in).

TIP

To evaluate the tonal sequences in one of your completed paintings take a digital photograph of the painting in question and then, by using a simple software package on your computer, convert the image to greyscale (shades of grey). Any mistakes that you may have made with respect to tone will be noticed immediately, giving you the opportunity to make any necessary changes.

Newlyn Harbour, 45 × 35cm (18 × 14in).

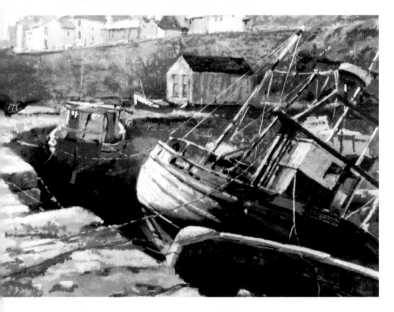

Greyscale photograph of the painting *Fishing Boats/Newlyn Harbour.*

Counterchange

When evaluating tonal relationships, counterchange (the alternation of dark and light tone) occurs everywhere, and if correctly observed and interpreted, it will enable you to solve many problems, concerning not only tone but also how convincingly three-dimensional objects are painted.

Counterchange, and its interpretation, can be seen in the painting *Boats/Corfu Old Town Harbour* where it appears in several places. For instance, observe where the light masts pass across both the dark background of the harbour wall and then the lighter-toned boat itself. Notice how the masts have been purposely lightened against the wall and darkened against the lighter elements of the boat. In this example, only small areas of local counterchange were used; however for some paintings you will need to use it in larger areas.

Once you begin to paint, you may find it useful to ask yourself constantly: Is this tone light enough or dark enough against the surrounding tones? And more importantly: Does this tone fit the overall tonal sequence of the painting? If the answer is no, then make any necessary adjustments. Closely related mid-tones are the most difficult to assess accurately, so always give these tones more consideration.

You may find that the assessment of tone and the differentiation between tone and colour is made easier by squinting your eyes. Try almost closing your eyes when looking at your subject; notice how the colour intensity reduces and shapes seem to merge. Practice this constantly as it will prove to be your most valuable aid.

Compare the digitally converted, greyscale photograph of the painting *Newlyn Harbour* against the full colour image; notice how all the tonal sequences still work.

Should you try this with one of your paintings and find that the greyscale image doesn't work, check your tonal range and tonal sequence. You should focus on tone/value rather than the colour.

In any painting one of the keys to achieving a convincing tonal composition is the importance of getting the overall tonal balance correct. You may find the following pointers dealing with the distribution of tone useful.

Using a Wide Tonal Range

The most obvious and common use of tonal distribution employs the full range of tones from light to dark. This arrangement can be very effective; however, ensure that the distribution of extreme lights and darks is well designed. An over-complicated distribution of too many distracting tones and shapes will destroy any focus and harmony. Also the viewer's eye will jump from one shape to another without moving smoothly to the focal point.

Using a Narrow Tonal Range

A relatively narrow range of tones can be quite effective, resulting in an uncomplicated painting which will be simple for any viewer to read. Try the following combinations:
- Light and middle value lights;
- A range of mid-tones;
- Middle value darks and darks.

Using a Combination of Tones

A combination of tones used in the following 2:1 proportions can prove extremely effective.
- Group the light and middle values together against a dark value.
- For dramatic effects, group the dark and light values together against the middle value.
- Finally try middle and dark values against a light value.

Using Isolated Accent Tones

Try using isolated accent tones, i.e. the lightest light or the darkest dark in or around the focal point. By keeping the rest of the painting relatively simple, you can achieve an extremely effective focus within your painting.

There are no golden rules laid down regarding the sequence that tones should be introduced to a pastel painting. However, you may have fewer problems by applying the darker tones first, followed by the medium tones and finally the lights. The reason for this suggestion is that occasionally, when a dark tone is used into or immediately against a previously applied light tone, a dirty edge or passage can result. Painting the lights into the darks is far safer, and a cleaner result is nearly always obtained. In almost all cases you will probably find that the highlights are best applied in the final stages. By doing this you will be assured of a crisper, cleaner result. The only time that you may have to deviate from applying your highlights towards the end of the painting is if you need to assess their tonal value at an earlier stage.

Some painters start a painting with the highlights, some with the extreme darks or even a combination of the two. By establishing these extreme benchmarks early on you may find it far easier to fit all the remaining tones somewhere in between; however, the choice is yours and only by experimentation will you find what suits you.

Just to reiterate, if there is only one golden rule to remember, it should be this: along with composition, tone is all important; you can be slightly incorrect with the use of colour, but never with tone.

Colour

The painting *Harbour Reflections/Whitby* illustrates the reflections of two Whitby cobles in placid water. In simple subjects such this, which is basically all about design and colour, striking colours are often needed to create the necessary impact.

Although composition, tone, drawing and the handling of edges remains paramount, colour gives artists the opportunity to express themselves in a more personal way. Colour is largely responsible for the emotion/excitement transferred to the viewer.

The small pastel sketch *Harvest Time towards Roseberry Topping* was painted *plein air*. The immediate attraction was the subtle interplay of complementary colours: the distant blues in the landscape worked so well against the warm colours of the bales and field of stubble, and so enhanced colour was used to exaggerate this feature.

Colour has, and will always be, a personal and often emotional response to the subject. For many artists colour is the most important element and is used to stimulate an immediate and often striking response to the subject. However, for other artists colour is much less important as they may be dealing with factors producing different emotions and responses.

As soon as I began blending those beautiful sticks of pure pigment with my fingers, I was hooked! – a medium with no drying time and such a tremendous variety of hues…

Kathryn Mullaney

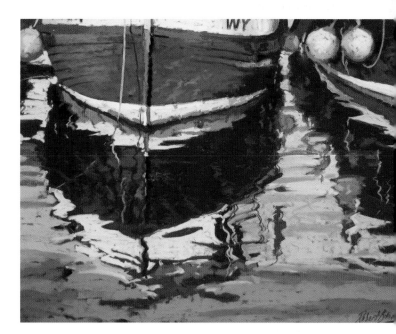

Harbour Reflections/Whitby, 33 × 28cm (13 × 11in).

As stated previously, colour has an emotional element which if used correctly will enhance many aspects of the completed painting; certainly the creation of mood and atmosphere is highly dependent upon colour selection.

In some respects, certainly for the beginner and in some cases for the intermediate pastellist, the level of understanding and knowledge concerning colour need not be too deep. One of the reasons for this is that the range of colours, tones and shades on offer is so great that the complexity of mixing a particular colour no longer becomes a problem. This of course is based on the assumption that the artist has built up a comprehensive selection of colours and tones suitable for the type of subject matter that they are working on. Even if the exact colour is not available, simple scumbling (glazing of one colour over another) can often produce the desired effect.

As you develop your pastel skills, however, you will reach a level beyond the basic ability of applying a basic colour to the surface. You may become interested in quite a complicated system of layering colour to produce further colours or shimmering textural effects. To achieve these effects a deeper knowledge of colour and how to apply it using pastel will be required. Bearing in mind these considerations, the remainder of this section will discuss colour theory in more depth, which will hopefully encourage those of you with little knowledge in this area to develop your understanding of how colour works.

Remember that when using pastels, colour mixing takes place on the surface being worked on and can be achieved by a number of different ways. Colours can be carefully applied one over the other and then blended or – even more carefully – glazed, one over another, building up the layers until the desired result is achieved. This method requires more practice

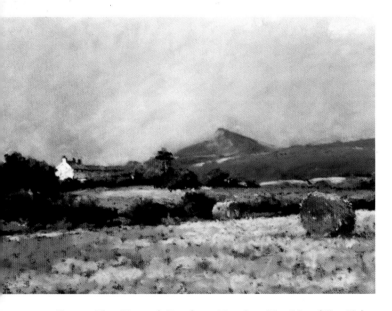

Harvest Time/Towards Roseberry Topping, 30 × 20cm (12 × 8in).

HUE VS CHROMA

Basically *hue* is the actual colour of a pigment or object. Judging a hue is the first step in colour mixing as it identifies what colour pastel to reach for.

The *chroma*, or saturation, of a colour is a measure of how intense it is. Think of it as pure, bright colour, compared to a colour which has been altered by the addition of white or greys. The pastel artist is extremely fortunate these days as most manufacturers produce vast ranges of pure colour together with all their variations with regard to chroma.

and an extremely light touch. A word of advice here: any blending undertaken to multi-layers of colour can result in dirty passages. In the following sections any reference to mixing means the layering/blending of colour on the paper.

Primary Colours

In the basic rules for colour mixing there are three colours that cannot be made by mixing other colours together. These three – red, blue and yellow – are known as the primary colours. This simple statement however, becomes a little more involved when you consider that there are various different reds, blues and yellows. For example, the range of blues, both warm and cool, varies immensely and includes Cobalt Blue, Cerulean Blue, Ultramarine and many others; similarly the reds include Alizarin Crimson or Cadmium Red; and of course there are a variety of yellows, such as Cadmium Yellow, Cadmium Yellow Light or Lemon Yellow. Remember, these are all primary colours, just different versions.

The question often asked is: What primary colours should I use? There is not however a definitive answer, as each blue, red or yellow is different and subsequently produces quite different results when mixed. The advice given in Chapter 1 on selecting a palette of colours should be all you need for starting out.

Many painters using other mediums, such as oils or watercolours, work with a very limited palette of colours, in some instances just three primaries, and in the case of oil painters the three primaries plus white. For pastellists however, this is not an option. Unfortunately for the artist who prefers to work with a limited array of colours, this is one of the few drawbacks of the medium.

The sketch *Thames Nocturne* was painted with a fairly restricted palette of colours which included a selection of reds, ochres, yellows, greys and blues.

Secondary Colours

A secondary colour is created by mixing two primary colours together. Mixing blue and red makes purple; red and yellow make orange; yellow and blue make green. The exact hue of the secondary colour you've mixed depends on which red, blue, or yellow you use and the proportions in which you mix them. If you mix three primary colours together, a tertiary colour is obtained.

Reds, yellows and oranges conjure up sunlight and fire, while the blues and blue/greens evoke snow and ice, sea, sky and moonlight.

<div align="right">Anonymous</div>

Complementary Colours

The complementary colour of a primary colour (red, blue or yellow) is the colour obtained by mixing the other two primary colours (secondary colour). So the complementary colour of red is green, of blue is orange, and of yellow is purple.

The creative use of complementary colours in your paintings is extremely important and can transform an ordinary piece of work into something far more successful. By placing complementary colours side by side in your work you may be able to create contrast or to enhance one element against another. Never be afraid to experiment with the use of complementary colour; it could make all the difference. A complementary ground, or underpainting, can be used in a similar way; for example, red works well under green, yellow under purple and orange under blue. Complementary colours can also be used when painting shadows; for example, the shadow cast by a red object could contain some green. It is important to train your eye to observe these subtleties.

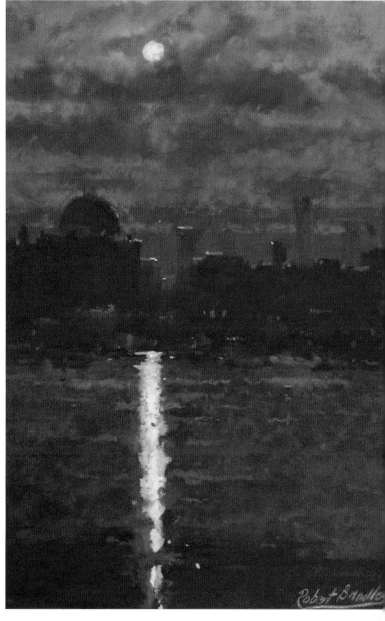

Thames Nocturne, 18 × 28cm (7 × 11in).

Tertiary Colours

Tertiary colours can be obtained in various ways. By mixing any three primary colours, or a primary and secondary colour, an infinite number of browns and greys will be produced, all of them tertiary colours. An even greater range of tertiary colours can be arrived at by varying the proportions of the colours mixed together.

The tertiary colour brown can be made by mixing any primary colour with its complementary; for example, add blue to orange, yellow to purple or red to green. You will of course need to pay particular attention to the proportions of each colour, as to produce brown you will require more red and yellow than

blue in the mix. By experimenting you will be amazed at how many subtle browns you can create.

Greys can be created in a similar way, but you will need to include a higher proportion of blue into your mixes. White added to all the subsequent grey mixes will result in an even greater range of subtle greys.

If your tertiary colours keep turning muddy/dirty, you are probably mixing too many colours together or overblending. If the brown or grey isn't looking as you want it, stop immediately, remove as much of the pastel from the surface and start again. Adding more colour in the hope that it will turn out fine usually ends up in disaster.

DEMONSTRATION *Hay Bales near Whitby*

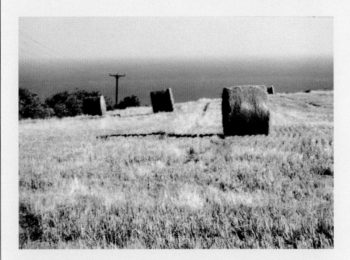

Reference photograph *Hay Bales near Whitby*.

This studio demonstration of hay bales was painted from the reference photograph for *Hay Bales Near Whitby* and illustrates how complementary colour can be used effectively, not only in the painting itself but also in the selection of the coloured ground. The painting was also carried out with the intention of applying as little pastel to the surface as necessary in order to utilize the Terracotta ground for the benefit of unity and harmony.

Materials

Paper:

Terracotta Art Spectrum Colourfix

Pastels

The pastels were Unison, from which some red earths, ochres, yellows, green earths, blues, blue/greys and blue/violets were selected. A light orange pastel pencil by Conte was used for drawing out.

Step 1: Drawing out

(Before any drawing was carried out the image was cropped to produce a more pleasing, square format, 30 × 30cm in size.)

Draw out the composition using the light orange pastel pencil; only a simple outline is required for this stage.

Step 1.

Step 2: Begin blocking in

Begin to paint the sky and sea using light and light/medium tones of blue/grey and blue/violet, taking care not to place too much pastel on the surface at this early stage.

Finally, apply medium and medium/dark ochre tones to the bales.

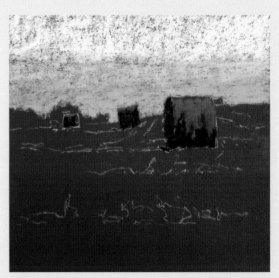

Step 2.

Step 3: Continue blocking in

Continue the block in for the entire surface of the paper, once again taking care not to overload the paper with excessive pastel.

Use the three tones of green earth for the trees, keeping the shapes as simple masses, without unnecessary detail. Four pastels can now be used to paint the stubble of the field; two light yellows and two medium/light red earths.

Step 4: Develop texture and lighter tones

Select a range of richer red earths and yellows; apply them to the surface, stippling and dragging the pastel to produce marks which represent the texture of both the stubble field and the hay bales; at this time, introduce random marks to the field, using two tones of blue/grey, which will add variety of texture and colour.

Select two very pale yellows and apply them to both the field and the bales for the highlights; these highlights should be applied convincingly, in one stroke where possible, with a minimal attention to detail. Finally add the telegraph pole around the focal point.

Step 5: Completion of the painting

To complete the painting, add further texture and highlights, taking care not to go too far.

Use a blending stump, or your finger, to carefully reduce the texture of the sky and sea; you may need to apply further colour at this stage. This blending helps to throw back the distance and at the same time accentuate the textural qualities of the foreground field.

Take time for assessment and reflection

The final assessment and reflection is vital for the success of any painting. Try to get into the routine of asking yourself some of the following questions:

- Does the composition work? Give special consideration to the visual path into the painting, and the focal point – in this case, the telegraph pole and clump of trees – which is positioned off-centre and towards the left-hand side of the painting.
- Do the tonal sequence and colour harmony work?
- Do any of the edges require further strengthening or softening?

Make any necessary adjustments

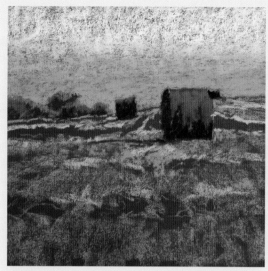

Step 3.

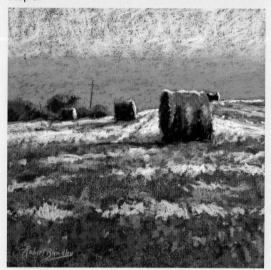

Step 4.

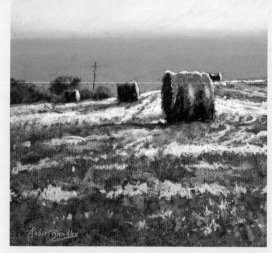

Step 5. *Hay Bales near Whitby,* 30 × 30cm (12 × 12in).

Black and White

Black and white cannot be created by mixing together other colours, although a good strong dark, very close to black, can be created by mixing three suitable primaries. Black is used by some artists, but its use is frowned on by many others.

Mixing white with black produces a variety of shades of grey. However, the diverse range of greys, classed as tertiary colours, produced either by a manufacturer or manually as outlined earlier, is preferred to the rather lifeless mechanical greys produced by mixing black and white. Nature contains a perfect harmony of colourful greys, and none of them can be produced by the combination of black and white.

What, you haven't any ivory-black on your palette? If you think you are going to make black with blue and red, I can't have you in my class. You might stir up trouble with such ideas.

Fernand Corman

Warm and Cool Colour

Every colour has a certain bias, either warm or cool. This bias is not often overwhelming but more often subtle. The colour temperature is an important element to be aware of when mixing colour as it has a real influence on any painting.

Generally speaking, reds and yellows are considered to be warm colours, and blue a cool colour. However, when comparing a variety of different reds, yellows or blues, you will notice that there are warm and cool versions of each, relative to each other. For example Cadmium Red is much warmer than Alizarin Crimson, although Alizarin Crimson is infinitely warmer than a blue.

It is extremely important for any artist to recognize these differences, no matter how subtle, as the observations made and put into practice are vital to the success of any painting.

Mixing two warm colours together results in a warm secondary colour; and conversely, if you mix two cool colours together a cool secondary colour will be achieved. A good example of this is: mixing Cadmium Yellow with Cadmium Red Light creates a warm orange; however mixing Lemon Yellow with Alizarin Crimson creates a cooler, greyer orange.

IN THE SPOTLIGHT

The painting *Autumn in the Park* was made in the early 1990s and was possibly the artist's first attempt at pastel.

Evaluation

This first, exciting step into the world of pastel painting stands up reasonably well considering that it was painted nearly twenty years ago, with no experience of the medium. However the honest evaluation and critical assessment of your work, from way back in the past, right through to your most recent works, is vital to your development as an artist. On reflection, the composition, mark making and the drawing of the cows could be improved upon.

Composition
The main problem with the compositional layout concerns the lack of foreground, which leaves little space for introducing a satisfactory lead-in, which is vital to ensure that the viewer's eye is taken slowly to the focal point.

Although the large tree on the right-hand side works quite well, it would have been far more successful in fulfilling its role as the focal point if the two cows had been positioned further to the right, adjacent to the tree trunk, instead of being left stranded in the centre of the painting. The cows and foreground bush on the left-hand side are evenly spaced out and strung across the base of the painting. Consequently the viewer's eye will jump from one object to the other without moving into the painting and finally settling on the focal point. Had there been another two inches or so on the bottom of the painting, a diagonal, cast shadow could easily have been introduced to lead the eye into the painting. The small bush could have then remained, acting as a stopper and forcing the eye back across the painting to the cows under the tree.

Mark-making
The process of making valid marks invariably causes problems to the beginner in most media, especially with pastel and to a lesser extent with oil paint. There seems to be no obvious reason for this. However, it may be that pastel painting is perceived by many beginners to be a drawing-based medium; after all the pastels themselves are shaped like pencils, and the colours are not fluid, like oils and watercolours. If this is indeed the case, it is no surprise that the marks made are often non-descriptive, tentative and over-fussy. It's never long, however, before most

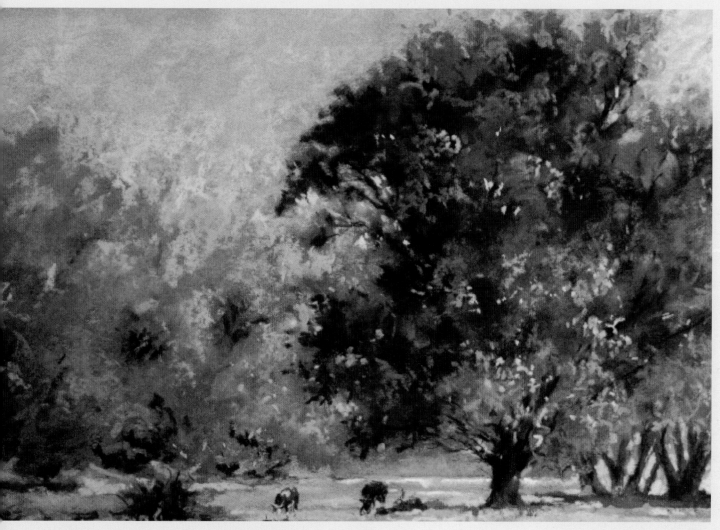

Autumn in the Park, 40 × 30cm (16 × 12in).

newcomers get to grips with the new medium, learning to block in, using the sides of the pastels in some areas, instead of relying too much on their edges and points. The critical evaluation of this painting revealed some of the above faults. It has an over-abundance of fussy, non-descriptive marks. However, mistakes are inevitable and part of the never-ending learning process.

Drawing

The drawing of the cows leaves something to be desired; however, looking back, I may have been over-concerned with attempting to indicate them too accurately. It is often better to develop an economic, shorthand method for painting field animals such as cows and sheep; however, this is only perfected by practice.

Comments

The shortcomings revealed by this evaluation, assessing the subject matter after many years, were not too drastic and could all be easily remedied should the painting be repeated sometime in the future.

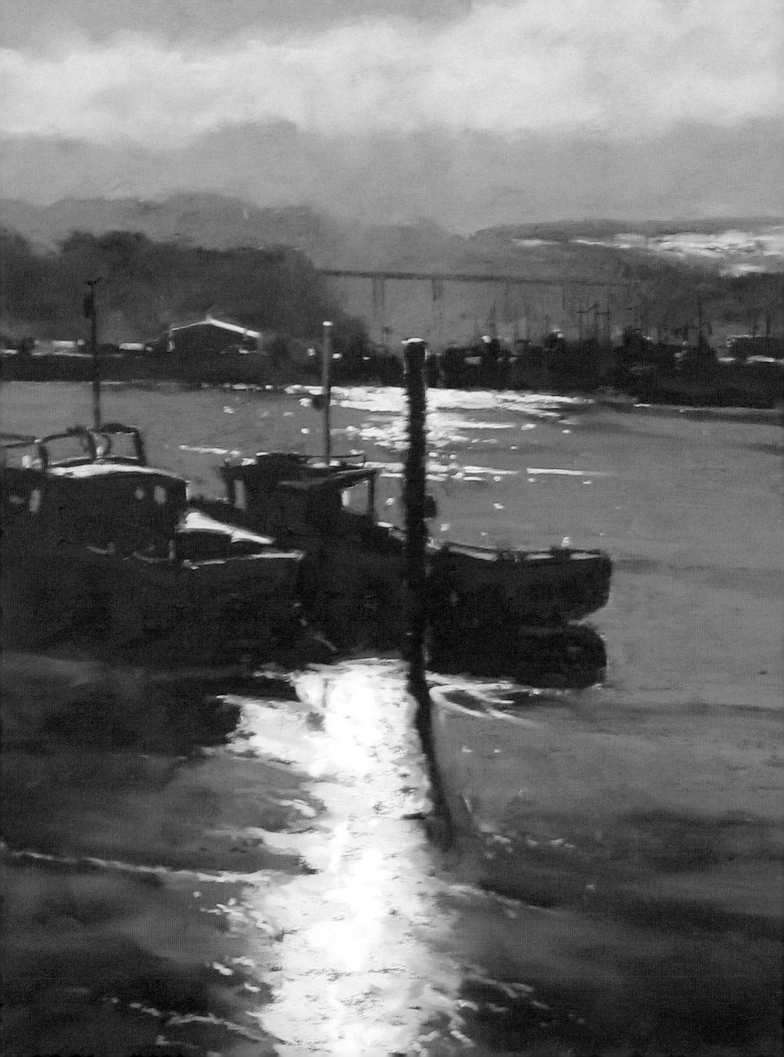

TECHNIQUES

The painting *Harbour Light/Whitby* uses many of the techniques discussed in this chapter. To create mood and atmosphere, extensive blending was carried out and a restricted palette of colours used. The crisp highlights and path of light in the water add drama to the scene.

Pastels are merely pure, ground pigment held together by a binder. Consequently, they can be quite a messy medium to work with. Pastel dust can be very difficult to remove from your hands. However, the problem doesn't end there. Airborne pastel dust is carried throughout the working area and even after only a brief period of working can be found on every surface. The pigments used are often extremely difficult to remove from some surfaces, and consequently care should be taken when attempting to remove pastel stains from any surface other than a hard, smooth, impervious one. To remove pastel dust from soft furnishings, such as carpet or fabrics, water or even a damp sponge or cloth should never be used. A powerful vacuum cleaner with the nozzle attached is probably the best tool for these purposes.

Work Clean

Bearing in mind the above factors, before discussing the various techniques used by pastel artists, consideration should be given to the importance of maintaining a clean working environment, developing a storage system, and establishing a way of working which will ensure that your pastels remain clean. The following suggestions may prove helpful when you are considering setting up a working place.

Easels and Working Surfaces

Work on an easel or surface where the painting stands at an angle of 60 degrees or more, to allow any excess pastel to fall out of the way. Try to work from top to bottom and avoid resting your hands on any of the paper where you have applied pastel. Severe smudges are difficult to remove!

One of the great advantages of working in pastel is that the medium allows the artist to address both value and color simultaneously … value, depending on the degree of pressure used in its applications.

Sidney Hermel

Mahl Stick

A Mahl stick can be a very useful aid for ensuring that your hand can be rested clear of the working surface. The photograph shows a poorly made, but functional, Mahl stick.

OPPOSITE PAGE:
Harbour Light/Whitby,
25 × 35cm (10 × 14in).

RIGHT:
This photograph shows
a homemade Mahl stick.

Catching Dust

Pastel painting should be carried out in an environment where any falling dust can be easily cleaned up. In an ideal situation, working in a studio with a hard, washable floor surface can't be bettered. In less than ideal conditions, you should consider standing on a fairly large piece of old carpet, dust cover or polythene sheet which can be cleaned or renewed when necessary. A dust catcher can easily be made by using a fairly rigid cardboard tube: cut the tube to the correct width for your easel or workbench, and then cut the tube in half along its length. The resultant gutter-shaped card can then be attached to the bottom of your easel or workbench.

Protective Gloves

Consideration should be given to whether or not you wear protective gloves. The benefits are twofold: they will protect your hands, keeping your skin in good condition, and they are easy to wipe or wash down at regular intervals while working. Most pastel artists tend to work without gloves, preferring to use Baby Wipes or damp paper towels.

Keep Your Colours Vibrant

Dust is easily transferred from the hands to other pastels or in some instances from pastel to pastel. Consequently, over a very short time all your pastels will become contaminated and appear to be the same uniform, lifeless grey. This makes the selection of colours and tones almost impossible.

A System of Working

A system of working can be adopted whereby, as different pastels are selected and used, they are not returned to the box but are placed on the adjacent work surface for ease of reselection. A piece of kitchen towel can be taped down to the work surface, and each time a particular pastel is selected the tip can be dragged across the towel to keep it clean.

Cleaning Your Pastels

Dirty, contaminated pastels can easily be cleaned by putting them into a container of ground rice. Shake the container vigorously allowing the rice to absorb the dirty layer of dust from the pastels. Many pastellists keep small pieces of pastel in a container of ground rice. These pieces often prove extremely useful for quick *plein air* sketches or detailed work. They can also be transported very easily.

Basic Techniques

The Bridge Cafe/Sandsend illustrates the versatility of the medium perfectly. The painting is founded on a sound drawing and shows a wide variety of marks/strokes, tone and colour.

Pastels are both a painting and a drawing medium, making them extremely versatile, probably more than any other. They are at their best when used boldly and with confidence. Their use can be more readily exploited by artists who possess good drawing skills. Their characteristics can be exploited if drama and a sense of design are important in the work. The strength of colour and contrast in your work can be enhanced by using a black or dark-coloured ground.

Through exploration of the different areas of the stick a wide variety of marks and textures can be achieved. For instance, with the side of the stick broad, painterly marks can be made which in turn can be manipulated by blending, blurring or layering with further applications of colour.

Working with the tip and various other edges of the pastel, you can create a variety of lines and other expressive marks.

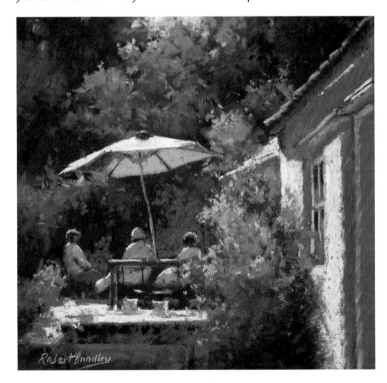

The Bridge Cafe/Sandsend, 28 × 28cm (11 × 11in).

Using the side of the pastel.

Using the tip or various edges of the pastel.

A combination of colour changes and random marks can produce many interesting passages.

Random Marks and Stippling

Random marks and stippling can be employed in areas such as deep grass, where there may be no definite detail, but a variation of texture and colour may be needed to achieve a convincing rendering. The use of colour change, in conjunction with a variety of rapidly applied random marks demands practice before the technique can be mastered and used convincingly.

Flat Strokes

To some extent the texture of the paper will have some bearing on the results obtained when applying flat, even strokes. Generally the pastel should be applied with a confident, firm stroke. Constant pressure will be needed to achieve even effects. Changing the direction of the mark made and varying the pressure will produce a variety of other interesting effects and textures.

Graduated Colour

For a graduated passage of colour the pressure applied to the pastel should be increased as the stroke is made. By starting the stroke with a greater pressure and reducing the pressure as the stroke is made you can reverse the resultant effect. Clear skies can be painted using this technique.

Flat strokes.

Overlaying Colour/Texture

Many rewarding effects and textures can be achieved by over-laying colour. Once again the results obtained will vary tremen-dously depending on the colour and texture of the paper. It is always recommended to apply the first colour with a light touch, thus ensuring that subsequent applications of colour and texture will adhere and at the same time remain fresh and unsullied.

The pastel sketch *View from the Campanile/San Marco* is an excel-lent example of virtually all of the above techniques, including:

- Marks made with the tip and the flat sides of the pastel are employed to produce many different effects; see the horizontal marks in the water, the mooring posts and the twinkling lights in the distance.
- The overlaying of colour producing a variety of textural effects; the sky and water use these techniques.
- Graduated colour is used in both the sky and the water.
- A limited amount of blending has also been used in parts of the sky and buildings.

LEFT: Overlaying colour/texture.

BELOW:
Sketch View from the Campanile/San Marco (detail),
30 × 40cm. (12 × 16in).

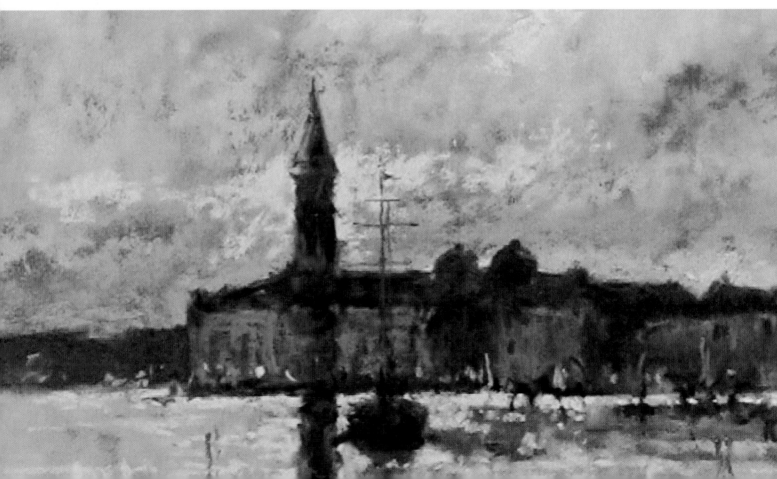

Linear Strokes

The successful creation of linear strokes when using pastel is dependent upon many factors. An ability to draw well and with a degree of confidence is a major asset. Hesitant, indecisive strokes are immediately obvious and can completely ruin a piece of work.

The key to all skills is practice, practice, practice. Until you are confident with the application and variety of marks possible, keep the rendering of the work simple. Many subjects can be portrayed in a simplified form, without the need for complicated mark making, producing extremely successful paintings.

The variety of linear marks that can be made with pastel is staggering. By varying the pressure, using different edges and changing direction, you can tackle volume, space, perspective and many other aspects of painting.

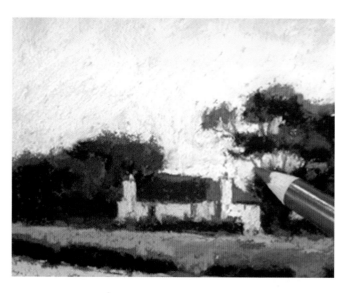

Fine lines used for distant tree trunks.

Hatching and Crosshatching

Hatching and crosshatching are techniques commonly used for building up tonal values. They are also used widely in ink, pencil and charcoal drawings.

Hatching is the use of separate, parallel strokes laid next to one another. The results obtained vary depending on several factors, such as the pressure applied, the stroke width and the closeness of the strokes. These varied results make hatching an extremely valuable technique for the artist to exploit.

Should you require additional texture or darker tonal values, crosshatching can be used very effectively. Crosshatching involves a further set of strokes laid over the top of the previously applied hatching at an angle of approximately 90 degrees.

Wider strokes and lines.

Fine strokes used for tree trunks and their reflections.

Varying pressure.

Crosshatching.

You can achieve areas of vibrant colour mixes by interweaving two or more different colours, if applied correctly. Viewed from a suitable distance a perfect blend of colour is achieved.

Hatching and crosshatching can be taken a step further by using a variety of curved parallel strokes, either in the same direction which can be useful for describing the contours on curved objects, or multidirectional which produces irregular texture.

Blending

The issue of whether or not to blend pastel has always caused artists to consider the benefits or disadvantages encountered. Many artists prefer the crisper, more spontaneous results achieved by leaving the pastel unblended, whilst others insist that blending adds another dimension to their work by creating diffusion, mood and atmosphere and restful passages to their work. Today the debate continues. Putting personal preferences to one side, the determining factor should be the success or otherwise of the piece of work.

The nature of this medium, being pure, finely ground pigment, enables the artist to blend the applied pastel, creating many subtle effects. Soft gradations of colour and tone are easily achieved, and intrusive lines and marks can be adjusted.

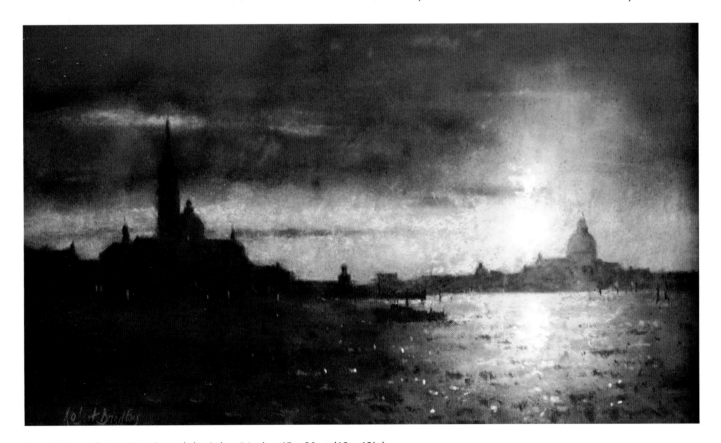

Sunset/Towards San Giorgio and the Salute/Venice, 45 × 30cm (18 × 12in).

Blending using a *Pro Arte* colour applicator.

Blending in conjunction with line work.

Marks made with a combination
of strokes using various pressures.

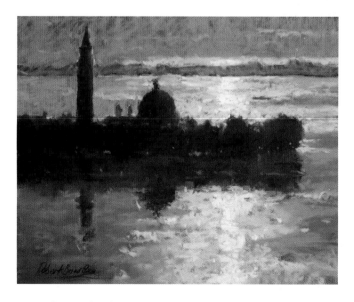

Towards San Giorgio/Venice, 25 × 20cm (10 × 8in).

There are several ways that pastel can be blended. Marks made by the tip, edge or side of the pastel and a relatively light touch, creating scribbles, even crosshatching or broader marks, can easily be blended. Care should be taken not to apply too much pressure when applying areas of pastel where you intend to use this technique, as any pastel which becomes too ingrained will be difficult to blend. The resultant surface can then be carefully blended using the fingertip, a soft rag, a tissue, a brush, a Pro Arte colour applicator or a paper stump. A combination of several of these blending techniques can be used if required. The entire process can be repeated to achieve a darker tone or to adjust the results.

The atmospheric painting *Sunset towards San Giorgio and the Salute/Venice* was produced by incorporating the blending technique. To produce a shimmering, textural effect, the pastel was blended and lightly fixed several times during the application of pastel. The final blended layers of pastel concerned with the lightest lights remained unfixed, thus ensuring a purity of colour.

Blending in Conjunction with Line Work

Blended areas can be overlaid and enhanced with further techniques including linear strokes to create a wide variety of interesting textures and surfaces.

The small painting *Towards San Georgio/Venice* uses virtually all of the above techniques. Extreme care was taken when building up this painting. Many applications and layers of pastel were used, and the tooth of the paper could have easily have been exhausted very early in the painting process, making it impossible to carry on.

The Initial Drawing

How detailed do I make the initial drawing? This is one of the most frequently asked questions and the reply is usually the same: the degree of drawing undertaken in preparation for the pastel painting itself remains an individual choice. For many painters the initial drawing is purely functional, intended to compose the painting by the arrangement of various shapes and values, often using just a few marks. Other painters feel that they need a more considered drawing as a sound basis to work on.

There are a few considerations to be made when you are making your decisions on drawing.

Always lines, never forms! But where do they find these lines in Nature! For my part I see only forms that are lit up and forms that are not. There is only light and shadow.

Francisco de Goya

The Pastel Surface and Drawing Implement

Consider which surface you will be working on and what you will be using to undertake the drawing. Depending on the surface, there is a variety of options available: good quality 2B drawing pencils, vine charcoal and pastel pencils are a few of the most common. All three will be satisfactory on most surfaces, and corrections are easy to make on all but the roughest.

Drawing in Conjunction with Underpainting

Should you be using an underpainting it is recommended that you experiment first to establish exactly how the drawing can be handled and how it may affect the outcome. In some instances smearing can occur, which may grey the freshness of the pastel being applied. You should, in all cases, make sure that you never press too hard with your drawing, as excess dust will almost certainly cause dirty, grey results especially when using lighter-toned pastels. Always blow off any surplus dust, or gently wipe over the surface with a soft kitchen towel before you begin to paint.

The drawing for *Racehorses* was made with a light Raw Umber pastel pencil on Elephant Colourfix paper. A fairly accurate drawing was required for this detailed subject. The drawing was fixed using a proprietary aerosol fixative to ensure that it remained intact whilst applying the block in.

The Degree of Detail Required

Before you commence the drawing you should also ask yourself how detailed you need the drawing to be in order to feel at ease with the execution of the painting. After all, spending too much time on an over-elaborate drawing may not produce the best painting. You may consider making a few thumbnail sketches before you start to enable you to sort things out in your mind. You will find that just a larger version of one of these sketches is all that is required.

Drawing for Racehorses.

Goathland/
North Yorkshire Moors,
28 × 28cm (11 × 11in).

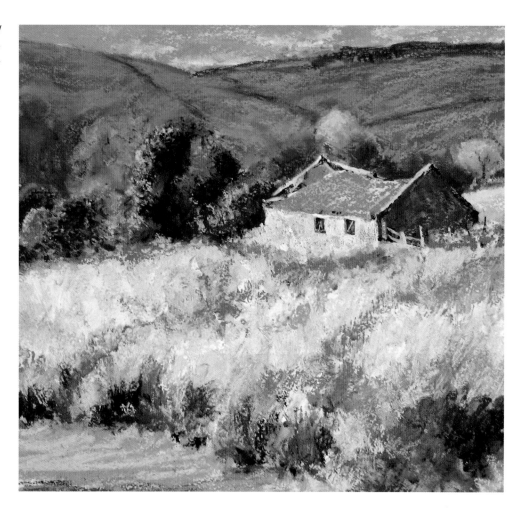

Try to bear in mind that the drawing is an invaluable way of tuning in to the subject, and in many ways time spent loosening up and working yourself up into the right frame of mind can save time in the long run.

Losing Some of Your Drawing

Never worry too much about losing some of the drawing once you start applying the pastel. The fact that you have thought carefully about the drawing and then physically produced it will ensure that you have the concept firmly established in your mind and will be able to remain in control.

Textured Surfaces

The sketch *Goathland/North Yorkshire Moors* was painted on 300lb rough watercolour paper which had been prepared with one coat of Golden acrylic ground to provide a coarse texture.

A loose watercolour underpainting was carried out before any pastel was applied.

By working on a textured surface you will be able to add variety to your work. There are numerous ways that the surface can be prepared. The following suggestions are given to encourage experimentation.

Golden Acrylic Ground for Pastels

A ground is used to provide a tooth for the application of pastels, charcoal and other art media. This ground is a 100 per cent acrylic medium which contains finely ground sand (silica) in a pure acrylic emulsion. It can be applied to paper, canvas, wood or any primed support and provides a toothy, gritty ground for many different media, including pastel. It provides a coarse tooth, and the tooth can be increased by adding Golden fine or coarse pumice gel. It allows almost limitless applications of pastel. In addition, the resultant ground can be coloured by mixing with Golden acrylic colours.

Before using, the acrylic ground for pastels medium will require thinning by adding 20–40 per cent of water until the desired consistency is obtained. The medium can be applied with a brush, paint-roller, spray equipment, squeegee or palette knife. Take care not to mix too much in one batch, as the solids settle rapidly and it can be extremely difficult to mix back into suspension.

The small sketch *Evening/St Marks Square* was painted on a 300lb rough watercolour paper treated with Golden acrylic ground. The prepared paper was underpainted with watercolour before the pastel was applied.

RIGHT:
Sketch *Evening/St Marks Square*,
20 × 20cm (8 × 8in).

Marble Dust

Marble dust boards can be made to your own liking with regard to texture and colour. The following notes may prove helpful should you decide to experiment:

MAKING YOUR OWN MARBLE DUST BOARDS

Materials

Acrylic gesso, marble dust, water (distilled if available), acid-free illustration board or similar (feel free to experiment with a different surface if you do not have illustration board), watercolour, gouache, acrylic paint or ink (to tint mixture, if desired). Marble dust can be purchased from most reasonably sized art stores.

Other sundries that you may need:

A bowl or bucket, a whisk, a spoon (paintbrush, sponge brush or sponge roller), an old cloth and a pair of rubber gloves.

Procedure for mixing the ground:

In the bowl or bucket, mix approximately a cup of gesso with 2-3 heaped tablespoons of the marble dust. The more dust you add, the more tooth your surface will have. Add enough water to bring the mixture to about the consistency of house paint. Whisk until smooth.

Lay the illustration board on the cloth and start to spread the mixture onto the surface using the sponge brush. You need to make the coating as smooth as possible.

To create a toothier surface, you can apply a second and third coat to the board. Be sure to allow the boards to dry completely between coats.

Tinting the mixture:

Should you prefer to work on a tinted ground, add colour to the mixture. Inexpensive watercolour paint, acrylic paint or inks work well; however acrylics tend to produce a more slippery feel to the surface. Add a generous squeeze of paint to the marble dust/gesso mixture and whisk until smooth and blended. The colour you see in the bucket is the colour it will be on the board, so adjustments can be made at this stage.

Lay the boards flat to dry. If you are working outside, you will find that they dry fairly quickly between layers, and it should not disrupt your work.

Once the boards are dry, you can store them flat with your other pastel papers/boards. They might slightly curl during drying, but you will find that they flatten out again once they are stored flat for a day or two.

You can store any leftover mixture in tightly sealed jars and use it again at a later date. As long as it is not exposed to the air it should stay workable for a fairly long time. If you notice it thickening, add a splash of water and whisk it to the desired consistency.

This mixture can be used on many other surfaces. When choosing paper, make sure it's suitable to withstand the applied texture. If it's too thin, it will buckle and warp; this can often be remedied with a thin application of acrylic primer to the reverse. Watercolour and printmaking papers of 100% cotton-rag content work well. If a rigid surface is your preference, wood fibre hardboards such as MDF will be more to your liking. Both of these substrates should be sealed first with a coat of acrylic to protect the surface from acidic migration over time. A rigid board may be preferred for travelling and *plein air* work as it will be less likely to get damaged.

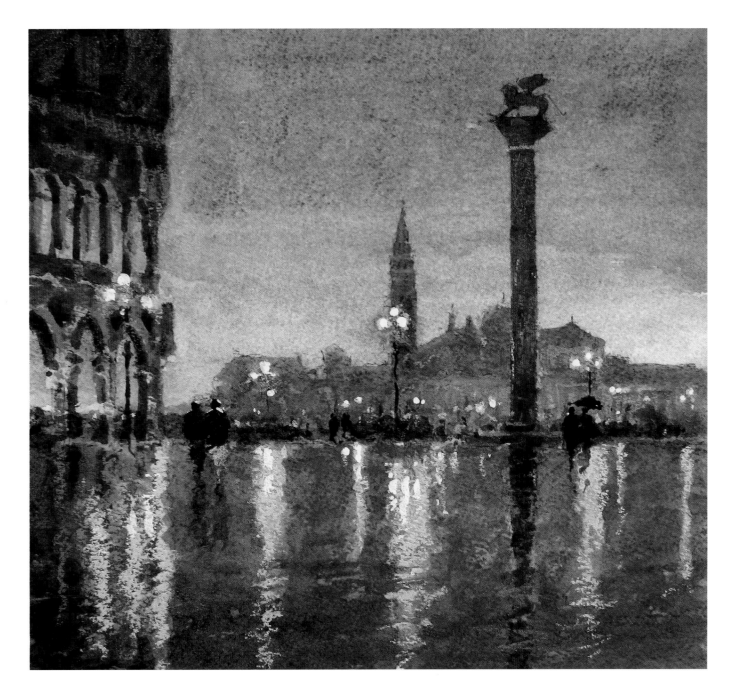

Working on Coloured Grounds

In representational landscape painting, one of the most universal practices is to begin the painting on a warm brownish undertone. Historically, artists worked either on a grisaille (grey) or burnt brown earth tone. Working on a toned surface helped to create a balance between overly light paintings produced on a white surface and overly dark paintings begun on a near black surface. Painting is a visual exercise, therefore we respond to what we see in front of us. The same mark that appears dark when made on a light surface will appear light on a dark surface.

We see the mark in context and adjust the tone or colour accordingly. By painting on a middle-value, toned surface, you will have a better control over the value range in your paintings.

Colour will also play a part in your choice of ground. In simple terms, everything is affected by what it's next to, appearing to take on the opposite of what surrounds it. Consequently, some things look lighter against dark, darker against light, warmer against cool, and cooler against warm.

The following demonstration painting *Evening/The Embankment* was executed on mount board, prepared with Aubergine Colourfix pastel primer.

DEMONSTRATION *Evening/The Embankment*

This small painting was inspired by an evening walk by the Embankment in London. The ground was extremely wet after frequent showers during the afternoon resulting in wonderful reflections. To take full advantage of these reflections, the horizon line was placed relatively high in the composition.

Materials

Board:

Mount board prepared with white acrylic primer and then one coat of Aubergine Art Spectrum Colourfix pastel primer.

Pastels:

The pastels were a mixture of Rembrandt and Unison using a selection of green earths, blue/greens, brown earths, yellows, blues, blue/violets and greys. Choose at least three tones of each colour should you decide to paint this demonstration. A pale blue pastel pencil by Conte was used for drawing out, but you can use whatever you are comfortable with.

Step 1: Drawing out

Draw out the composition with just sufficient information to be able to paint from. Pay particular care with the lamp posts as they need to be drawn fairly accurately and their perspective should be convincing.

Step 2: Begin blocking in

Begin to block in the major shapes and masses. For the sky use a light blue/violet and a light, warm grey. The mass of the tree can be blocked in with a mid-toned green earth and a dark blue/violet. The lamps, wall and ground can be painted with a combination of dark blue/violet, a mid-toned blue/violet and two mid-toned brown earths. Take care not to overload the tooth of the board at this early stage.

Step 3: Continue blocking in

Continue to develop the block-in using the same selection of colours plus a lighter blue/violet and a lighter grey. Use the side of the pastel and vary the direction of the strokes made. At this stage you can begin to layer the pastel in some areas. This layering can be seen in the sky and certain areas of the ground. Once again, keep the blocking in loose, without any detail and don't apply too much pastel to the board.

Step 4: Develop the whole painting

In this step, more attention can be given to the drawing and the development of the masses and values over the whole surface of the board.

To paint the lamps, the colour of their lights and the resultant reflections, you will need to select several brighter pastels from the yellow and brown earth pastel range. For the trees you will need two or three additional green earths. Finally, for the sky and left-hand wall, you will need a light and a mid-toned blue/green. These additional colours should be carefully introduced to the painting, overlaying the previously applied colour in some areas without blending. In other areas you may find that a little selective

Step 1.

Step 2.

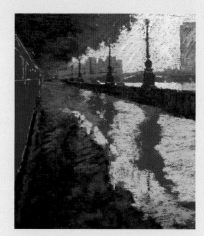

Step 3.

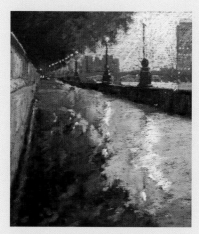

Step 4.

blending, using your finger or a blending tool, will produce the effects you are looking for.

A word of caution here with regard to the blending of pastels. Whenever you are considering blending dark areas of pastel always bear in mind that you will often produce a dirty effect. This does not generally apply to lighter areas of pastel, where more successful results are achievable. The tree masses in the demonstration, which include dark pastels, have not been blended. The pastels used were carefully overpainted which produced a convincing rendering of the foliage in shadow. Notice how a little blending of the lighter areas in the reflections has been used effectively, without any dirty results. Until you gain further experience, in order to keep your paintings clean and crisp, you may find that blending should be kept to the absolute minimum.

You can now begin to add all the distant half-toned lights; however, don't add too much information at this stage.

Step 5: Layering colour and building up detail

This step is a continuation of Step 4, where the same colours and techniques are used to advance the painting. Looking at the photograph of Step 5 and comparing it with Step 4, you will notice that by overlaying colour, texture has been created in the foreground, left-hand wall and the lighter areas of the overhanging trees. In addition to this the lamps have been detailed more accurately, and more consideration has been given to the sky and distant buildings. To take full advantage of the Aubergine ground, leave enough of this in evidence to provide unity.

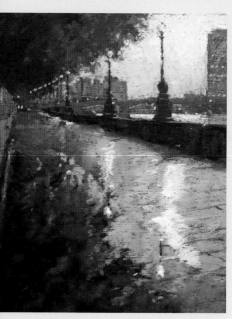

Step 5.

Step 6: Add the figures and final details

This final step concerns the adding of all the final details and touches which will ensure the success of the painting. If you decide to add a little life to the scene, a couple of figures can be incorporated. Consider carefully the placing of the figures and decide exactly how important a part you want them to play in the final piece of work. Figures placed in the distance will obviously play a very insignificant part and are generally used to draw the viewer's eye into the painting. Prominent figures placed in the foreground can be extremely effective; however in this case, as the painting is very small, large figures could be too dominant and destroy the overall impact. Quite often the safest option is to use medium-sized figures placed just off centre, where their function is twofold: adding life to the work and at the same time providing a stepping stone, ensuring that the viewer's eye travels at a controlled rate into the painting.

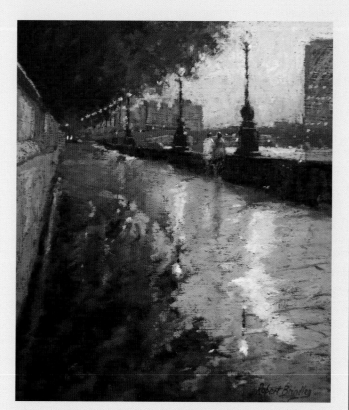

Step 6. *Evening/The Embankment*, 20 × 18cm (8 × 7in).

Step 7: Evaluation

At this stage you will need to take the usual time for evaluation with special regard to edges, composition and values. Never settle for an attitude of 'it will do' – it won't. If something is not quite right, decide what it is and try to resolve the problem.

Warm Grounds

When considering and putting into practice the above details regarding working on a coloured ground, you will find that a warmer painting results when working on a warm-toned surface. This is not only because of the warm tone showing through, although it does help, but because every mark you make will look cooler, and you will naturally gravitate to a warmer choice of hue. When the surface is completely covered, without any of the undertone showing through, you will have achieved a warmer colour harmony throughout your painting.

There are well proven reasons why we are more at ease with warmer paintings. The landscape is flooded with a shared, daylight light. This light is much warmer than we think, and it is all too easy to become over-concerned with local colour, thereby not giving enough consideration to the effect of light and its warmth throughout the scene. It is well worth stressing that even the greenest and bluest of spring and winter days are flooded with light.

We also feel calmer and more secure in a warm environment. This is why warm paintings tend to sell better than cool paintings.

If you feel that your landscapes are lacking a natural sense of daylight, try working on a warm surface. The sky will still be blue and the trees green, but the completed, warmer painting will prove to be a more natural landscape.

With these observations in mind, be careful not to go overboard, producing overly warm/hot landscape paintings. You should be sensitive to the prevailing temperature of the light at all times.

Cool Grounds

The facts discussed above concerning value and colour relationships remain equally true with regard to working on cooler grounds. However, it is better not to become too formulaic with any aspect of your work. By experimenting with cool grounds you will achieve variety in your work.

Creating Your Own Coloured Ground

The vast range of proprietary papers and boards, with a variety of textured finishes and colours has already been discussed in detail. Different coloured, textured, pre-mixed grounds are also readily available; however, you may not be able to find the coloured ground that you are looking for from those commercially available.

There are solutions open to you, some of which have already been discussed earlier in this chapter (see Tinting the Mixture), where a variety of colours were added to a prepared, textural mixture.

Many proprietary papers and boards can be painted a different colour; however carry out a little research, or experiment on a small scrap before you go ahead.

As mentioned previously, acrylic paints or inks, watercolour paint or gouache are all perfectly suitable for this purpose. They can be applied by watering down the pigment, producing a tint, or full strength, straight from the tube or bottle. Special care should be taken when applying acrylic paint to finely textured surfaces, as the tooth could be filled, making it difficult for the pastels to stay in place. As always, only by experimenting will you find the correct solution for you.

Underpainting

Many artists start their pastel paintings with a transparent, wet and loosely applied underpainting. This underpainting allows the artist to take the drawing stage a little further to establish a more positive foundation before starting to use the pastels.

This underpainting should never be developed too far, as it is not intended to be the finished painting; however a successful underpainting often plays a major part in the appearance of the final piece of work. The decision concerning the amount of underpainting which remains visible in the finished piece is not always made at the start of the painting session; it can be made at any time during the development of the painting.

The illustration showing the underpainting for the painting *Trees/Eskdaleside* was carried out using a fairly accurate drawing and was intended to be an integral part of the finished piece of work. Bearing in mind the type of paper, board and finish that may be worked on, the underpainting itself can produce an astounding variety of appearances, some so striking that the artist may decide to incorporate them in a fairly large area of the finished work.

If you have never used an underpainted surface before, experiment with weak watercolour or acrylic washes first. Try incorporating spatter using watered-down paint applied with a toothbrush, or just shaken off an ordinary watercolour brush. The resultant texture, if successful can be incorporated into the final work.

Thin oil washes can be used very successfully; however you will need to determine how this medium will respond to the surface and how it will interact with the pastel. Undertake a little research and experimentation of your own before committing yourself to methods which may not stand the test of time.

The introduction of acrylic-based sizing and binders in the manufacture of recent commercial pastel surfaces goes some way towards ensuring that the surface will remain stable whilst oil-based paints are applied and also preventing these paints from attacking the underlying paper or board.

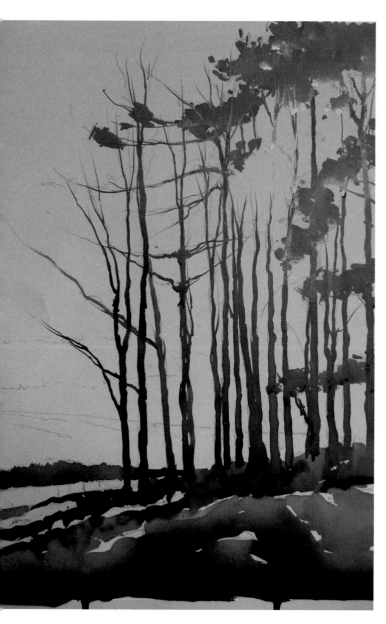

Underpainting for *Trees/Eskdaleside*.

DEMONSTRATION
Trees/Eskdaleside

An underpainting of acrylic ink was used for this autumn painting, which was inspired by an early morning walk in the village of Sleights, near Whitby. The sun was fairly low in the sky and sufficiently strong that it had the effect of melting away the trunks and branches. This effect, if interpreted successfully, can make all the difference between an ordinary and a successful painting.

Materials

Board:
A piece of black Hermes sandpaper board.

Pastels:
The pastels were a mixture of Rembrandt and Unison using a selection of greens, green earths, blue/greens, brown earths, yellows, blues, blue/violets and greys. (Should you decide to follow this demonstration, select at least a light, medium and dark value of each colour. A wider range of tones will allow you to achieve more subtlety and variety in the finished painting.) A 2B pencil was used for drawing out.

Miscellaneous Items:
Perfix colourless fixative by Daler-Rowney or similar (optional).
Daler-Rowney acrylic inks: Black, Blue 119, Red Earth 554, Burnt Umber 223 and Sepia 251 were used for this demonstration. Diluted acrylic tube paints could also be used to produce very similar results.

Step 1: Drawing out
A fairly accurate drawing will be needed for this painting. It will need to provide sufficient information for you to underpaint the trees with either acrylic ink or paint. The drawing can be fixed with an aerosol fixative if necessary.

Step 2: Underpainting with acrylic inks
Paint the landscape and trees, wet into wet, using all the acrylic ink colours.

Never use thick applications of oil paint. The drying time would prove prohibitive, and the amount of oil binder could interact unfavourably with the pastel.

The oil washes should be applied using a highly refined mineral spirit or specialized products such as fast drying oil painting medium and low odour solvent (available from most stockists, including Jackson's Art).

Apply these very thin washes with a brush, allowing them to run and interact to produce an interesting underpainting. It should be stressed that this is merely a stain and should be thin, about the consistency of really weak tea. After the mineral spirits evaporate, which happens very quickly, pastel can be applied.

DEMONSTRATION *Trees/Eskdaleside* (Continued)

Step 1.

Step 2.

Step 3.

Step 4.

Step 3: Begin blocking in

Begin to block in the major shapes and masses using the following pastels for each element:

Sky: Use light tones of blue/violet, warm grey, yellow and an even lighter yellow. Using delicate strokes with the flat sides of the pastel sticks, block in the entire sky, cutting around the major foliage masses and trunks. Use the lightest tones in the bottom of the sky and around the sun.

Trees: Use mid and mid-dark blue/violet pastels for the foliage masses and two dark brown earths for the tree trunks. Once again, retain a light touch and be economical with the use of pastel at this stage.

The landscape: Use three mid-toned green earths, three mid-toned blue/greens, two medium-dark blue/violets and a fairly light green.

Step 4: Continue blocking in

Continue to develop the block-in using the same colours. In this stage you will be involved in covering virtually all of the surface of the board and at the same time beginning to create texture and depth of colour by layering the pastel. Begin to introduce some of the detail in the trees and fence.

Step 5: Layer in lighter colours and add all the details

The sky was blended at this stage; however, this is very much a personal preference, so if you prefer your sky to be left open-textured leave well alone.

Choose a range of lighter tones from the previously selected colours. With this wider range of colours, you will be able to lighten the distant landscape, enhance the flash of light in the mid-distant field and add all the lighter, brighter colours to the trees, hedgerow and foreground.

You will now be at the stage where the painting is near completion. Before adding the final touches, make sure that all the major masses are working well and completed. Once the finer details have been added it becomes far more difficult to make substantial changes to any of the larger, underlying areas of the painting.

When you are satisfied that everything is in order, you can complete the painting by adding the final twigs to the branches, finer details to the fence and hedgerow and the odd flick or two of brighter red in the foreground.

Evaluation

Now is the time to set the painting aside for reflection and evaluation. Take your time over this and never frame the work until you are satisfied that everything works.

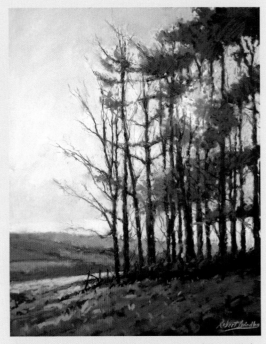

Step 5. *Trees/Eskdaleside,* 30 × 38cm (12 × 15in).

IN THE SPOTLIGHT

The small sketch *Night/St Marks Square/Venice* depicts a wet October evening. The subject is all about the wonderful reflections of the Basilica and lights in the wet surface of the square. This impromptu sketch was painted on returning home, as a rapid demonstration for an evening class.

Evaluation

Although this piece of work proved to be fairly successful as a demonstration piece there are several issues with regard to composition, tone and colour that would need attention before working on a more considered piece of work.

Composition

The composition has several minor faults which could have been easily avoided with a little more consideration before the painting was started.

- The horizon line lies exactly through the centre of the painting, resulting in imbalance. On reflection, it would have been far better to include more of the immediate foreground as shown in the photographic reference.
- The single figure has been positioned poorly. It coincides with the left-hand end of the Basilica and also a lamp column. Moving the figure 20mm or so to the left or right would have made all the difference. The overall composition would have also benefitted by the inclusion of several more figures or figure groups. When including figures in your own paintings, include more than one and avoid even numbers; three, five, seven are far more successful. Also aim to overlap some of the figures used, as single figures dotted around the painting have a tendency to look contrived and unrealistic.
- The final compositional error lies with the reflections of the lamps and shop lights on the left-hand side of the painting. They are fine in themselves; however their positioning within the composition creates an imbalance. With a little artist's licence, and adding a few further lamps and reflections on the right-hand side of the painting, a better balance would have been achieved.

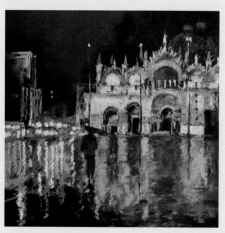

Night/St Marks Square/Venice, 15 × 15cm (6 × 6in).

Tone and Colour

The painting lacks real impact. This could easily be resolved by increasing the contrast. The extreme darks and mid-tones could be made darker and warmer as a foil to the lighter tones. The highlights could also be warmed slightly.

The sketch *Evening/St Marks Square* was painted a little later and goes some way to resolving a few of the above issues. The horizon line has been lowered and two figures (slightly offset from the edge of the Basilica) included, resulting in a more balanced composition. The tonal contrast was increased and warmer colours used, which combine to produce a far better painting.

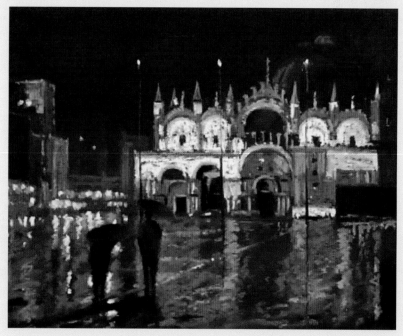

RIGHT:
Evening/St Marks Square,
30 × 25cm (12 × 10in).

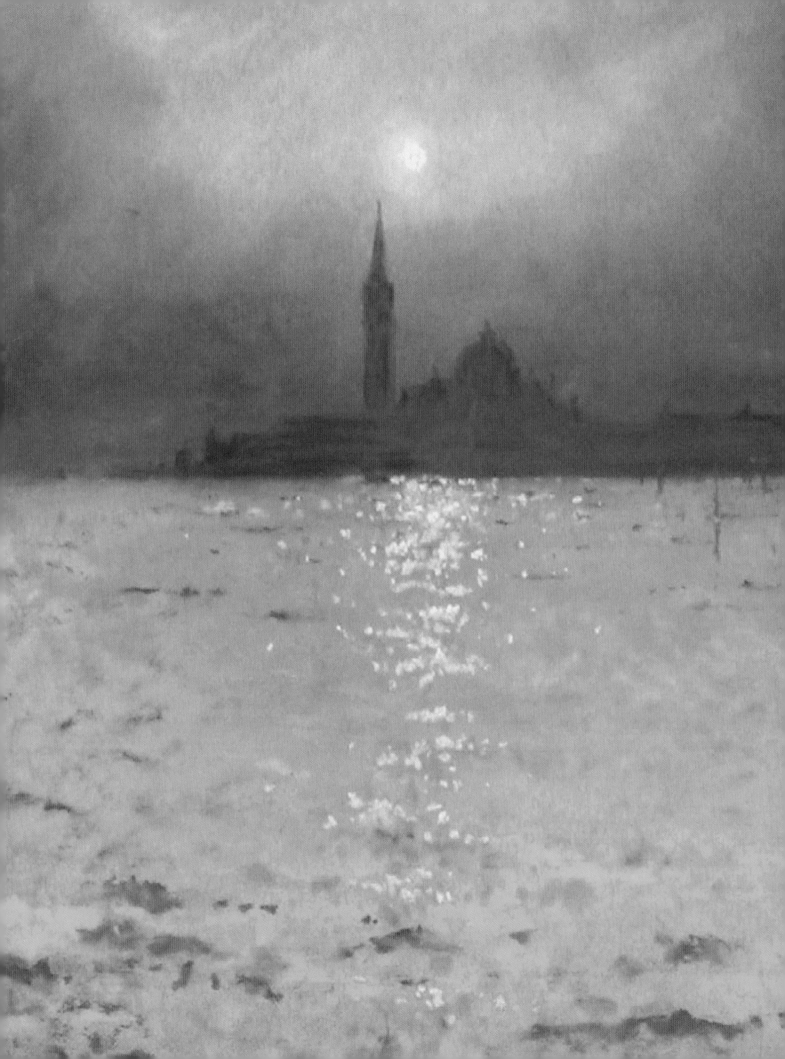

PLEIN AIR VERSUS THE STUDIO

Evening Light/San Giorgio/Venice illustrates diffused light and was painted from a small watercolour sketch and photographic reference.

Working *Plein Air*

Painting *plein air* (in the open air) on a regular basis is an essential ingredient for your development, and doing so will enable you to make far more accurate observations than working in the studio from photographs alone. Photographs are a useful source of information; however, where possible, use them in conjunction with sketches, small on-site paintings and your experience of painting in the field. When painting outdoors, or just information gathering, train yourself to analyze the subject. Look carefully into shadows, and be aware of the subtlety of colour which is often overlooked by inexperienced painters. By understanding the many problems encountered when painting from photographs, their use becomes more valid.

A successful *plein air* trip depends on many factors, some of which are beyond your control, for example the weather. To ensure that you gain the maximum benefit from your trip, the following considerations may prove useful.

Selecting Suitable Subject Matter

The selection of suitable subject matter can be a real problem for many artists. The range and diversity is immense. It often helps, therefore, to have some idea of the type of subject matter that you are looking for before you set out. In some instances you will know exactly where you are going and what you want to paint. You may be visiting a favourite location, or one that you recently

found and need to explore in more detail. However, more often than not you will be venturing out with nothing in mind and relying on chance alone. The following subjects may help focus you mind on some of the options available.

- The open vista, which may cover several miles of landscape.
- Cameo scenes, which may concern a special light effect. It could be something as simple as a gate into a field with light streaming through it, or a group of figures in a café or on the beach.
- Farms often make wonderful subjects, not only in their entirety but also in the variety of subject matter found in the outbuildings and vicinity. Weathered timberwork, old barn interiors make wonderful subjects, often dealing with texture, light, mood and atmosphere.
- Haymaking and harvest scenes make fascinating subjects and seem to conjure up memories of past times.
- Woods and individual trees with striking features or character.
- Tracks and lanes offer a wonderful opportunity for lead in and compositional devices.
- Snow scenes offer the opportunity to paint the landscape in entirely different conditions. Never assume that snow is colourless; the variety of subtle warm and cool colour variations in lying snow can be amazing.
- The coast offers the painter both diversity and an endless source of subject matter. Beaches, empty or bustling with life, cliffs and rocks, harbours including boats and other marine craft, salt marshes, tidal creeks and rivers are enough to make any painter's mouth water. In addition to these subjects you also have the opportunity to try your hand at painting water at close quarters. Breaking waves, shallow water, wet sand, rock pools are a joy to paint.

Many of these subjects will be dealt with in detail later in the forthcoming chapters.

Snow near Roseberry Topping shows a fresh covering of snow on a January morning. This painting was undertaken from photographic reference immediately on returning to the studio, while the essence of the subject was still clear.

OPPOSITE PAGE:
Evening Light/San Giorgio, Venice, 28 × 43cm (11 × 17in).

Snow near Roseberry Topping, 46 × 30cm (18 × 12in).

The Subject's Initial Appeal

Before making a start, establish firmly in your mind exactly what attracted you to the subject in the first place. These first impressions are often lost during a speedy execution and are absolutely vital to the success or otherwise of the resulting piece of work. It may have been a particularly striking light effect, the mood or atmosphere or potential design. This process should be of paramount importance and will ensure that you are able to begin your work with a clear aim. Try not to incorporate too many elements in your painting, as any future viewer should be left in no doubt exactly what your painting is concerned with. Remember once again, less is sometimes more.

Take Time to Become Familiar with a Location

Unless you are familiar with the area or know what you are going to paint, always take your time over subject selection.

A little time is always needed to absorb all the possibilities, as there is often a more rewarding subject to be found that is not immediately apparent. However you should also be aware that too much deliberation can result in wasting valuable time. Even when you feel that you have found a suitable subject, consider carefully small variations regarding the viewpoint. Moving a few feet to the left or right or painting the subject sitting or standing can sometimes make a tremendous difference. A valuable tool for aiding composition is a viewfinder. Make your own by cutting several windows of different proportions in a piece of stiff card.

If you are painting in a hilly location remember to consider high viewpoints, as they invariably offer greater drama and better design than the same subject viewed from a lower elevation.

Once the subject has finally been decided upon, keep your aim firmly in mind throughout the painting process. Begin to paint in a controlled manner, be single minded, make every mark count, don't panic and never step out of your comfort zone by rushing and making rash statements. If the weather or light changes too much and you have to stop working, always remember that a good start, even if not complete, is far more valuable than a hast-

ily completed, poorly observed piece of work. You will more than likely to be able to complete the painting back in the studio from memory and any back-up sketches or photographs.

Weather and Light Conditions

Weather is always a factor, especially when working in the United Kingdom, so if the forecast isn't good, plan to paint from some form of shelter. Farmers may be willing to allow you access to barns or outbuildings in inclement weather conditions. Old barn interiors make wonderful subject matter even though the lighting conditions are often less than desirable.

When dealing with rapidly changing lighting conditions, consideration should be given to working small or taking advantage of the time available to make sketches.

As you develop your ability as a *plein air* painter you will naturally speed up, which will effectively give you far more time – a bonus in rapidly changing lighting conditions. With experience you will also become aware that you are able to develop a shorthand, often using swiftly executed marks, useful when rendering the smaller, less important elements of the composition.

Practice

Undertake as many small *plein air* studies as you can. Set yourself a reasonable time limit of around an hour. For added drama, consider working both in the early morning and in the evening when the light source is much lower, the shadows much longer and the subsequent design potential much greater. Many of the sketches in the following section were painted under these conditions.

Whether you opt to work from your studio or to paint *plein air*, remember that you should always have sufficient control over the chosen medium to deal with the complexity of the subject matter. An extremely simple trick to enable you to evaluate colour, tone, shapes and masses more accurately is to view the subject upside down through a mirror. When subject matter is observed in this way, the mind is unable to react as normal by responding immediately to the subject. Instead the mind tends to observe the subject in a far simpler form in terms of colour or tone. This allows you to produce a much stronger painting which relates to the subject matter in a more sympathetic manner.

Using a mirror to observe a painting in progress allows you to identify any errors in drawing or composition. When painting *plein air* you can use a small pocket-sized mirror or a ladies' compact.

With practice, you will become more adept at assessing this simplified information and subsequently become less reliant upon such devices.

A Venice Sketchbook

This section examines and discusses the merits of a selection of small sketches/studies completed on a recent painting trip to Venice. Pastel is an ideal medium for undertaking sketches such as these. The pastels and equipment required for painting *plein air* are minimal and therefore easily transported. Sketches can be executed in a very short time, in most cases no more than an hour, and provide invaluable reference for developing more considered paintings back home in the studio.

As I apply my colours, I vary the amount of pressure on the sticks. This helps to create a more interesting variation … by mingling more transparent areas among the opaque passages.

Kathryn Amisson

What to Take

Pastels: Careful consideration should be given when selecting a reduced palette of pastels or pastel pencils, enabling you to capture, as accurately as possible, the colour, mood and character of your intended location. For this Venice trip, a palette of rich ochres, blues, blue/greens, yellows and reds were selected, as well as the following materials and equipment.

Pastel Card: Twelve A4 sheets of Art Spectrum Colourfix mounted on stiff card, in a range of mainly warm, rich, darker colours, which ensured unity where the board was not completely covered by pastel.

Greaseproof Paper: Twelve sheets of greaseproof paper, or something similar, cut to the same size as the pastel board, and two bulldog clips. These can be used for separating any completed sketches and transporting them home safely without the risk of smudging the pastel. Any minor damage can easily be corrected back in the studio.

Miscellaneous Items: A good quality 2B pencil, two fine waterproof ink pens (black and sepia), a small bottle of Daler-Rowney black acrylic ink, a small tube of white gouache, two No.3 watercolour brushes, Wet Wipes for cleaning hands and a small water container.

Occasionally, sketches such as these have sufficient merit to frame and exhibit without any further development, and in some instances these original observations capture far more than a more considered, larger work. Most of these sketches, however, were not intended as complete works, purely as memory joggers for further development.

Sketch for *Sparkling Light/ Grand Canal/Venice*

Photographic reference for sketch
Sparkling Light/Grand Canal/Venice.

The photographic reference for *Sparkling Light/Grand Canal/ Venice* was taken to support the on-site sketch; it depicts the early morning light from the Academia bridge at around 9am. The pastel was painted on a Storm Blue Colourfix paper, using three or four blue/violets and blue/greys, two warm orangey-pinks, a bright orange for the glow on the water, and finally a warm white for the sparkle on the water.

Notice how no attempt has been made to cover the paper surface with pastel. Instead, the colour of the paper has been used as a dark, mid-tone to unify the painting. Also note that there has been no blending to the laid pastel. The descriptive, unblended marks made during this rapidly executed sketch have far more to say than smooth blended passages.

This subject was chosen for developing a more considered studio painting; it can be seen later in this chapter.

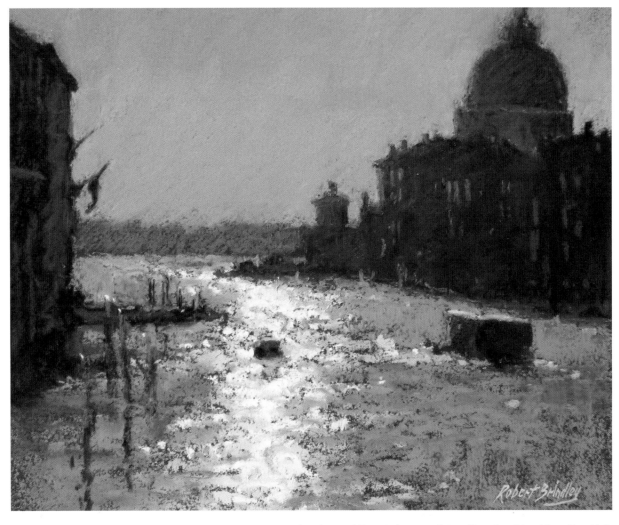

Sketch *Sparkling Light/Grand Canal/Venice*, 23 × 20cm (9 × 8in).

ABOVE:
Photographic reference
for sketch *Gondola
Moorings/Grand Canal.*

LEFT:
Sketch
Gondola Moorings/Grand Canal,
15 × 23cm (6 × 9in).

Sketch for *Gondola Moorings/Grand Canal*

This late afternoon/early evening sketch once again features Santa Maria della Salute and sparkling light. On this occasion it was decided to exaggerate the colour and simplify the form. The painting was executed on Aubergine Colourfix pastel card, which provided a rich, dark ground to work on.

The initial drawing was undertaken rapidly with a mid-red Conté pastel pencil, paying no attention to unnecessary detail.

The dark shapes of the gondolas, the mooring posts and some of the windows were painted with Daler-Rowney black acrylic ink, which provided a good base for all the darks. Once the ink was dry the painting was started, using a selection of neutral greys, purple/greys, cool blues, together with a small selection of warmer colours, including siennas, umbers, reds and yellows.

No attempt has been made to develop this sketch into a finished piece of work, as this often results in a loss of freshness and spontaneity.

Sketch *Gondolas/Rialto/Venice*, 23 × 17cm (9 × 7in).

Photographic reference for sketch *Gondolas/Rialto/Venice.*

Sketch for *Gondolas/Rialto/Venice*

This small sketch was painted from the Rialto Bridge at around 6 o'clock in the afternoon. Although the Rialto is always extremely busy at any time of the day, this time is especially crowded with tourists looking for that special 'into the light' evening shot.

I worked fairly rapidly to get down the basics. Once again black acrylic ink was used to establish the darkest darks, and approximately one third of the paper's surface area was covered – just enough to provide sufficient information to complete the sketch at the apartment. A Raw Sienna Colourfix pastel card was used to provide a warm ground, with a similar selection of pastels as on the previous sketch.

Particular care was taken not to overwork the sketch when it was completed back at the apartment. On returning home, this subject was chosen for a larger, more considered painting to be used as the step-by-step demonstration which can be found later in this chapter.

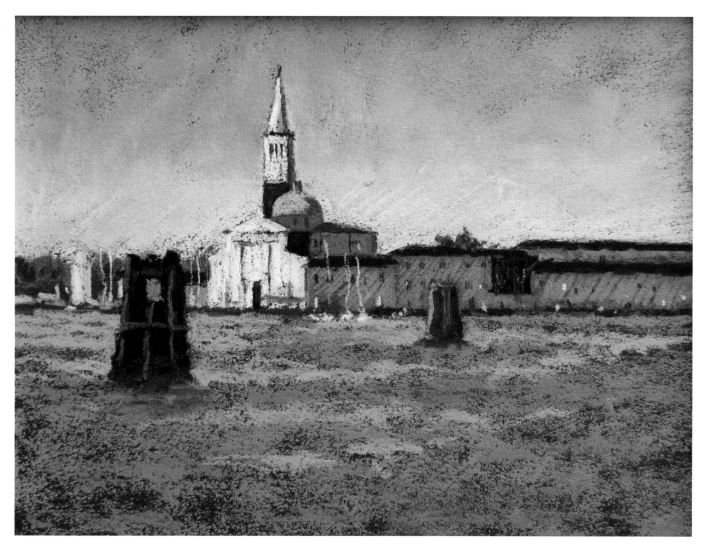

Sketch *Towards San Giorgio*, 25 × 23cm (10 × 9in).

Sketch for *Towards San Giorgio*

This sketch was carried out around mid-morning in bright sunlight. The facade of San Giorgio and the buildings on Giudecca were bathed in warm light. A little more time was taken for this subject, as it was relatively quiet and the Zattere is fairly wide so there was room to work at the chosen location.

Burgundy Colourfix pastel card was used which provided a rich, warm ground. The pastels used were a selection of warm and cool blues, blue/purples, a sienna, two reds, burnt umber and two warm whites.

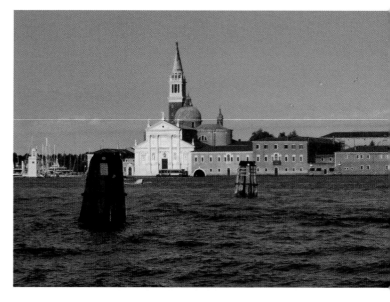

Photographic reference for sketch *Towards San Giorgio.*

Photographic reference for sketch *Bianale Opening/The Zattere.*

Sketch for *Biennale Opening/The Zattere*

The first week of the Venice Biennale art festival has numerous private functions and openings taking place throughout the city and this sketch features guests attending one of the private views on the Zattere. Once again the weather was perfect, bathing the scene in sharp, warm light.

This sketch was executed rapidly and reflects a group of figures in deep conversation after viewing the exhibition. Fortune was kind in this instance as the figures stood for some time, allowing a fairly detailed drawing to be made. The incidental figures in the background were added swiftly whenever a suitable passing subject came into view.

Blue Haze Colourfix pastel card was used, which provided a light, cool ground for this subject. The pastels selected were similar to those used for the previous sketch.

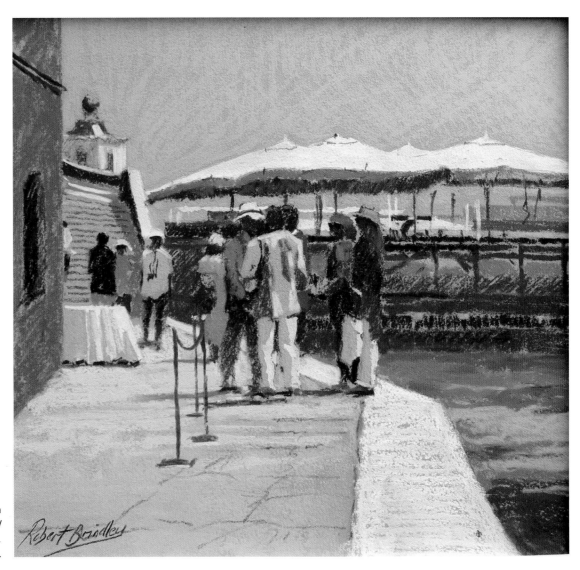

Sketch
*Biennale Opening/
The Zattere,*
23 × 23cm (9 × 9in).

Sketch *Coloured Boats/Burano*, 19 × 25cm (7½ × 10in).

Sketch for *Coloured Boats/Burano*

The Venetian island of Burano is a superb painting location, ideal for the painter who wants to paint colourful, varied subject matter in a quieter, more relaxing location. This wonderful group of boats and their reflections was sketched from a bridge over one of the numerous canals.

Deep Ultramarine Colourfix pastel card was used, providing a harmonious ground for this subject. The darks in the reflections of the boats were painted in with Daler-Rowney black acrylic ink. The pastels used were a selection of blues, blue violets, blue greys, sienna, two reds, two oranges, two warm whites and a vivid green.

The complicated shapes, details and colour changes in this subject were resolved by reducing them to the bare essentials.

Sketch *The Gondolier*, 18 × 24cm (7 × 9.5in).

Photographic reference for sketch *The Gondolier.*

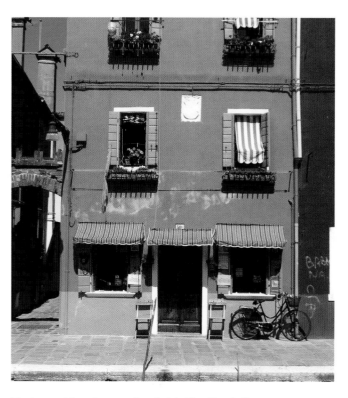

Photographic reference for sketch *The Bicycle/Burano.*

Sketch for *The Gondolier*

This subject offered a must-paint opportunity. The gondolier, in a quiet period, was deeply engaged in the daily newspaper. A quick sketch was made and a few photographs taken from different angles, and the painting was then executed later in the evening at the apartment.

Care was taken to use broad simple marks to maintain freshness. The pastel card was again Colourfix and the ground black, a perfect colour for this subject. The pastels used were as in the previous sketch.

Sketch for *The Bicycle/Burano*

This colourful subject was also found on the island of Burano and was immediately appealing for the brilliant colours chosen by the house owners. The blue shutters for instance work extremely well with the burnt orange walls, and the bicycle adds the finishing touch to the composition. The photographic reference used to execute this painting shows the full facade of the house, which will be useful for a future studio painting.

Aubergine Colourfix pastel card was used, together with a selection of blues, blue-greys, oranges and reds. The darks for the bicycle and the window opening were painted with black acrylic ink. The painting was carried out using rapid, bold marks, with no attempt to over-detail the work.

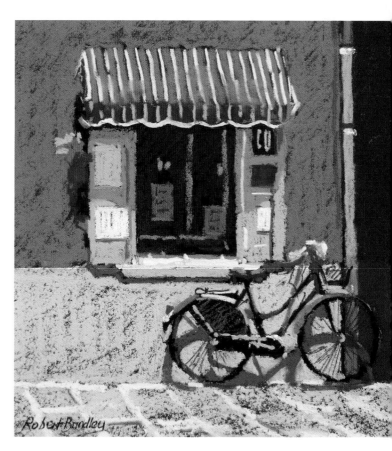

Sketch *The Bicycle/Burano*, 20 × 20cm (8 × 8in).

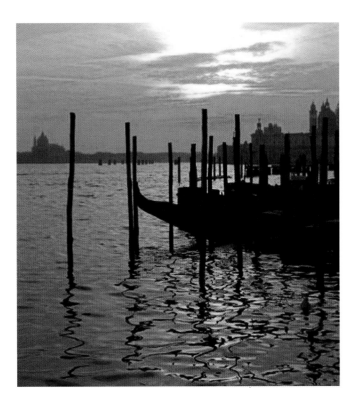

Photographic reference for sketch *Evening Moorings/Venice*.

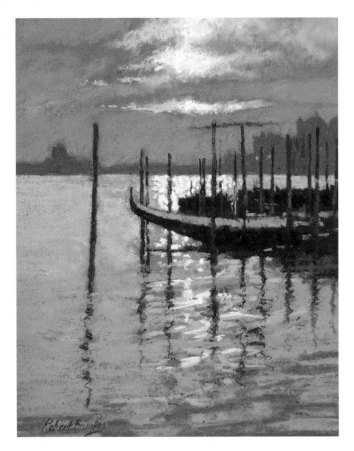

Sketch Evening Moorings/Venice, 20 × 24cm (8 × 9.5in).

Sketch for *Evening Moorings/Venice*

This sketch was made in rapidly deteriorating light just before sunset from the Riva degli Schiavoni, looking across the entrance to the Grand Canal towards the Dogana. Time was at a premium, therefore only the bare essentials regarding tone and colour were noted. To assist in rendering the dark shapes of the gondolas, the mooring posts and all the reflections, black acrylic ink was used. An extremely limited palette of blues, blue-greys, siennas and warm whites were blocked in, using loose, cross-hatched marks. No blending was carried out, and the sketch has been left as it was when the light got too poor to continue working.

When painting from this location during the daytime you should be prepared to be disturbed by tourists, and at times your view could be restricted. However, this is an extremely good location, both early morning as well as in the evening, when everything is much quieter.

Sketch for *Reflections/Venice*

This sketch developed into more of a considered study than intended and proved to be the least rewarding of all the sketches.

When you are working on subject matter such as this with constantly changing, moving water it will prove impossible to draw exactly what you see at any one moment. It is therefore recommended that you sit for five or ten minutes observing the constant changes to the reflections and deciding on a plan of campaign as to how you simplify the subject. It may be beneficial to make quick shorthand sketchbook studies using only pencil.

A Rich Sand Colourfix pastel card was used for this sketch, and before any pastel was applied, a simplified outline was drawn out in black acrylic ink using the sharpened end of a stick of bamboo. The main dark areas were then painted again with black acrylic ink.

A wide variety of warm and cool pastels were used and, as time was not critical, the pigment was applied more carefully, covering more of the paper surface than in any of the previous sketches.

This sketch proved to be less satisfying and certainly not as successful as some of the others, lacking the urgency so often necessary to produce a successful piece of work. Often an artist's most successful work is produced under less than favourable conditions, where time is at a premium. For some reason, in these situations, the painting seems to flow more naturally. However, the time spent in wonderful surroundings and in beautiful weather was not regretted.

Photographic reference for sketch *Reflections/Venice.*

Sketch Reflections/Venice, 30 × 18cm (12 × 7in).

Working in the Studio

There are many advantages to be gained from working in the studio, either from sketches, *plein air* paintings, photographs or completely from memory.

- For the creative artist who may like to develop the subject matter further, either by abstraction or by making other adjustments that may concern composition, colour or texture, studio work allows unrestricted time for the germination of ideas and the painting process.
- Numerous experimental sketches can be produced, if required, to develop and complete the final piece of work.

- In addition to these advantages, the fact that you have your complete range of materials readily at hand is an enormous benefit.
- Having a peaceful, comfortable working environment, where you can relax and contemplate, is extremely important to any painter.
- Working *plein air*, on a large scale, is virtually impossible for the pastel artist unless conditions are ideal.

The weather, especially in the United Kingdom, is rarely suitable for undertaking anything other than small or medium-sized works. Wind and rain are the worst offenders for any *plein air* painter; however, for the pastellist these conditions are almost impossible to work in. Rain especially can be disastrous, both for the painting and the materials. Continuous interruptions,

even by showery weather, can be intolerable, and wind can cause havoc. Unless weighted down extremely well, pastels, being both loose and light, can be easily upturned in gusty weather conditions. Oil painters can quite easily carry on working in showery conditions and quite often the weight of the materials themselves provides some stability from light winds. The watercolour painter, although more vulnerable to adverse conditions, needs only to cover up their painting from time to time in showery conditions, as a little additional water on the palette does no harm at all.

For these reasons, a spacious, peaceful painting environment is essential for the painter who enjoys working large scale.

Photography

As stated earlier in this chapter, photographs are a valuable aid to developing studio paintings; however, always be wary of their validity with regard to tone, colour and recession. Photographs are very often incorrect, especially when they have been taken directly into the light, or when a zoom lens has been used. Into the light photographs are notoriously inaccurate in terms of tone as the camera lens struggles to cope with bright light, resulting in photographs with the darks too dark and the lights too light. A powerful zoom lens distorts distance and often closes distances between objects several miles apart, so they appear only a few hundred yards apart.

Of course there are many artists who for one reason or another prefer to paint from photographs. It may be that shortage of time, disability and various other factors are a consideration. In these instances it is still possible to produce wonderful paintings. There are also a vast number of artists producing excellent results who feel that, rightly or wrongly, they don't need the stimulus of painting in front of the subject.

It must be stressed, however, that successful results are only ever achieved through an understanding of how a photograph can be used and interpreted correctly, by compensating for the many pitfalls. Some of the more obvious ones are listed below.

Inaccuracies in Colour Reproduction

Be aware of inaccurate colour reproduction in photographs. On many occasions there is a colour cast, often produced by a dominant colour in the scene which influences the entire photograph. Some summer scenes, for example, where there is an over abundance of green, can produce a green cast to the entire photograph.

Inaccuracies of Tone

Look for inaccuracies in tone especially in dark, flat areas of shadow where the camera reveals no detail or colour change. You will need to improvise here by trying to remember exactly what was hidden in the shadows or by creating your own interest, by using a minimum amount of vague detail, together with subtle colour and tonal changes.

Zoom Lenses

Be aware of using photographs where a powerful zoom lens has been used. Although often stunning, they tend to compress the scene too much, resulting in a lack of distance and recession.

Interpretation of Detail and Simplification

A photograph nearly always contains far too much information. With this in mind try to use the photograph as a drawing aid and a memory jogger only. When you have drawn out the work as economically as possible with regard to detail, try to refer to it as little as possible when painting, and never try to reproduce unnecessary detail. Simplify as much as possible.

Remember Less Is More

It may help you to cast your mind back to when you first observed the subject. Ask yourself a few simple questions: What were your first impressions? What attracted you to the subject? It may have been a dazzling light effect, or something far less exciting. The main thing to remember is that when you saw the focal point (the thing that first attracted you), you would have been unaware of the unnecessary detail and clutter around the extremities of the scene. Remember this when you paint the subject. Your main aim should be to reproduce this effect in your final painting, ensuring that the viewer's eye is immediately drawn to your focal point and that not too much extraneous detail is used throughout the entire painting.

To help you to create the magic and excitement from a subject when it was first seen, it is useful to understand how the human eye observes and interprets everything so differently from a camera lens. The human eye scans the scene, constantly refocusing and recording information sent back to the brain. Only the object being observed at any one time is in focus; the remainder of the scene remains in a blur around the peripheral vision. The human brain itself reacts to the information given by producing an emotional response.

The camera, unfortunately, has none of these attributes. It records a static image often in sharp focus, over the entire picture, providing far too much information and often none of the magic which is the essential ingredient for any successful painting. Too much information stifles the imagination and creativity, resulting in a painting which at best is a lifeless rendering of the photograph itself.

Digital Tools

There are however, some advantages to be gained by working from photographs in the comfort of your own studio, especially in this age of digital photography. The images captured can be enhanced in many different ways, a real advantage for the more creative painter. Colour, texture, contrast and many other features can be easily adjusted by using relatively simple software. Probably the most used feature will be the means to crop the image to any proportion and within a few seconds to have a hard copy printed off and ready to use. Cropping has always been an important tool and can provide numerous options with regard to composition, proportion and scale. In some instances it is possible to consider as many as five or six compositional arrangements from one photographic image. An example of this is shown in the photograph showing crop variations.

A Quick Glimpse

Before leaving the subject of photography as an aid to your painting, there is a further, less obvious use for the modern digital camera. The importance of thumbnail sketches when planning your paintings has already been discussed. These sketches for many less experienced painters are a vital step in assessing the strengths and weaknesses of a particular subject. Time is always short, and often in rapidly changing light conditions a quick start is vital. The time spent sketching in some instances can mean that a painting cannot be executed in situ.

There is however a possible solution which may speed up the evaluation and decision-making process. If you don't have time to produce thumbnail sketches, the digital camera can quickly provide similar information. By taking a series of reference shots of the scene under consideration, you can then scroll back, viewing them using the camera screen. Should the colour be a distraction,

you can adjust the camera settings to take greyscale (black and white) images (colour images can be taken at the same time for future reference). Hold the camera at arm's length to minimize the picture size. While scrolling through the images for comparison, look for visual impact. Closing one eye and squinting may help this assessment. Strong patterns of value and shape will be noticeable, making it easier to see which images have the strongest elements to work with. When you begin to paint, you can refer to the digital image at any time, should you need to.

Remember, this quick remedy should never to be used as a substitute for the preparation of sketches. It's always better to devote time to a series of thumbnail sketches in advance of painting, should conditions allow. But for those times when you just can't wait, a quick digital review will prove invaluable, providing a quick glimpse at the possible options.

Crop variations.

DEMONSTRATION *Evening Moorings/Venice*

This painting illustrates how the sketch for *Evening Moorings/Venice* was developed into a larger painting. The work was carried out as a demonstration for a local art society on how to work from sketches.

Materials

Board:
Mount board, textured or smooth.

Pastels
Unison pastels in the following colours were chosen: reds, oranges, yellows, blues and greys. At least three tones of each colour were used. A light grey pastel pencil by Conte was used for drawing out.

Additonal Items:
- A bottle of black acrylic ink.
- An old No.10 watercolour brush.
- A ceramic watercolour palette.
- White acrylic primer.
- Terracotta Art Spectrum Colourfix Primer. These primers are available in 259ml pots, in fourteen shades plus clear, and are the same as used on the Colourfix papers.

Board preparation
Obtain a 60 × 45mm offcut of mountboard and treat both sides with one coat of white acrylic primer (both sides should be treated to prevent warping).

When dry, apply one coat of Terracotta Colourfix primer. Either side can be painted, depending on the texture required.

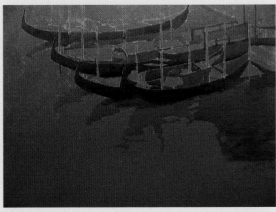

Step 1.

Step 1: Drawing out
Draw out the composition using the light grey pastel pencil. Only a simple outline is required for this stage. To establish some of the basic tonal relationships use the black acrylic ink to indicate where the main darks and intermediate darks are located. Add water to the ink where necessary to create the lighter tones.

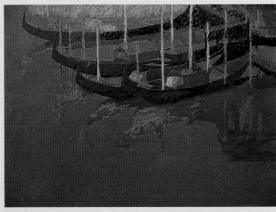

Step 2.

Preparing the mountboard with white acrylic primer.

Terracotta Colourfix primer.

Preparing the mountboard with Terracotta Colourfix primer.

Step 2: Begin blocking in

Begin to paint the boats and their reflections using dark, medium and medium-light tones of blue/grey. Take care not to place too much pastel on the board in the early stages, as this could result in filling the tooth of the paper, giving no scope for layering up in the later stages. Work generally from dark to light, as cleaner crisper highlights are achieved by placing them in the final stages.

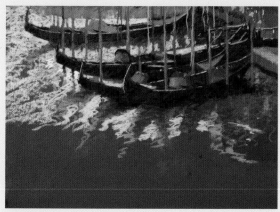

Step 3.

Step 3: Develop the reflections

You will now need to develop the light reflections further. Work in the same manner as Step 2, with the addition of a light blue/grey together with one or two green/greys.

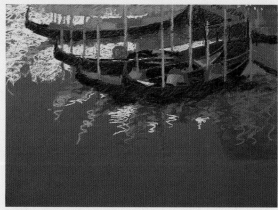

Step 4.

Step 4: Develop the gondolas

Continue to block in the water and at the same time begin to introduce the blue/greys, reds and oranges to the gondolas and the warm lights from the canalside cafes. To retain as much spontaneity as possible, as well as a lively texture, try to resist any blending.

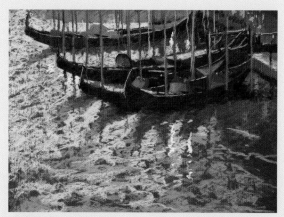

Step 5.

Step 5: Complete the block-in

Complete the block-in by working over the entire board, taking care not to overdevelop any particular area such that it becomes out of step with the whole. To ensure that the underpainted Terracotta ground continues to unify the entire painting, try to find the correct balance between the pastel applied and the ground remaining visible. You may find that more of the ground can be left showing around the perimeter of the painting, away from the focal point.

Close-up showing the pastel marks and the amount of terracotta ground left at this stage of the painting process.

Step 6: Final details, assessment and reflection

When you are satisfied that the balance of the painting is working, you can turn your attention to all edges and masses. Be careful not to add too much detail; otherwise any impact that you have may be lost. Concentrate your sharpest edges around the focal point. This area should also contain the lightest lights against the darkest darks, that is, the area of maximum contrast and therefore impact. Pay attention to ensure that you have achieved subtle blending where the gondolas meet their reflections in the water. This gradual transition is vital to ensure that the gondolas sit convincingly in the water and do not appear to be levitating. In any successful painting there should always be a combination of hard/soft and lost/found edges. This variety in the handling of edges ensures that there are restful areas within the painting and will invite the viewer to move around the painting at ease, allowing personal interpretation. Finally you should consider the masses in

DEMONSTRATION

Evening Moorings/Venice (Continued)

the painting. Ask yourself if they are convincing. Do they balance correctly? Are they carrying the correct weight and having the required impact? In order to balance out and adjust the masses, you may consider increasing the density of the pastel to cover up more of the ground. Compare Step 6 to Step 5.

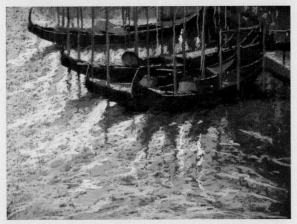

Step 6. *Evening Moorings/Venice*, 60 × 45cm (24 × 18in).

When you are satisfied, take a little time for evaluation and reflection. This is overlooked by many artists in their excitement, thinking that the work is complete and rushing to have it framed. A little extra time spent now can save you having to de-frame the work later to make adjustments. Ask:

- Does the composition work? (Give special consideration to the visual path into the painting, and the focal point, which in this case is the bows of the gondolas towards the top left-hand corner.)
- Does the tonal sequence and colour harmony work?
- Do any of the edges require further strengthening or softening?

Make any necessary adjustments.

Further Practice

A fairly limited, quite bright range of pastels were used for this painting to enhance its impact. Try to find a similar subject for which you can use a similar range of colours.

Too much sparkle can detract from the focal point of the painting, so I blend some areas to tone down the look of the pastels in less important areas.

Paul Murray

IN THE SPOTLIGHT

The sketch *Sparkling Light/St Ives/Cornwall* was undertaken as a short demonstration for an art society and was concerned with capturing a sparkling light effect. To this end the painting proved to be fairly successful; however, it falls short in other aspects with respect to composition, tone, recession and mark making.

Evaluation

The shortage of time invariably dictates that most demonstration paintings fall short in one respect or another. The shortfalls in this particular painting are significant enough to merit further deliberations.

Composition
Considering the simplicity of the subject matter, there is not too much wrong with the composition. The only comment would be that the boat, which is the focal point, has been positioned a little too far over towards the left-hand edge. The perfect position for the boat would have been on the golden third, that is, one third of the way across the painting. This small error can be slightly improved upon by careful cropping. A strip of the painting could be cut off the right-hand side to adjust the balance marginally; in this instance a complete cure is not possible, as to get the correct balance too much trimming would be necessary. See the digital alteration of the sketch for *Sparkling Light/St Ives*.

Tone
Once again there appears to be very little wrong with the tonal values distributed throughout the painting. However, the distant landscape could be lightened, to increase recession. By doing this, the nearer landscape would also require minor adjustments. This would entail some adjustment to the tonal variety of the entire shape. If these adjustments were carried out, it is possible that the tones in the hull of the boat would also need minor adjustments. This exercise underlines the importance of tonal balance and harmony in all paintings and illustrates that, when changes are deemed necessary, no matter how small, their repercussions are felt often throughout the entire painting.

Recession
As stated previously there are minor problems with recession in this painting, some of which were discussed in the section on tone, above. However, the biggest concern lies in the bottom half of the painting, where there is very little recession in the beach and shallow water.

The solution to these errors and any possible remedies concern tone, colour and mark making. Consequently, the

Sketch *Sparkling Light/St Ives/Cornwall*, 28 × 18cm (11 × 7in).

adjustments would need to be made gradually almost by trial and error, carefully observing which of the three elements, or a combination of them all, helps to resolve the problems.

The following suggestions could have been attempted to resolve the errors:

- The sea could have been lightened at the horizon and gradually darkened as it progressed down the painting. The colour of the water could also have been intensified slightly towards the bottom. These adjustments would have an immediate effect on recession by pushing the horizon back, tonally. There is however an element of risk involved in doing this, as the success of the sparkling light effect depends on its containment by a darker tone. Any lightening of the surrounding tones therefore will reduce this effect.
- The second possible solution involves taking a middle of the road approach to the above, in conjunction with the adjustment of the tones and colour in the beach. The tones in the top of the beach could be lightened and the tones in the bottom of the beach darkened slightly. At the same time, the intensity of the colour in the beach could be increased; warmer tones tend to come forward, which could help to increase the recession in the painting.
- The final adjustment concerns mark making. In this painting, more consideration should have been given to the direction,

size and tone of the marks being made. Some of the marks in the nearest water for instance are as prominent in size and tone as the marks used in the immediate foreground. Reducing the regularity, size, direction and tone of the marks in the water, and doing the opposite with the foreground marks in the beach, should help in minimizing some of the errors.

As stated earlier, these recessional errors can only be resolved by trial and error.

Digital alteration of sketch *Sparkling Light/St Ives.*

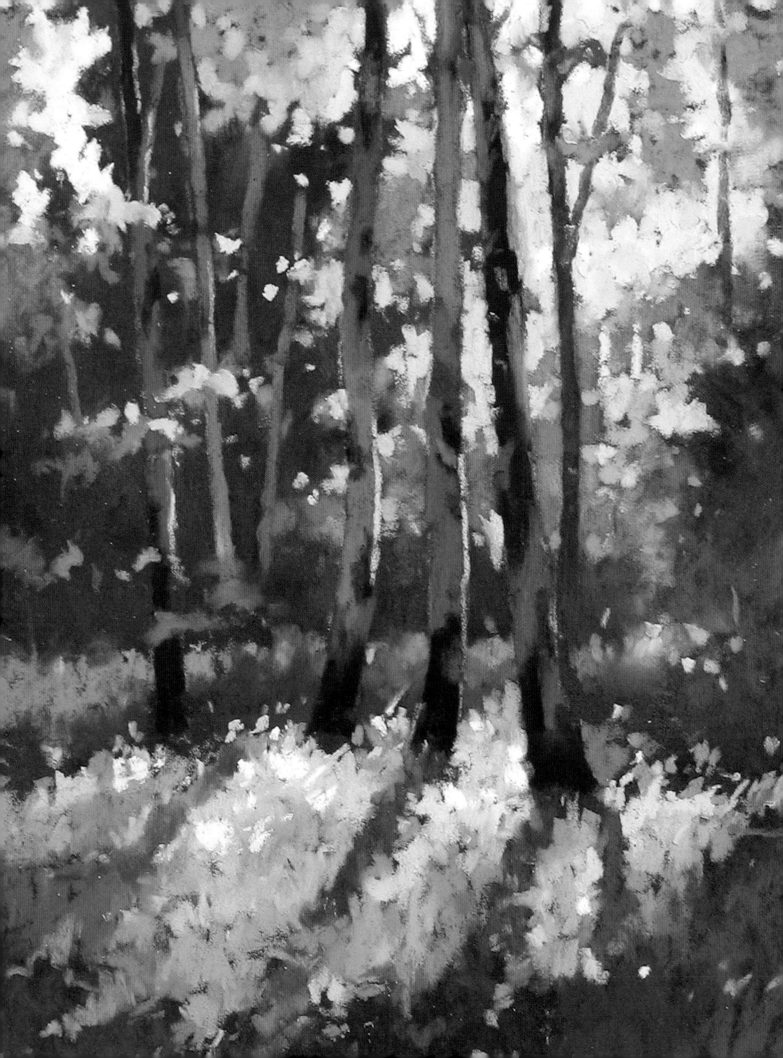

PAINTING THE LANDSCAPE

The painting *Woodland Glade* was painted on site on a sunny, warm spring morning. The strong vertical lines tend to create the impression of height and grandeur. The black Hermes sandpaper ground proved to be particularly useful when painting the distant bank of trees and the foreground shadows.

Painting the landscape has been a passion for countless artists over the centuries, never more so than today where many more of us have time available for leisure. To achieve any success with your landscape paintings it is essential to communicate with the viewer, transporting them immediately to the chosen location and capturing the essence of the place.

Until more recent times, unlike other mediums, the majority of pastel paintings were executed in the safety of the studio. For one reason or another (see Chapter 4), painting with pastels *plein air* was fairly rare. Gradually however, artists have realized that extremely successful results can be achieved with a relatively small selection of pastels and supports. Pastels are light and easily transported and offer a quick and direct method of working; the medium requires no drying time, very little colour mixing and you are free from the restrictions of brushes, turpentine, mediums and water. You will find that the set-up time is far quicker than for other mediums and that you are able to respond rapidly to changing light conditions.

The painting *Ponies near Iburndale* was painted from an on-site sketch and photographic reference. A very small selection of pastels were used for the sketch, which needed to be undertaken rapidly. The painting is a good example of how animals can be incorporated into the landscape, adding interest and life.

The essential ingredient of all paintings is light. Without light there would be no visual stimulus to excite the viewer. This is especially so for landscape painting which, above all other subjects, relies generally on the sun as the major source of light.

Sunlight is ever changing, creating many varied and wonderful effects. It is never the same from one day to the next and pro-

OPPOSITE PAGE:
Woodland Glade, 13 × 20cm (5 × 8in).

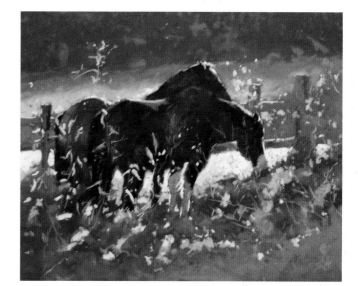

Ponies near Iburndale, 25 × 20cm (10 × 8in).

duces unusual effects when it passes through the atmosphere, striking different objects in its path. It may be beneficial to have a little basic knowledge of the value of light before considering its effect on everything we see. Our primary light source, the sun itself, never changes. It is the earth's spinning on its tilted axis in combination with its revolution around the sun which creates day and night and the changing seasons.

There are other factors than the light which have to be considered when painting the landscape. The weather for instance, especially in the UK, provides the painter with many challenges. The humidity often causes problems; however, in some instances fog or low-lying mist can produce magical effects. The sky itself is forever changing, and you need to be prepared for rapid changes in relatively short periods of time.

All these factors ensure that the *plein air* landscape painter will have to do constant battle with the elements. The paintings and sketches made outdoors provide wonderful material for the more considered studio works.

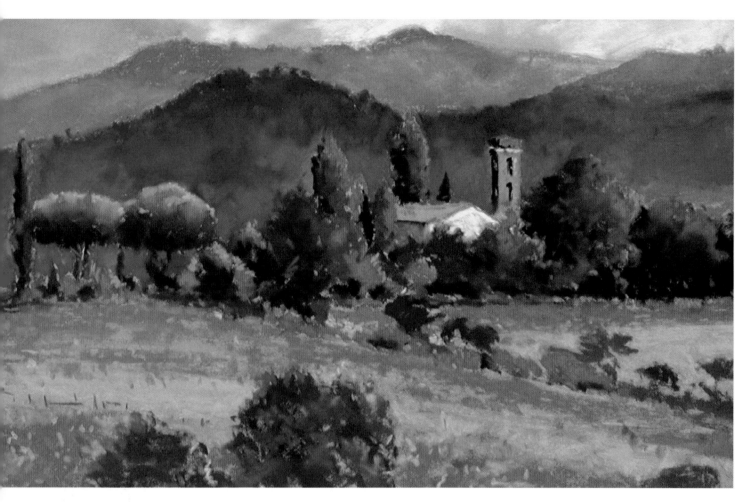

Blue and Gold/Tuscany, 50 × 35cm (20 × 14in).

Landscape Painting Abroad

The painting *Blue and Gold/Tuscany* was painted many years ago, inspired by the Tuscan landscape. Additional impact was created by exaggerating the complementary colours (blues, blue/purples and golds) used in the subject.

The British landscape is unsurpassed, giving an unparalleled variety of subject matter. However the opportunity to travel, both at home and abroad, has further increased the scope and variety of subject matter available, and the results of these opportunities can be witnessed at most exhibitions. Travel opens up new horizons and provides an added stimulus to most painters, and can also turn out be a vital factor in their development.

When painting landscapes from overseas, you may have to adjust/expand your usual palette of colours. The light can be brighter, resulting in more vibrant colours. All the major manufacturers offer a huge range of bright colours for your consideration. Unison in particular have a wonderful range of Dark, Additional and Special colour ranges.

Bright colours or dark ones, sparkling clarity or misty atmosphere, landscape, still life, portrait – I haven't met a subject, style or mood yet that can't be portrayed beautifully in pastel.

David Beckett

The English Landscape

Landscape painting has captured the imagination of all artists worldwide for hundreds of years; however it is widely regarded that the English paint the landscape far better than anyone else. Of course many countries throughout the world can offer breathtaking scenery that could never be equalled in the British Isles; the Alps, the Grand Canyon, the landscapes of China and Japan are just a few examples. However, it is the huge diversity of scenery, in conjunction with four very different seasons, which make many observers believe that the British Isles are unrivalled for their landscape and landscape painters.

The Seasons

Every season has its charm. Finding inspiration in these seasons is part of what makes landscape painting so enjoyable. The seasonal changes are inevitable, and this fact ensures that our subject matter remains fresh and varied.

Light and darkness, the seasons and weather conditions create radical changes to our perception of what nature looks like.

Peter Folkes

You may have a favourite season; for a variety of reasons it may inspire you to produce your most successful work. The weather conditions are often a factor which influences which of the seasons are preferred by artists; it may be too windy, rainy, cold or hot. By painting in the studio of course you will be able to paint any season, reflecting any weather condition. If you wish to paint *plein air* throughout all the seasons, it is imperative that you take full advantage of favourable weather and special lighting conditions.

Spring

Spring is a favourite season for many artists. It offers a vital stimulus at the end of long winter months. With temperatures rising and the daylight hours rapidly lengthening there is more opportunity for the artist to venture forth in the search of new material.

The greys of winter are gradually replaced by the fresh, yellowy greens of early spring, which are far easier to paint than the harsh greens to follow in the early summer. Trees bursting into leaf often appear to be covered in a haze of soft green, or even warmer orangey greens that can sometimes carry some of the colour of early autumn.

For capturing spring colours in pastel, you will benefit from having a wide range of warm and cool greens available to you. Unison make the following greens from which you could make your choice: Yellow 1–18, Yellow Green Earth, 1–18, Green 1–36, Turquoise 1–6, Blue Green Earth 1–18 and Blue Green 1–8.

Spring.

There are also a small number of subtle greens included in their collections of Additional, Special and Dark colours.

Spring flowers and blossoming trees of all kinds make spectacular subjects and can be used for adding a burst of colour to your paintings.

Spring brings the added advantage of early morning and evening mists, creating conditions of wonderful atmosphere and filtered light – a joy for any painter. For atmospheric, misty effects, the following colour ranges could be considered: Blue Violet 1–8, Grey 1–6 together with a small number chosen from the Additional colours 1–6. For any serious landscape painter, early morning and evening subjects offering these lighting conditions should not be missed.

Spring being a tough act to follow, God created June.

Al Bernstein

Summer.

Summer

The summer is probably the best time of the year for the majority of *plein air* painters. The daylight hours are long, the temperature in the main is bearable for most artists and the English landscape, with the exception of the strident greens of midsummer, is shown at its very best. For tackling summer greens a similar range of pastels, as discussed previously, should prove to be adequate.

For those artists who struggle with the overabundance of green, there is no better time than during the height of the summer to paint coastal scenes.

The late summer running into autumn presents the painter with a variety of quieter greens and the warm yellows and straw colours associated with haymaking and ripening crops. A selection of colours suitable for capturing late summer colours can be made from the following: Brown Earth 1–6, Grey 1–6, Neutral Earth 1–8 and Additional colours 1–6.

The painting *Haymaking near Helmsley* features freshly cut hay bales in a field just outside the North Yorkshire town of Helmsley.

Haymaking near Helmsley, 40 × 25cm (16 × 10in).

Autumn.

Autumn

Autumn is known not only for its colour but also for the wonderful misty, atmospheric mornings and evenings that inspire many artists. The transition from greens to warm yellows, oranges, and reds never seems to disappoint. Areas such as the New Forest and the Lake District can be spectacular in autumn.

However the juxtaposition of cool and warm colour in many autumn scenes often makes them difficult subjects to paint, as they can look artificial and the colours garish. Many competent landscape painters who have no difficulty painting winter, spring, and summer struggle to make a vibrant autumn scene look convincing.

If you have a problem with painting convincing autumn scenes, try choosing a dominant colour temperature for your painting. A painting, in the main, should avoid the use of opposing colour groups; consequently, the colours you choose should be biased towards this dominant colour temperature as a means of unifying the whole. By doing this you may find that any opposing and overwhelming colour becomes easier to handle. For example, choose a warm colour temperature and then tone down the intensity of any blue sky or green grasses to ensure a better unity with any bright, intense, warm tones that dominate the painting. The action of toning down or greying the cooler tones makes them naturally warmer, thereby allowing the warm passages to dominate your painting (see *Autumn by the Lake*). Choosing a cooler colour temperature would affect the intensity of the autumn foliage, making it slightly greyed. The result would achieve a better unity with an intense cool sky.

RIGHT:
Autumn by the Lake,
20 × 13cm (8 × 5in).

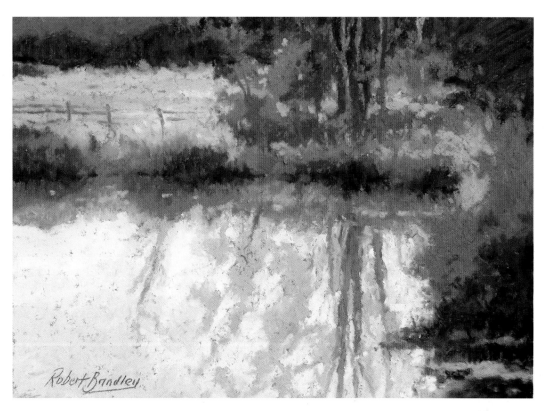

BELOW:
Autumn/Cross Butts,
20 × 13cm (8 × 5in).

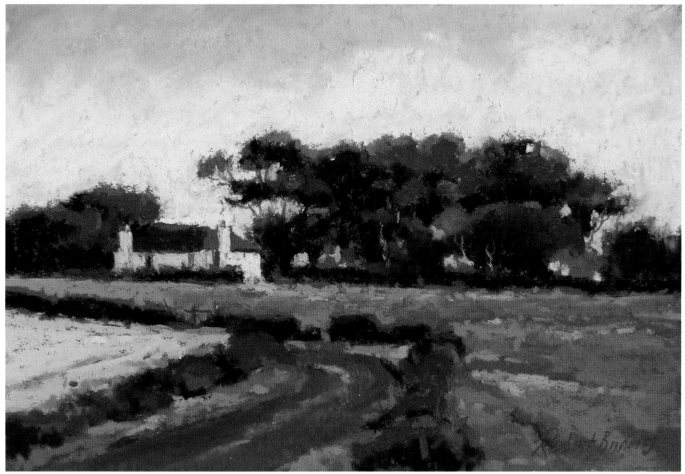

DEMONSTRATION
Autumn/The Hermitage

Autumn/The Hermitage illustrates perfectly how pastels can be used for interpreting the landscape in any season. The Terracotta ground used for this work proved to be especially effective for enhancing the warm colours of autumn on a fine and sunny day. The reference photograph shows how the subject has been adjusted with regard to composition, colour, texture and the degree of detail used.

Step 1. Step 2.

Materials

Board:
Mount board prepared with white acrylic primer and then two coats of Terracotta Art Spectrum Colourfix pastel primer.

Pastels:
The pastels used are Unison with a selection of reds, red earths, yellows, green earths, blues and blue/violets. Should you decide to follow this demonstration, at least three tones of each colour will be required. A mid-tone purple pastel pencil by Conte was used for drawing out.

Step 1: Drawing out

Draw out the composition using a pastel pencil of your own choice. Only the minimum amount of drawing will be required for this painting, just sufficient for you to be able to position the farm buildings and main trees fairly accurately.

Step 2: Begin blocking in

Begin to paint the sky, trees and farmhouse. Use two light tones of blue/violet for the sky; two, mid-toned red earths, together with a mid-toned yellow for the trees; two darker-toned blue/violet for the shadows, and finally a mid-toned red earth and a light-toned yellow for the farm buildings.

Use the sides of the pastels to create a variety of flat strokes, taking particular care not to apply too much pastel on the board in the early stages as successive layers will need to be built up as the painting progresses. Paint the tree trunks using the end/tip of the pastel, as they are features to be drawn in and not blocked in as the other areas.

Step 3: Continue blocking in

Continue to develop the block-in by selecting three further red earths for the masses of foliage and branches. Use two mid-tone green earth pastels for painting the tree trunks and the foliage mass on the extreme right of the painting.

Take the sky a step further by selecting a very light yellow, together with the previous sky colours, this time forcing a little more pastel into the surface of the board. This will allow you to model the foliage masses by using negative painting.

Step 4: Developing the farm buildings

The farm buildings can be developed further by using the red earth pastels already selected, supplemented by a light grey to

Reference photograph for *Autumn/The Hermitage.*

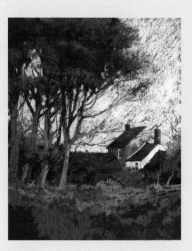

Step 3. Step 4. Step 5.

be used for the windows and other details. The ends of the pastel sticks need to be used almost exclusively for this step. To achieve fine lines, look for any sharper edges on the pastels; otherwise, just break the pastel in half to create the required edge.

You could apply a little blending to the foliage masses at this time if you feel it necessary; however, no blending was carried out for this demonstration. When you are using a range of pastels of similar colour and tone, the blending required can be achieved by carefully layering one pastel into or over another as necessary.

Step 5: Continuing the block-in and adding detail

Continue the block-in as described above and at the same time begin to work on the foreground bracken. For these areas select three further red earths (one darker, for the branches and two lighter, for the foliage and bracken), a brick red and two lighter green earths for the foreground. Use the pastels in a variety of ways, using the flat sides in some areas and the tips in others. To develop the lighter sides of the farmhouse, two further light greys will be needed. These lighter areas of the farmhouse will form your focal point, so you will need to ensure that they work effectively in terms of the crispness of the drawing and the light against dark tones used.

This is a good time to remember to retain a certain degree of texture in your painting; you will need to ensure that some of the Terracotta ground remains visible.

Step 6: Adding the final details

In this last stage you should be concerned with the final blocking in and the completion of the detail. Making sure not to overdetail, or make any unnecessary marks around the outside edges of the painting. Overdetailing marks such as this will distract from the focal point. Probably the most important part of the completion

of your painting will be the attention to edges. You will need to look carefully at your painting to decide which edges are the most important (usually around the focal point), and which edges could be softened, or even lost altogether. Any successful painting relies on a combination of hard, soft and lost and found edges. Your final detailing should be concerned with the branches, the texture of the foreground bracken and grass, the fence against the dark of the farm buildings and the farm building itself. Remember less is more; never get carried away by providing too much information.

When you are satisfied, take a little time for evaluation and reflection.

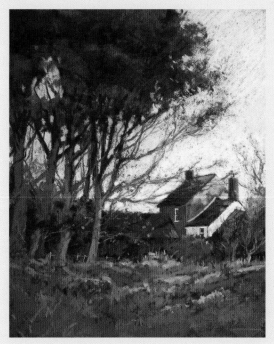

Step 6. *Autumn/The Hermitage*, 28 × 33cm (11 × 13in).

Winter.

Winter

The winter can seem to go on forever with many cold, damp and grey days. However, there are also wonderful days when low, soft light offers the painter more even and constant conditions to paint, sketch or gather material. The weaker winter sun reduces the tonal and colour range, which is invariably less intense; consequently the wonderful array of subtle warm and cool tones are a joy to capture.

Snowy days also offer variety and an added stimulus to artists. Unfortunately, snow invariably melts rather quickly, often creating damp atmospheric conditions. As pastel is vulnerable to dampness it is often not possible to work under these conditions, and quick sketches in oil, watercolour or pencil may be your only solution. This reference material, supplemented by photographs, should prove invaluable when developing paintings back in the studio.

The camera is an extremely useful tool in adverse weather conditions, enabling you to capture the location and lighting conditions while allowing for minimal exposure to the elements. You will of course need to bear in mind the pitfalls of working from photographs as discussed in Chapter 4.

A useful tip when photographing snow in brightly lit situations is to adjust the exposure slightly to compensate for the glare from the white, highly reflective surfaces present. By overexposing by at least one stop, the darks and shadows will be slightly lighter, providing the information you will need to produce a convincing studio painting.

Being highly reflective, snow reflects colour more than most other surfaces. As with other white objects its subtle tonal and colour variations are often overlooked, especially those in shadow areas.

The majority of snow paintings are made up of cooler tones and to counteract this bias it may be worth considering working a warmer ground or underpainting. The pastel applied on top of any warm underpainting will appear cooler to the eye, allowing you to adjust colour selection accordingly, resulting in a more natural, warmer colour harmony.

DEMONSTRATION
January Snow/Roseberry Topping

The painting *January Snow/Roseberry Topping* was painted from reference material gathered over a week or so in different lighting conditions. A warm Burgundy ground was chosen for this painting to counteract the cool colours present.

Materials

Board:
Burgundy Art Spectrum Colourfix textured board.

Pastels:
A selection of the following Unison pastels were used: brown earths, green earths, blue/greens, blues, blue/violets, greys and yellows. Should you decide to follow this demonstration, at least three tones of each colour will be required. A mid-light grey pastel pencil by Conte was used for drawing out.

Step 1: Begin blocking in from a simple drawing

A relatively simple drawing delineating all the main features in the painting is all that is required. Begin the block in by using two mid-tone blue/violets for the distant hills, two green earths and a mid-toned blue/green for the trees and distant fields and finally, a light grey and light yellow for the sky. At this stage take care not to apply too much pastel to the board.

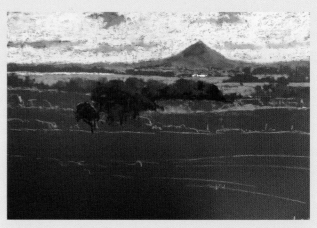

Step 1.

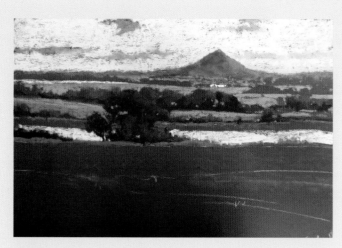

Step 2.

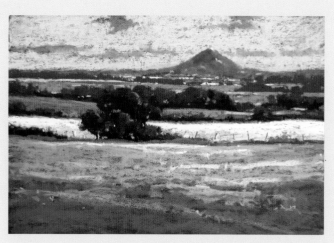

Step 3.

Step 2: Continue the block-in

Continue to develop the block-in by working down the board adding two further light yellows to the previously selected colours.

Step 3: Complete the block-in

Complete the block-in by working pastel over the entire surface of the board. Try to retain some of the coloured ground showing through to provide an underlying unity. You can now start to overlay colour in the sky, where a light brown earth and a further light grey were selected. Use two or three additional brown earths, green earths and yellows to develop form and texture in the trees, distant fields and foreground. The marks used in the foreground should be kept very simple so they don't detract from the more important areas towards the centre of the painting. Finally introduce the fence line and the light patches of distant lying snow.

Step 4: Complete the painting and evaluate

Further textural marks were made to the distant fields using a variety of green earths, brown earths and blue/greens. Additional patches of snow that were picking up light were introduced to the distant fields and hills. The fence was completed and three sheep introduced to add a little life.

Further blues, blue/violets and greys were overlaid in the foreground, softening the previously applied textural marks.

The sky was blended to accentuate the details in the landscape. This is a personal preference, and you may decide to retain the texture and presence of the ground colour throughout the painting.

Now is the time for evaluation, where you assess the entire painting, starting with the composition, moving on to tone, colour, edges and drawing. Be very critical. If something doesn't work, make the necessary adjustments.

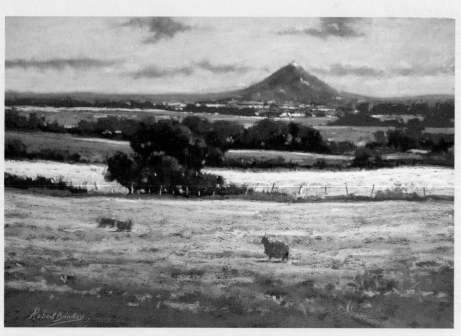

Step 4. *January Snow/Roseberry Topping*, 46 × 30cm (18 × 12in).

The selection of a warm ground will serve you especially well for those paintings dominated by the cooler side of the colour wheel.

A wider selection of colours suitable for winter paintings, including snow scenes, could be made from the following Unison pastels: Light Set 1–18, Blue Green Earth 1–18, Blue Green 1–18, Blue Violet 1–18, Grey 1–36, and Additional colours 1–36.

The painting *Snow/Roseberry Topping* depicts a bright winter morning with a fresh covering of snow. A warm mid-grey Sennelier pastel card was selected for this painting. This colour ground worked harmoniously with the blues and blue/greys which cover most of the painting surface and at the same time provided a perfect foil for the warmer colours present.

Greens

Over the years the question 'How do I handle green?' crops up with regularity amongst artists. Many renowned painters have struggled with the use of greens in their paintings. One or two of these painters subsequently stopped painting the English landscape as they never mastered their use.

One of the fundamental problems encountered by the artist when painting greens is that what we see in nature is light reflected off a surface. It shares a relationship with its surroundings as well as the bias of the light source. As man-made colours are only capable of representing what is seen, even the finest of

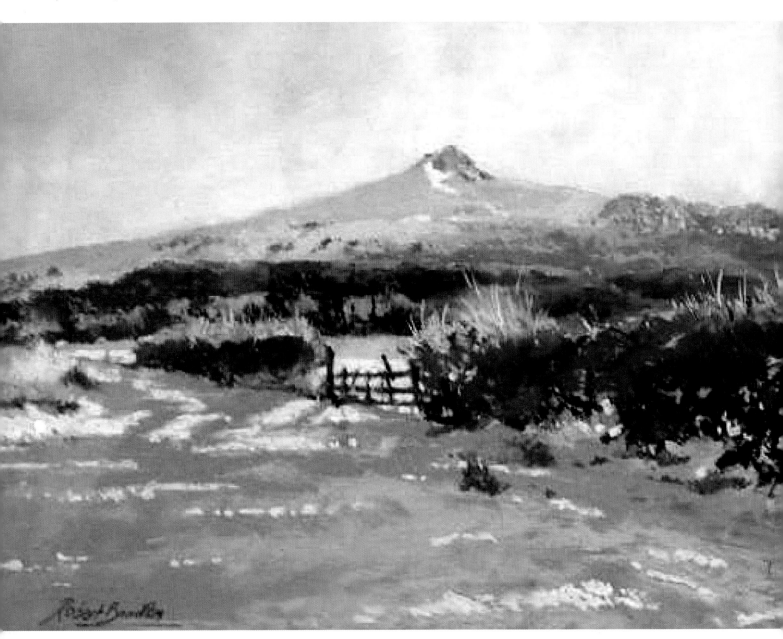

Snow/Roseberry Topping, 35 × 30cm (14 × 12in).

paintings fails to capture the real light which falls on any given surface. These pigments have limitations in as much as they are artificial and cannot be related to the greens found in nature. Even the strongest blue/green in nature is rarely as intense as pure viridian or phthalo green pigment.

To deal with this problem, a degree of layering of other colours over these greens is sometimes necessary to produce a more natural appearance.

Some manufactures offer only a limited number of colours within each range, providing little subtlety of colour and tone. Others, however, offer an extensive range of colours, obtained by mixing pigments together. These colours are the equivalent of the subtle, colour and tonal mixes achieved by oil and watercolour artists. The result is a range of more natural green tones which has made painting the landscape with pastel much easier. If your green palette is small, it will serve you well to widen its range, for use when landscape painting.

A few years ago the pastel artist Glenna Hartmann was asked how she handled green. After a perfectly timed pause, she quietly responded, 'I avoid it at all costs.'

Considering the problems with green further, it may be helpful to begin with the colour wheel. By studying the relationships of individual colours and how they interact with each other, you will develop a better understanding of why certain colours work when placed together. This is a powerful tool in choosing what to place in a painting.

Colour is made up of three primaries (red, yellow and blue), from which all the other colours are derived. They share no relationship until mixed. When mixed, they create secondary colours: orange, violet and green. Any combination of these secondary colours can be used to create a natural harmony.

Certain colours work better in relationship to others; everything is affected conversely, according to what it is next to. For example, an object may appear lighter when placed against a dark background and warmer when placed against a cool background. This is very useful when using greens and goes some way to explaining why one green pigment can never be perfect for all situations.

An understanding of these colour relationships is invaluable when planning your paintings. It may be useful to try this exercise. Using a selection of greens, oranges and violets, make a number of random marks on a piece of pastel card or paper. As

the surface becomes covered, it will become apparent where the green choices are working and where they are not. You will notice that some of the marks made work better than others. By studying these relationships you will begin to appreciate the importance of using the correct orange or violet against a certain green.

It may be beneficial to paint a green picture, putting everything you have learned into practice. Experiment with a number of greens, oranges and violets, looking for the most successful combinations.

Trees

The *plein air* sketch *Towards the Sea/The Hermitage* illustrates how a group of skeletal winter trees can be used effectively as an important compositional device in a painting. The mass of the trees, positioned on the golden third, provides a vertical element to the work.

Trees offer an infinite variety in shape, colour and texture, providing excellent subject matter for the landscape pastel painter whatever the season. They can be painted either as the primary subject or part of a more general landscape painting.

Generally speaking, it is not necessary to have a knowledge of botany when painting trees. It is, however, extremely important that you pay particular attention to the characteristics of any tree that you decide to include in your work. To achieve authenticity, the overall shape or form, the structure of the branches and the colour of trees are a few of the elements you will need to get right.

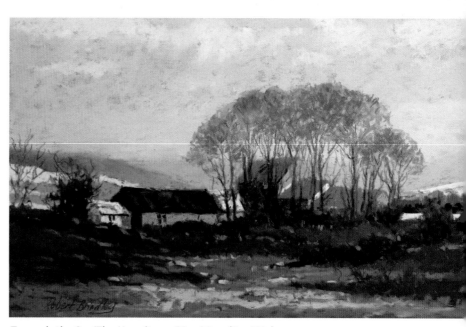

Towards the Sea/The Hermitage, 20 × 30cm (8 × 12in).

DEMONSTRATION *The Track/Aislaby*

Reference photograph for *The Track/Aislaby*.

Materials

Board:
Mount board was painted on both sides with white acrylic primer. When dry, two coats of Terracotta Art Spectrum Colourfix pastel primer were applied.

Pastels:
The pastels used were Unison in the following colours: brown earths, greens, green earths, blue/greens, blues, blue/violets, oranges, greys and yellow/green. Should you decide to follow this demonstration, select at least three tones of each colour to work with. It may be that you will not need to use all of the pastels selected, but you will at least have them available for consideration. A light grey pastel pencil by Conte was used for drawing out.

Additional items:
- A bottle of black acrylic ink.
- An old No.10 watercolour brush.
- White acrylic primer.
- Terracotta Art Spectrum Colourfix primer; these primers are available in 259ml pots in fourteen shades, plus clear, and are the same as used on the Colourfix papers.

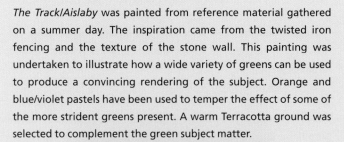

The Track/Aislaby was painted from reference material gathered on a summer day. The inspiration came from the twisted iron fencing and the texture of the stone wall. This painting was undertaken to illustrate how a wide variety of greens can be used to produce a convincing rendering of the subject. Orange and blue/violet pastels have been used to temper the effect of some of the more strident greens present. A warm Terracotta ground was selected to complement the green subject matter.

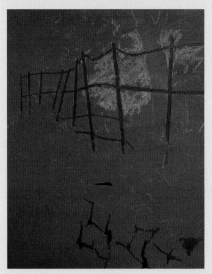

Step 1.

Step 1: The Drawing
Undertake a loose contour drawing using a light-toned pastel pencil.

Using the black acrylic ink, paint the fencing and the darkest joints in the stone wall. You can water down the acrylic ink if you require a lighter tone.

Use a medium blue/violet pastel for the shadowy bush behind the tree, being careful not to apply too much pastel at this stage.

Step 2: Starting the block-in
Begin to block in by using the following colours:

Tree foliage and grass: medium to medium-light tones of green, blue/green, orange, yellow/green and grey.

Shadowy bush: medium to medium-dark tones of blue/green, blue/violet and a light grey for the sky holes.

Tree trunk: medium tones of brown earth and lighter tones of blue/green for the light-struck side of the trunk.

Use the pastels very lightly, with descriptive, directional strokes where necessary, avoiding detail.

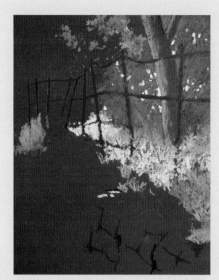

Step 2.

Close-up showing the introduction of detail to the grass.

Step 3: Developing the block-in

Develop the block-in by using the above range of colours and tones. For painting the sky and distant tree, further light-toned greys and blue/violets were selected. Apply these closely related colours and tones to the sky, using multi-directional, layered strokes.

At this stage you can begin to introduce a little more detail and refinement to your painting (see close-up).

Step 4: Complete the painting and take time for evaluation

Now complete the block-in and add the final details to the painting. A little blending can be used at your own discretion; however, be careful of overblending around the focal point, as this will destroy the impact of the painting. Take care not to overdetail, especially around the edges of the painting, as once again this will destroy the effectiveness of the focal point.

When you feel that you are coming to the end of the painting take time out for assessment and evaluation.

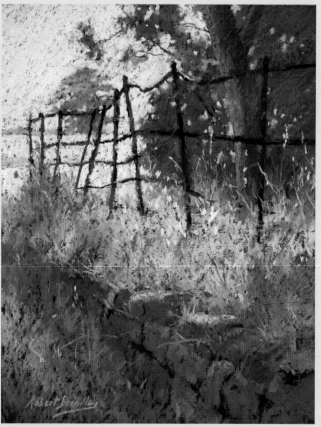

Step 3.

Step 4. *The Track/Aislaby*, 25 × 30cm (10 × 12in).

The sky is the source of light in Nature and it governs everything.

John Constable

Skies

The sun, which illuminates the daytime sky, is the main source of light and ultimately colour, as discussed in Chapter 2. It is the key to most landscape painting, reflecting the conditions and moods of nature. In most cases the sky, as a light source, will be almost entirely responsible for the initial appeal of the subject to the artist. It is therefore vital to acknowledge the importance of the sky by making every effort to interpret its influence in all of your paintings.

The atmospheric sunset found in *Sunset/Camber Sands* inspired a desire to capture the colour and drama present. Pastels are the perfect medium for capturing this type of subject, especially if you are working *plein air* with rapidly changing lighting conditions.

This sky reveals many subtle colour and tonal transitions, where a fair degree of blending may be required. Therefore, to be able to choose a ready-made colour or tone, without having to mix, is extremely important when working within a tight time-frame.

The colours from the sky were echoed in the sea below, creating a wonderful harmony throughout the entire scene. The main

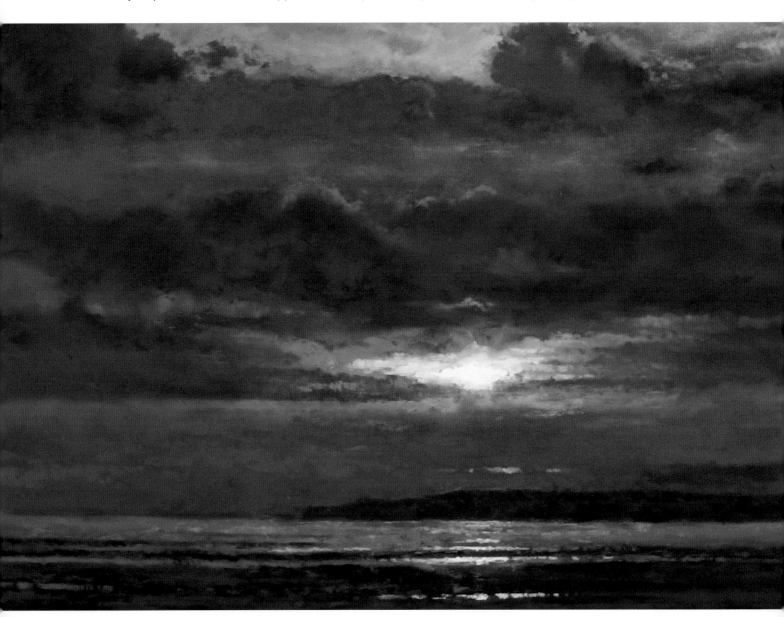

Sunset/Camber Sands, 38 × 28cm (15 × 11in).

focus of this painting concerns the sky; consequently the sea was reduced to a narrow strip along the bottom of the painting. In some paintings the sky itself is the major element; however, in other works it plays a far smaller role as merely a backdrop. In some instances, where the subject is viewed from above, the sky may not be in evidence at all.

Artists deal with painting the sky in many different ways; however, more often than not, one of two ways is generally adopted.

- The first method builds the sky progressively, along with the rest of the painting. This method allows you to create a sky that has progressed in step with the rest of the painting, where you have probably made several observational decisions along the way.

- In the second method, the landscape is developed until near completion before too much consideration is given to the sky. At this stage the sky can be developed and given more consideration with regard to the colours and tonal relationships used in the landscape. Some adjustment can be made to the landscape at this time to produce harmony throughout the finished painting.

The one drawback with this second method is that you may have observed subtle changes in the sky while you have been painting the earth, but you will not have recorded them as you worked. Consequently, you may have missed out on many changes you wish you had recorded. In addition to this, you run the risk of having to work on a sky that has changed beyond recognition and no longer relates to the landscape. In situations such as this, you will benefit from a good memory to complete the painting of the sky.

If you have enough imaginative skills you can always invent a sky; however, this type of sky is rarely convincing in its relationship to the remainder of the painting.

Sky Colour

When painting the sky, be acutely aware of the array of subtle colours observed; from blues to blue/greys, greens, reds and oranges and purples. In many cases they may be so subtle that the tendency is to ignore them. Never do this; have faith in your powers of observation and use them with discretion.

The accurate observation and assessment of values is also vitally important. Ensure that the colour you use in a sky, maybe a particular blue, relates in value to a colour on the ground plane. This comparison will need to be repeated throughout the sky in order to produce a convincing painting.

The sky is quite often the lightest part of the painting; however, this is not always so. On bright, clear sunny days the light will strike certain elements of the landscape making them far lighter than the blue in the sky.

On grey days the sky is invariably the lightest part of the painting. Bear this in mind when painting; keep the sky values light, ensuring that none of the darks used in the sky is darker than, or competes with, the darks in the landscape.

The vast array of colours and tones available to the pastel painter makes the task of meeting all the above criteria far easier.

Clouds and Recession

It is always helpful to have a certain amount of knowledge regarding any feature to be included in your paintings; this applies to skies and particularly to clouds. There are a variety of cloud types to be considered: cirrus, cumulus, and nimbus are just a few. Quite often the sky has a combination of cloud types present, and a little basic knowledge will add to your appreciation and interpretation of their form.

Generally speaking a cloudless or solid overcast sky will offer no excitement or interest to the painter; therefore remember to use these skies in situations where the landscape itself holds more importance.

Whenever you are outdoors, make the most of the opportunity by studying the sky in all its guises. Take particular notice of the recession in the sky; generally speaking the more distant clouds are smaller than the ones overhead. By using this knowledge alone you will be able to create a feeling of depth within your paintings.

Cloud shadows are also extremely important. They can be used effectively to divide large expanses of the landscape into smaller areas, providing endless possibilities for you to strengthen the composition. Try to use cloud shadows creatively, as if you are directing a stage set, to add drama to your paintings or to ensure that the viewer's eye is directed to the focal point.

This compositional device has been used effectively in the painting *Towards Whitby from Hawsker* where a cloud shadow has been used in the foreground to accentuate the thin sliver of intense light on the sunlit field, which is the focal point of the painting.

Along the same lines you may find the following suggestions useful when using cloud shadows creatively:

- The drama of a brightly-lit foreground could be emphasized by its juxtaposition with a background enveloped in deep shadow.

- The exact reverse situation can be adopted by painting a dark foreground against an extremely light middle ground or distance.

- Another option for your consideration is to imagine that you are holding an extremely powerful spotlight which you can direct anywhere within the boundaries of your painting. These brightly lit areas can be used as a device to draw the viewer's eye to the focal point.

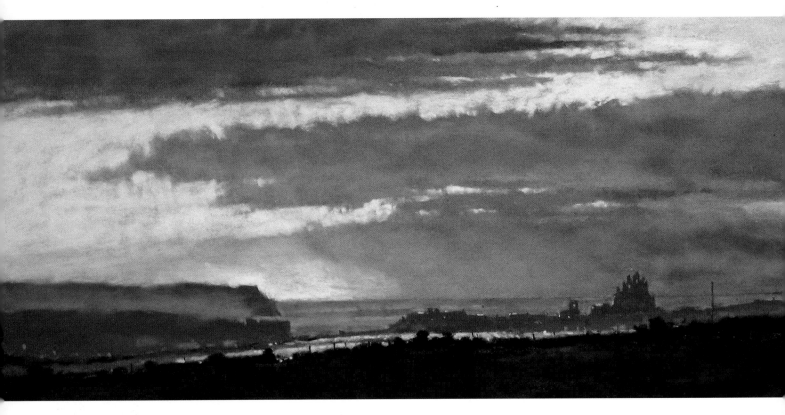

Towards Whitby from Hawsker, 50 × 25cm (20 × 10in).

The Gradation of the Sky

The gradation of the sky is another valuable aid for the artist. It begins immediately overhead as a fairly strong blue (this blue appears much stronger in countries where the intensity of the light and heat is far greater); then it lightens and warms progressively towards the bottom of the sky. Careful observation will reveal a warmer, pearly grey haze at the horizon. In the evening there is occasionally a subtle hint of yellow or pink. Further observation will reveal a subtle, lateral, tonal and colour gradation.

These gradations, although quite often only just discernable, recede in value as they move away from the light source. This can be seen in the painting *Snow/Roseberry Topping*, shown earlier in this chapter. The right-hand side of the sky, where the light source emanates from, is far lighter and warmer than the left-hand side.

The characteristics of pastels make them an ideal medium for faithfully reproducing the gradation of any sky.

Reflected Light

When painting any sky, look for the true colours evident in it. These colours can be observed on many occasions; however the more subtle effects can easily be overlooked. These more subtle effects will be more apparent to experienced artists who are aware of their value in creating a convincing, harmonious painting.

When searching for reflected colour, be aware that the sky is influenced by the colours from the landscape and vice versa; for example, the vivid yellow from large fields of oil seed rape will be apparent in the sky.

Finally, wherever possible, work directly from the sky itself or good reference material. An invented sky, or a stock, formula-painted sky, invariably seem to fail. A successful sky from a previous painting won't necessarily work in another.

MIRROR IMAGE

Have a mirror hanging in your studio to view your painting through. This can be done at regular intervals during the painting process and is invaluable for the ongoing evaluation and the identification of incorrect composition, values, tonal masses, drawing and so on. The painting, when viewed through the mirror, is laterally inverted, enabling you to observe the image as if through fresh eyes.

Cities and Urban Landscape

A Quiet Corner/Venice illustrates a corner in one of Venice's many campos or squares. The stairway, architectural doorway and dappled light were the inspiration for this vertical composition.

City and urban landscape subjects give the painter a refreshing opportunity to escape from the traditionally more popular subject matter of the countryside. A wealth of fascinating subjects abound in and around every city or town, providing the artist with an interesting variety of shapes, tones and colours to work with. City scenes in particular offer the opportunity of painting confined spaces, often bustling with activity and movement.

When you are visiting any major town or city, take along a sketchbook for recording paintable subject matter. Consider a wide range of subjects such as:

- Buildings that may have a strong architectural slant.

- Smaller buildings, houses and shops. It may be that some of these subjects still have iron railings and trees in front of them. These elements are a wonderful attribute to any painting, providing vertical and textural interest.

- Wide vistas or narrow passages make excellent compositions.

- Figures, cars and taxis provide movement and interest within a painting (see the demonstration painting *City Night Scene*).

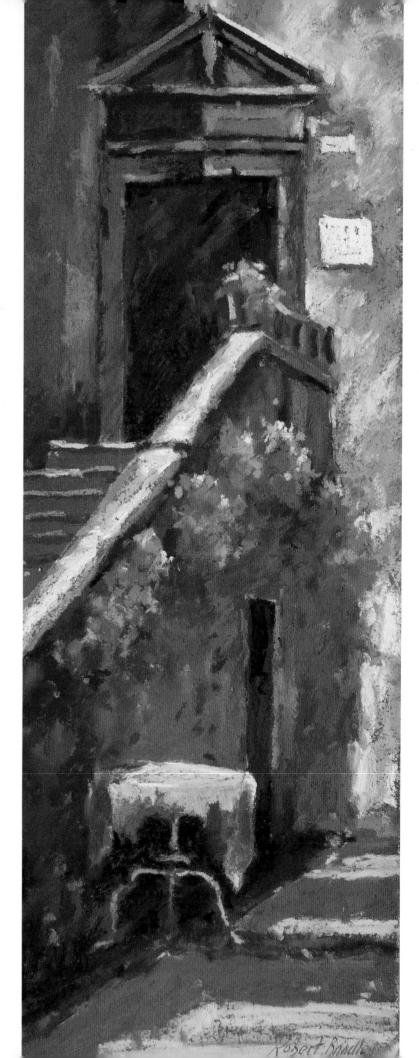

RIGHT:
A Quiet Corner/Venice,
38 × 14cm (15 × 5½in).

DEMONSTRATION *City Night Scene*

City Night Scene was painted from a friend's reference material. The inspiration came from the illumination of the subject. The dark shapes of the cars have rim lighting, making them stand out strongly against the background.

A warm Burnt Umber ground proved to be perfect for this painting, which has a blend of warm and cool colours.

Materials

Board:
Mount board painted on both sides with white acrylic primer and then two coats of Burnt Umber Art Spectrum Colourfix pastel primer.

Pastels:
The pastels used were Unison from which the following colours were chosen: brown earths, reds, red earths, yellows, blues, blue/greys, greys and darks.

The Dark range of Unison pastels are particularly useful for paintings such as this. Black pastels can be too insistent in some instances, and occasionally, layering other colours over the top of black can result in a dirty effect. A fairly extensive range of pastels will allow you to create the subtle darks needed in paintings such as this. A light Burnt Umber pastel pencil by Conte was used for drawing out, together with a selection of warm, light-toned pastel pencils for painting the signs and finer highlights.

Additional items:
- A bottle of black acrylic ink.
- An old No.10 watercolour brush.
- White acrylic primer.
- Burnt Umber Art Spectrum Colourfix primer. Colourfix papers.

Step 1: Drawing out
Draw out the composition using a light-toned pastel pencil of your own choice. A fairly accurate contour drawing will be needed for the cars; however, only a small amount of detail will be required for the background.

Step 1.

Step 2: Underpaint the cars and begin the block-in
Paint the cars in with diluted black acrylic ink.

Begin to paint the background using mid-toned brown earth and yellow. At this stage, apply the pastel lightly. The board will have to take several further applications of colour, and leaving sufficient tooth is essential.

Step 2.

Step 3: Continue to develop the background
Develop the background by adding further applications of pastel. The tonal range can be widened by using darker and lighter tones from your brown earth, yellow and grey pastels. Introduce a little more colour at this time.

Step 3.

Step 4: Continue the block-in

Begin to block in the cars using the dark pastels together with several mid to dark-toned blue/greys.

At this time, should you wish, you can carry out a little blending to the background. Be careful with blending as it is very easy to produce dirty effects.

Begin to introduce colour to the road surface using mid-toned red earth and brown earth.

Step 4.

TIP

When blending colours, try to work the lighter colours into the slightly darker ones as this always produces a cleaner result. Working darker colours into lighter ones often produces a dirty effect.

Step 5: Complete the cars and develop the background

You can now complete the cars by working into all the highlights and details. Use the lighter-toned red, yellow and grey pastels.

Begin to develop the background by adding lights, windows, signs and so on. Be extremely careful not to overdetail any of these elements.

Step 5.

Step 6: Complete the painting.

Paint the road selecting pastels from the full tonal range of red earth, brown earth and yellows. Finally add all the background details and highlights. Carry out the usual evaluation of the painting, making changes wherever necessary.

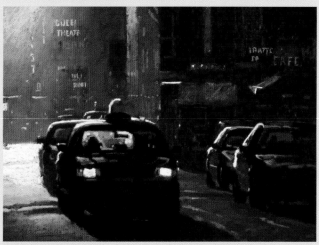

Step 6. *City Night Scene*, 33 × 25cm (13 × 10in).

IN THE SPOTLIGHT

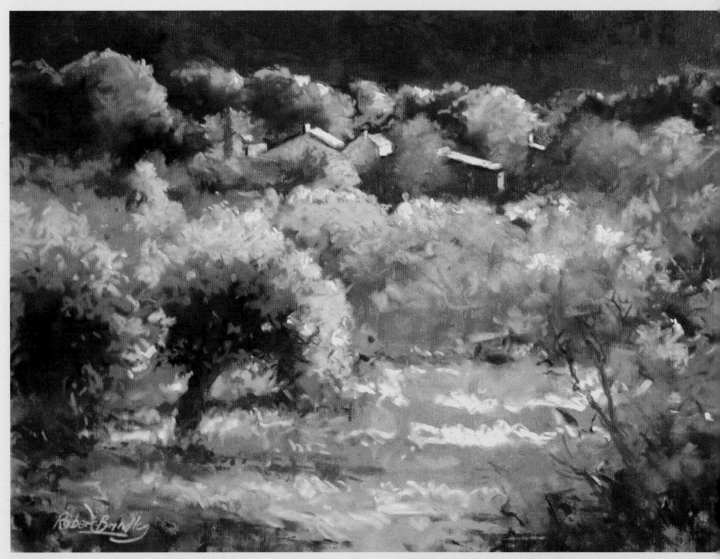

Olive Groves/Tuscany, 45 × 38cm (18 × 15in).

The painting *Olive Groves/Tuscany* was undertaken some years ago and with very little experience in the use of pastels. At the time the end result was acceptable; however, as time goes by and the learning process continues, you become more critical of many of your past works. Although it may be too late to do anything about the errors, it is always an invaluable part of the learning process to evaluate both your own work and that of others.

Evaluation

The use of colour appears to work fairly well; however, there are several issues regarding composition, tone, masses/shapes and some of the marks that were used to describe certain features in the painting.

Composition
The initial lead-in, from the bottom edge of the painting and moving slightly to the right, works perfectly well until this shape meets the edge of the vineyard. The horizontal line used here

forms too much of a barrier and subsequently prevents the eye from travelling easily through to the next area of the painting. It might have helped to break up the line slightly to overlap a few tall grasses or small bushes across it. Another solution might have been to create a narrow path through the vines, which would have helped the eye to travel through to the edge of the houses.

The shape of the vineyard is also a fault, forming a too-symmetrical rectangular block right in the centre of the painting. This error is accentuated further by repeating this horizontal feature in the shape formed by the distant village and trees. The use of three horizontal lines, positioned like this, is inadvisable.

The top edges of the bushes in the left-hand side of the painting also coincide with one of the three offending horizontals, which is not ideal.

Tone

The tonal relationships throughout the painting work quite well; however, the central mass of vines is far too regular in tone. This area would have benefited greatly by the use of some dark tones in the base of the vines to give them shape and form.

Masses and Shapes

Generally, the masses and shapes, with the exception of the vineyard, have been tackled reasonably well. However if this subject had been re-painted the following changes would have been made:

- The height of the foreground bushes on the left-hand side would have been raised above the level of the top of the vines.
- The entire mass of the vines would have been broken up by tonal changes and varying the top edges of the vines, creating a more interesting shape and at the same time reducing the horizontal line effect.
- The top edges of the distant trees would have been made more varied; with the addition of some taller trees the entire background mass would have become more interesting and far less repetitive.

Mark-making

Once again, taking into account the relative inexperience of using pastels, the marks made are generally quite satisfactory. The main concern is that the marks used are not very descriptive of the nature of the vines. The other area where the use of marks is a little ill-considered is in the parched, foreground grass. The marks used do not describe the nature of the ground, and at the same

time, in places they tend to form a slight barrier, preventing an easy passage into the painting.

Comments

After such an evaluation and assessment, criticizing many small errors, it would be easy to become downhearted and to lose confidence. However, it is essential to concentrate on the positives gained from this exercise; the results will encourage you to learn from the experience. Such an analysis clarifies the number and complexity of factors that can go wrong in any painting, with a view to avoiding such errors in the future. The other vital thing to remember is that, at the time, you may not have had the experience needed to arrive at some of these conclusions. It is only by going through this evaluation procedure, constantly searching for ways to enhance your painting, that you will improve as an artist.

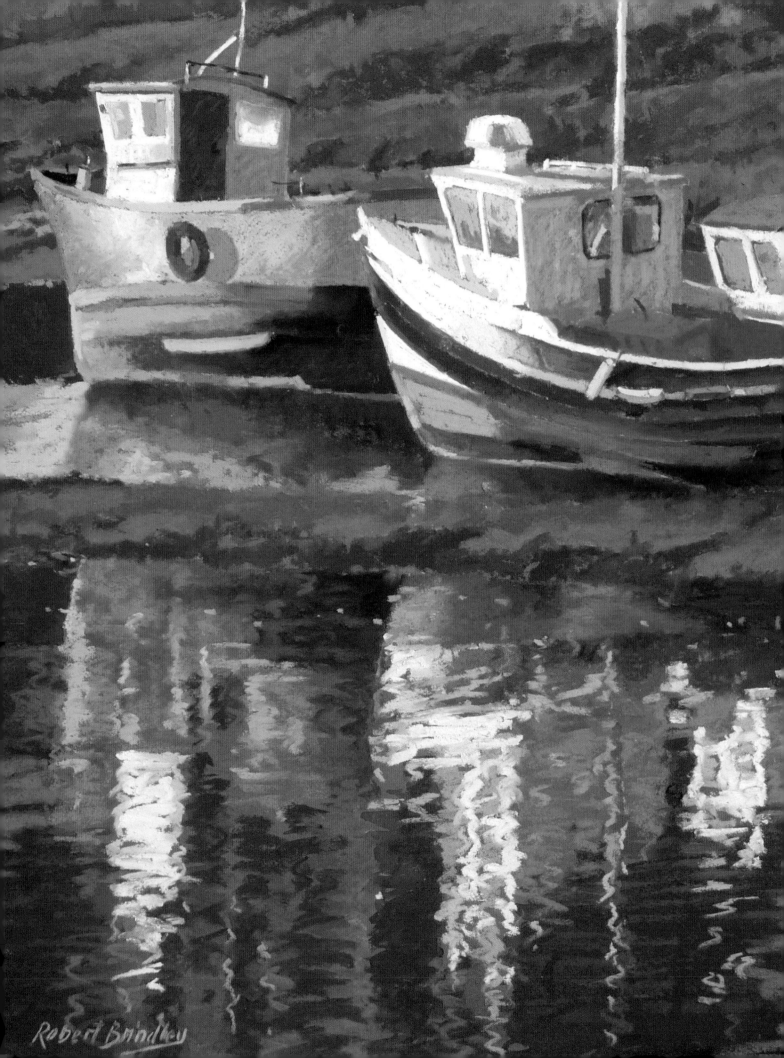

Robert Brindley

COASTAL SCENERY

The harbour scene *Reflections/River Esk/Whitby* illustrates boats moored at low tide. By employing a relatively high horizon line, emphasis has been given to the reflections, resulting in a more visually stimulating painting. The painting has been included as a step-by-step demonstration later in this chapter.

To emphasize something means that the other parts of a picture must be muted.

Irwin Greenberg

The British, being an island race, have always had an affinity with the coast, and this is reflected in the works of many noted painters throughout our history. The interest in everything marine, with special regard to painting, is probably only rivalled by the Dutch painters of the eighteenth and nineteenth centuries.

Turner, one of this country's greatest ever watercolourists, featured the sea in many of his better known works. From the latter part of the nineteenth century and right through the twentieth century, the number of artists noted for their marine subjects increased dramatically. The paintings of Henry Somerscales, W.L. Wyllie and Henry Scott Tuke laid the ground for painters such as Edward Seago and Edward Wesson to carry on where they left off. The resurgence of interest in painting with pastels in more recent times has added a new dimension to coastal paintings where colour, texture and design play an important part.

This chapter will deal with painting the coastal scene with particular emphasis on the United Kingdom, where the variety of subject matter is so diverse; from the flat beaches and huge skies of the southeast coast, to the smaller, more intimate beaches, coves and cliffs of Cornwall, and the beauty, peace and quiet of the west coast of Scotland takes some beating, especially if you are fortunate enough to have good weather.

OPPOSITE PAGE:
Reflections/River Esk/Whitby, 35 × 45cm (14 × 18in).

There are numerous aspects to be considered when painting the coast; however the sea itself will be discussed in some depth before considering further subject matter.

The small painting *Evening/Sandsend Ness* was executed rapidly in response to a wonderful June sunset. The distant cliff and foreground beach are dark, featureless silhouettes which serve to enhance the drama of the setting sun.

Evening/Sandsend Ness, 14 × 19cm (5½ × 7½in).

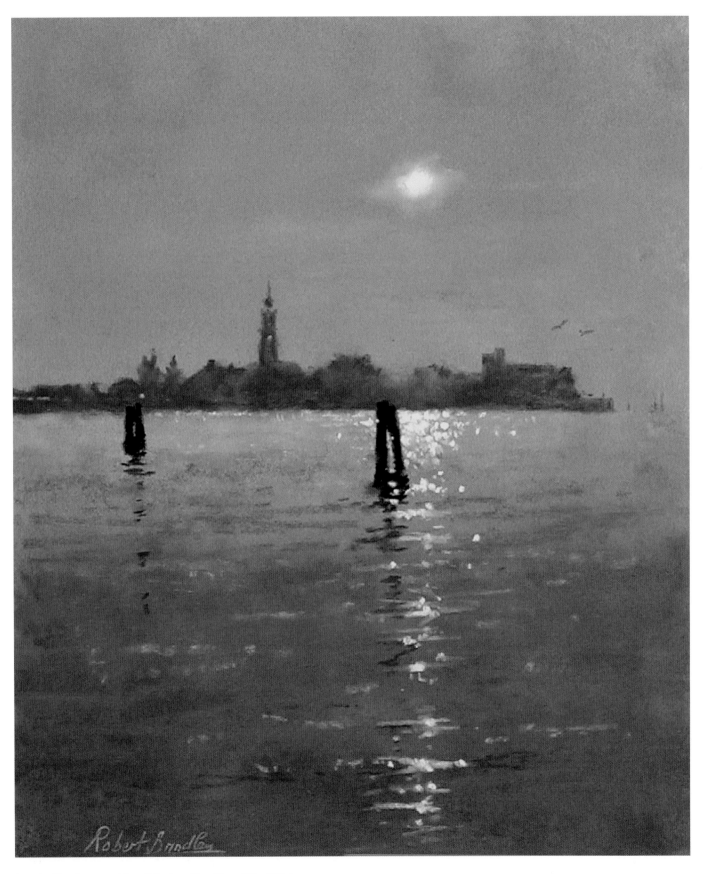

Sunrise/San Lazzaro Island/Venice, 45 × 55cm (18 × 22in).

Calm Water

The painting *Sunrise /San Lazzaro Island/Venice* depicts a hazy, autumn sunrise over calm water when setting out for a day's painting on Torcello. The rays of the rising sun and the reflection of the navigation marking posts were broken only slightly by a gentle swell.

One of the essential ingredients necessary to capture calm water convincingly will be your ability to paint reflections. It is therefore advantageous to have a basic understanding of reflections and their properties.

Reflections

You will have observed the perfect reflections produced in a mountain lake on a calm day. Subject matter such as this is often featured in tourist guides or calendars; however, it could be considered a little twee or obvious by many painters. Reflections are often described as the mirror-like ability of the water surface to bounce back shapes and colours; however, this assumption is not strictly true. The following observations may prove useful when considering painting reflections.

*Reflections are not a
mirror reflection of the scene.*
You are in fact seeing the reflected images and the scene in front of you from two different viewing angles. The reflection is coming off the surface of the water, but you see the reflection from an angle as far below the water's surface as you are above it. Depending on your visual height, compared to the reflective surface, this can vary considerably. If you are six feet tall, standing on the edge of the reflective water surface, the reflection would be coming from a distance of six feet below the surface of the water. In other words, the reflection is showing you the underside of what you can see and, due to its angle, may not reflect things you are capable of seeing in the distance. This is made clearer when looking at the photograph *Whitby Reflections*. The brick section of the large industrial building and the distant landscape cannot be seen in the reflection. From the water surface, the lower section of the building and the distant landscape would not be visible, but to you it may be very clear.

It may help to imagine that you are submerged in the water, looking up. The angle of vision would be greatly different from what you see eye-level from the shore. This becomes more pronounced when you are closer to the reflection and is less noticeable at great distances.

Photograph *Whitby Reflections*.

*Generally, darks reflect slightly
lighter and lights slightly darker.*
Depending on the clarity of the water, this can be more, or less pronounced. Colour will be affected by the surface tone and is rarely brighter in chroma than what is being reflected.

All reflections move towards you.
To paint a convincing reflection you must consider three elements: the objects being reflected, the surface they are reflected on, and yourself (you will however rarely be included in the painting).

Reflections travel towards your eyes and will appear to follow you when you move.
This can best be seen at a boat basin where you can observe the reflections of tall upright masts in the water. The tops of the masts (which are at the bottom of the reflection) will appear to come towards your feet. You may have to look closely to observe this, as the effect can be quite subtle.

Edges should always be slightly softer in the reflections due to the refractive nature of even the stillest water.
Sparkles on the surface of the water should also be softened and radiate from near white to a slight orange/yellow as the light is being bent. As light hits the surface of the water, it is shattered. Try not to paint those perfect little white dots that photography is capable of capturing, as they need to be reproduced with a little more subtlety in a painting.

Technique

By studying these elements carefully, you will become more sensitive with regard to the composition of reflections and be able to capture them more convincingly in your paintings.

It is wise to look carefully at reflections, as they can easily be confused with cast shadows. In some instances the cast shadow of an object will coincide exactly with its reflection, causing a darkening of tone, often accompanied by a loss of transparency. These conditions present no special difficulties for the painter to handle. However be aware of the situations where the shadow and reflection are not totally coincidental. These conditions can provide the artist with a difficult challenge when trying to produce a convincing portrayal of what is actually happening.

It may help to view your painting through a mirror, where the image will be laterally inverted. This will assist you in identifying any confusion within the subject. The greatest problem is encountered where a shadow cuts across part of the reflection resulting in three different areas for you to resolve: one for the reflection, one for the shadow, and finally the area where the two elements coincide. In each of these areas changes in tone, colour and transparency should be observed and interpreted.

On some occasions there will also be a problem with regard to composition, especially where the shapes and tones created become too insistent. You should never begin to paint such a subject if you have no solution to the problem. It's always preferable to find a similar subject that will present you with fewer difficulties.

From the Riva/Venice, 33 × 25cm (13 × 10in).

Moving Water

Calm water is wonderful to paint, the reflections being the primary attraction. However moving water, although more demanding, provides the artist with a greater variety of subject matter.

Painting and sketching moving water will present many problems for the novice and even some of the more experienced painters. To improve your understanding of the character of moving water, together with your powers of observation and drawing skills, it is recommended that you should persevere with these *plein air* studies. Photography can be extremely useful as an additional aid when producing studio paintings of moving water, as the images will capture the movement of water as if frozen in time.

Moving water is produced by numerous factors and conditions, especially the action of the wind or the tide. All of these conditions produce varying degrees of disturbance, subject to the strength of the wind, the steepness of the slope of the beach and the ever-changing seasonal tides. The severity of these conditions has a drastic effect on the reflective qualities of the water surface, producing broken reflection not only of the objects above the surface but also of the sky. These broken planes of water, in conjunction with light bouncing from the sea bed, also produce further unexpected shapes, tones and colour for consideration.

As mentioned previously, one of the best ways to improve your observational powers and learn to paint moving water convincingly is to carry out numerous *plein air* sketches and small paintings. This time will be well spent, as you will develop the ability to collect information at speed, capture the feeling of motion in your paintings and at the same time boost your confidence.

When painting moving water with pastels it is essential to that you use loose, expressive marks; otherwise the painting will appear too static. Take time to observe the many nuances of colour and tone in the water that may be caused by reflected light from the sea bed or sky. Never be afraid to be creative in the use of colour; the rich variety of colour available to you as a pastel artist should be taken advantage of in subject matter such as this.

The painting *From the Riva/Venice* was executed on-site in rapidly changing light, with gently undulating water. The attraction to this subject was the simplified shapes in the reflections and the sparkling light on the Giudecca Canal.

Coastal Skies

Most aspects of painting the sky has been discussed fully in chapter five, however, coastal skies and their effects on the reflective surface of the sea below are spectacular. The two elements, water and air, often combine seamlessly to produce subject matter containing wonderful colour and tonal harmony.

Beach Scenes

The painting *The Windbreak/Sandsend Beach* portrays a group of figures enjoying the last of the sunlight towards the end of a hot summer's day. The painting works well on several levels; the light effect on the windbreak and the interaction between the figures should ensure that the viewer will be successfully engaged.

Beaches have always inspired artists, providing them with a source of ever-changing subject matter. There are several reasons why painting the beach is so popular:

- The foremost is probably the association with times gone by, maybe childhood memories of playing in rock pools and making sandcastles.
- In addition to this, most people have an attraction to water, especially the sea.
- When painting beach scenes you are able to observe the human figure at leisure, either on a packed, sunny beach or maybe a solitary figure walking the dog. Packed summer beaches with colourful beach huts, deckchairs, windbreaks and children playing with buckets and spades, can provide an endless source of material. When selecting a painting subject in situations such as this, don't only consider the larger view, as there will often be a choice of small cameo scenes such as the painting The *Windbreak/Sandsend Beach*.
- The sea itself can be painted by carrying out studies of breaking waves over rocks, reflections in wet sand and so on – the choice is endless.

The Windbreak/Sandsend Beach, 56 × 50cm (22 × 20in).

- Over the years man has constructed piers, breakwaters, groynes and sea defences, some of which make interesting subjects if you are concerned with form and texture.

Groynes/Sandsend Beach was painted from sketches and reference photographs taken on a painting expedition to Sandsend near Whitby. The aim of this painting was to capture the colour and texture of the groynes as simply as possible without too much unnecessary detail.

Groynes/Sandsend Beach, 20 × 30cm (8 × 12in).

DEMONSTRATION *Sails at Sunset*

The small demonstration sketch *Sails at Sunset* illustrates perfectly how pastels can be used for interpreting the harmony between sky and sea. The black Hermes sandpaper ground chosen for this sketch is a perfect foil for the warm, light colour used in this sunset.

It is a useful exercise to work against the clock occasionally. This is only a small, relatively simple painting; therefore, should you decide to attempt this demonstration, set yourself a time limit of around twenty minutes.

Materials

Paper:
Black Hermes sandpaper mounted on stiff card.

Pastels
A selection of Rembrandt soft pastels from the landscape range were used for this painting. Reds, red earths, yellows, blues and blue/violets were the predominant colours used. You should select a minimum of three tones of each colour when painting a simple painting such as this. Any fairly light pastel pencil would be ideal for the initial drawing-out.

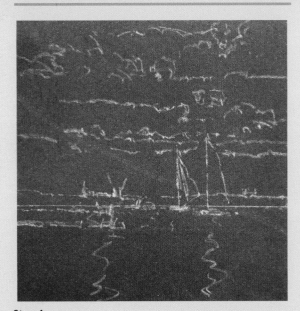

Step 1.

Step 1: Drawing out
Execute a rapid sketch trying to include only the basic information required.

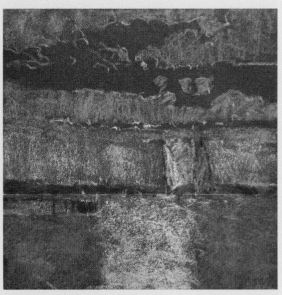

Step 2.

Step 2: Beginning the block-in
Using a mid-toned pastel from each colour, lightly block in the major colour and tonal masses. Be careful not to apply too much pastel to the surface at this time.

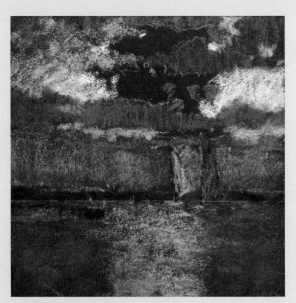

Step 3.

Step 3: Continue the block-in

This step is just a matter of continuing the block-in by gradually overlaying colour. At this time you can begin to use the full range of tones to define all the elements with a greater degree of accuracy.

Step 4: Complete the painting by adding details and final highlights

At this time you can add all the final highlights to the sky and water. To liven the water surface, dots of pure colour were added. Complete the painting by adding the final details to the yachts and jetty. Keep the painting loose and fresh by trying to capture the feeling of a rapidly executed *plein air* sketch

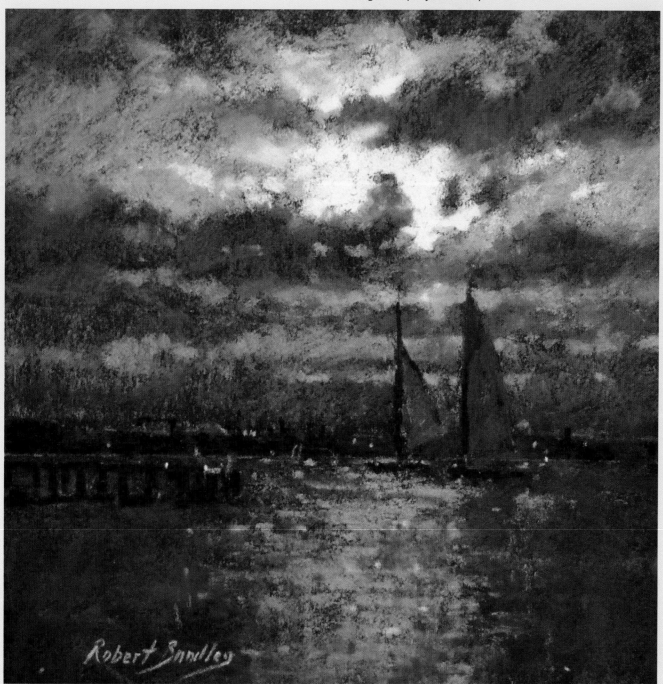

Step 4. *Sails at Sunset,* 20 × 20cm (8 × 8in).

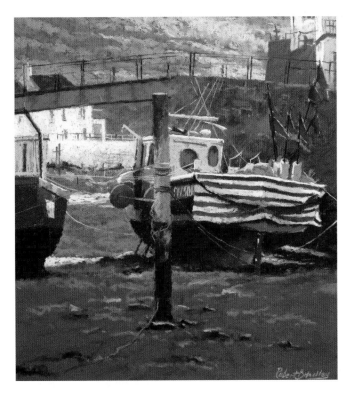

Red Marker Flags/Staithes Beck, 35 × 38cm (14 × 15in).

Boats

Red Marker Flags/Staithes Beck is an ideal subject for painting boats in pastel.

Should you be interested in painting the coast, including boats in your work – either as additional interest or as the main subject – will add variety and interest to your work. From the smallest of rowing boats to the larger vessels found in ports and harbours, the variety and choice available for the painter is enormous.

It is always helpful to have a little knowledge of any subject matter before using it in your paintings. This is especially true of boats. A little research into the construction methods used, their purpose, together with an understanding of their basic shape and form would be highly recommended. This fairly basic knowledge will prove to be especially useful for capturing the essence and character of the particular vessel. Always recognize the importance of painting or drawing a real boat. The ability to be able to draw a stock boat shape is not really of value.

Sketching and painting boats in any medium, on a regular basis, will enable you to develop your skills. When doing this remember to take your time to consider the best viewpoint and to make several studies from different elevations and angles. Knowing exactly what to include, or more important-ly, what can be omitted, is vitally important to the success of your painting.

Finally, it may prove helpful to pay particular attention to the position of all the major features such as cabins and masts. Compare the width of the boat in relation to its length and height. The width and height of any cabin or superstructure, including masts, should also relate accurately to the above. Try to develop a shorthand method when simplifying features such as masts, rigging, etc., without sacrificing the essence of the whole.

Harbours

Each individual harbour, small or large, will offer a wealth of subject matter. In some instances, the choice of subject matter may be overwhelming; on these occasions you may find the following suggestions helpful.

Consider Cameo Scenes

The chosen subject does not always have to be of the entire scene in front of you. Consider painting small, cameo scenes. These cameos may be just a collection of miscellaneous fishing-related items on the harbour wall or a study of a boat unload-ing its catch, with lots of figurative interest. Cast your eyes over everything. Make use of a simple card viewfinder which may be useful for isolating the subject from its background or making decisions of where to crop the subject to aid composition.

Experiment with Textures and Patterns

A study of textures and patterns in harbour walls, old buildings and boats often make wonderful subjects, especially when using pastels on a heavily textured ground.

Visualize What Attracted You to the Subject

When considering a possible subject, ask yourself what it was that attracted you in the first place. It may have been the light effect, the mood and atmosphere or the design. Keeping this vision firmly in mind throughout the painting process is vitally important to ensure that it features strongly in the finished piece of work. Unless you do this, you will be in danger of los-ing focus and begin to paint everything in front of you with no end result in mind. Remember, less is sometimes more, especially when you are trying to portray a specific light effect, or mood and atmosphere.

Take Time to Get to Know Your Subject

Whenever you visit a new painting location spend a little time searching for the best subject amongst all the possibilities. Never settle for the first subject that attracts your attention unless you are absolutely positive that it's what you were looking for. Of course, time is always at a premium, so you must also be aware not to spend too much time deliberating.

When you eventually find a suitable subject make sure that there is not a better viewpoint. It may be that by just moving slightly to the left, right, up or down, the view could be improved. Be aware that a higher viewpoint almost invariably offers greater drama and a better design than the same subject viewed from a lower elevation.

Check Tide Times

Tide times are always relevant. A rapidly changing tide can be disastrous for the *plein air* painter. Try not to begin a major piece of work unless you have fairly constant conditions to work under. It can be so frustrating to start a painting where the boats are afloat one minute and then high and dry a short time later. Do a little research beforehand to ascertain the tide times and also how quickly the tide changes.

Note Weather Conditions

Weather can also be a factor, so if the forecast is very bad, plan to paint from some form of shelter. Should the weather be particularly inclement, find out if there are any interesting interiors that could be painted. Buildings such as boat building sheds and lifeboat houses make wonderful subjects.

Remain Single-Minded and Focused

Once you have settled on a subject, be single-minded, stay focused and take your time. Never work too quickly unless conditions force you to do otherwise. Keep any important features and special aims firmly in mind and try to eliminate or play down the importance of everything else that you can see. Try to think carefully about every mark that you make. Careless statements always produce an unsuccessful piece of work.

The Red Groyne/South Shields shows the entrance to the River Tyne at South Shields. Look out for interesting subject matter such as this when considering painting harbours or harbour mouths.

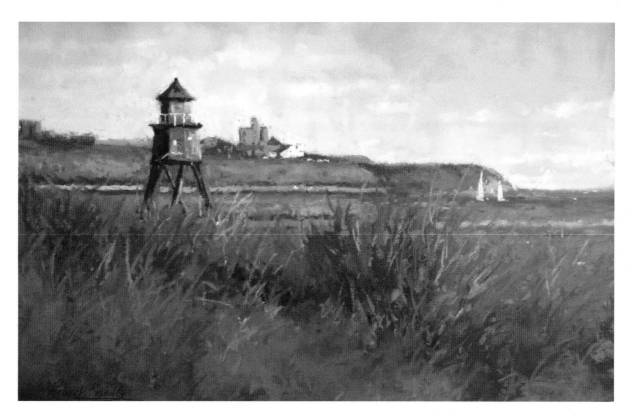

The Red Groyne/South Shields, 30 × 20cm (12 × 10in).

DEMONSTRATION *Reflections/River Esk/Whitby*

Reflections/River Esk/Whitby was painted as a demonstration from photographic reference. Low afternoon light illuminated the boats creating colourful reflections on the placid water surface.

Materials

Board:
Elephant Art Spectrum Colourfix board

Pastels
A range of Unison pastels in the following colours were used: reds, brown earths, yellows, greys, blues, blue/violets and greens. At least three tones of each colour were selected. A light orange pastel pencil by Conte was used for drawing out.

Additional items:

- A bottle of black Rowney acrylic ink
- An old No.10 watercolour brush

Pastels used for demonstration *Reflections/River Esk/*Whitby.

Step 1: Drawing out
Draw out the composition using the light orange pastel pencil. A fairly accurate outline drawing may be necessary for this painting. Use the black acrylic ink to indicate where the main and intermediate darks are located. Add water to the ink where necessary, in order to create any lighter tones. In some instances, where a range of fairly bright colours are to be used, it may help selection by making small marks on the board before committing yourself too far.

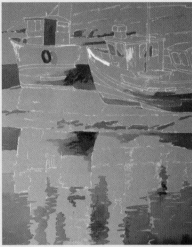

Step 1.

Step 2: Begin the block-in
Begin to paint the boats and their reflections using medium and medium/light tones of blue, blue/violet, grey, red earth, brown earth and yellow. As usual take care not to apply too much pastel on the board in the early stages.

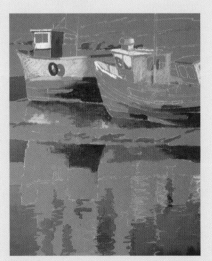

Step 2.

Step 3: Develop the boats and reflections

Continue to develop the boats and reflections using the above colours, plus lighter and darker tones of each. Begin to paint the rough grass on the banks of the river using a medium and dark green.

Close-up showing the marks made for the reflections.

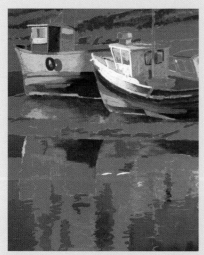

Step 3.

Step 4: Develop the reflections and the river bank

You can now work over the whole of the board surface to develop the reflections and riverbank using the all of the pastels originally selected. Try to work on the painting as a whole, ensuring that everything is in step and to the same level of development. Resist the temptation to over detail, or apply too much pastel onto the board surface. Once again it is important that the Elephant ground plays its part in the finished piece of work.

Step 5: Complete the painting by adding details and highlights

Before commencing this stage, take time to decide exactly where you want to take the painting. You may decide to go a step further than this demonstration, by adding more detail, reducing the amount of ground remaining visible, or carrying out more blending. The decision is yours; at this stage the painting remains in a state of flux with many options available to you.

For the purpose of this demonstration, the decision was taken to leave the painting fairly loose, to carry out very little blending and to retain a high proportion of the ground colour. The spontaneous, fairly crude, marks made in the reflections were left well alone as they seemed to introduce a little movement to the painting.

When you feel that you have finished take the usual time for assessment and evaluation.

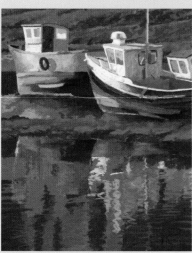

Step 4.

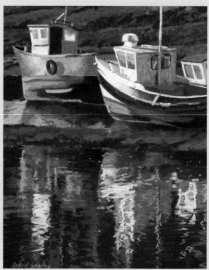

Step 5. *Reflections/River Esk/Whitby*, 45 × 35cm (18 × 14in).

DEMONSTRATION *Reflections/Whitby Harbour*

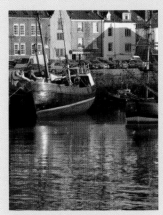

Reference photograph for
Reflections/Whitby Harbour.

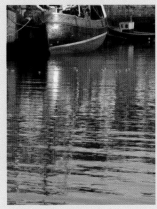

Cropped reference
photograph.

Reflections/Whitby Harbour was painted from sketches and photographic reference. The warm, evening light illuminated the boats and harbour side buildings, creating wonderful reflections in the calm water.

In order to ensure a strong focal point and at the same time emphasize the reflections, the photograph was cropped. This cropping eliminated some of the distracting detail evident in the buildings above the harbour wall.

Step 1: Drawing out

Draw out the composition using the light-grey pastel pencil. Only a simple outline is required for this painting. Use the black and blue acrylic ink to indicate where the main darks and intermediate darks are located. You may add water to the ink where necessary, in order to create any lighter tones.

Materials

Board:

Mount board, approximate size 15 × 11.

Pastels

Unison pastels were chosen for this demonstration and the following colours were used: red earths, brown earths, greys, blues and blue/violets. At least three tones of each colour were selected. A light grey pastel pencil by Conte was used for drawing out.

Additional items:

- A bottle of black and blue Rowney acrylic ink
- An old No.10 watercolour brush
- White acrylic primer
- Burnt Umber Art Spectrum Colourfix primer (these primers are available in 259ml pots, in fourteen shades, plus clear, and are the same as used on the Colourfix papers)

Board preparation

To prevent warping, treat both sides of the mount board with one coat of white acrylic primer. When dry, apply two coats of Burnt Umber Colourfix primer. Either side of the mount board can be painted depending on the texture required.

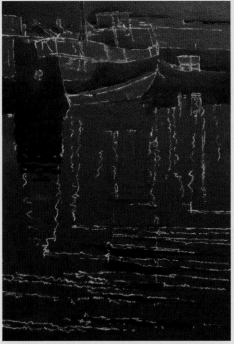

Step 1.

Step 2: Begin the block-in

Begin to paint the boats, harbour walls and their reflections using medium and medium-light tones of blue/violet, grey, red earth and brown earth. Take care not to apply too much pastel to the board in the early stages. A good general rule for the early stages of any pastel painting is to work from dark to light. By adhering to this practice, cleaner, crisper highlights are achieved in the final stages.

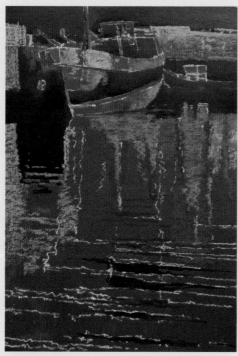

Step 2.

Step 3.

Step 3: Develop the boats and reflections

You will now need to develop the boats and their reflections further. Work in the same manner as Step 2, but with lighter tones of the same colours. Be wary of overdetailing at this stage.

Step 4: Finalize the block-in and complete the painting

Using the same colours and tones, complete the block-in by working over the entire board. Continue in a controlled manner and resist adding any details until the final stages. Remember to retain some of the underpainted Burnt Umber ground to ensure unity.

The final step is to place all the highlights and details using the lighter pastels. In order to keep the painting loose and spontaneous, resist the temptation of adding too much detail.

Look carefully at all the edges created. You should have a combination of hard and soft, lost and found edges which are vital to the success of any painting.

Take time for assessment and reflection. After careful consideration make any necessary alterations.

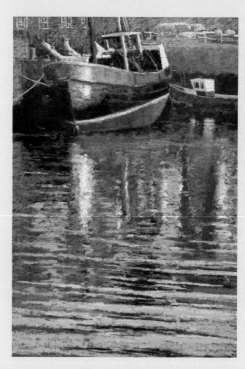

Step 4. *Reflections/Whitby Harbour,* 23 × 35cm (9 × 14in).

IN THE SPOTLIGHT

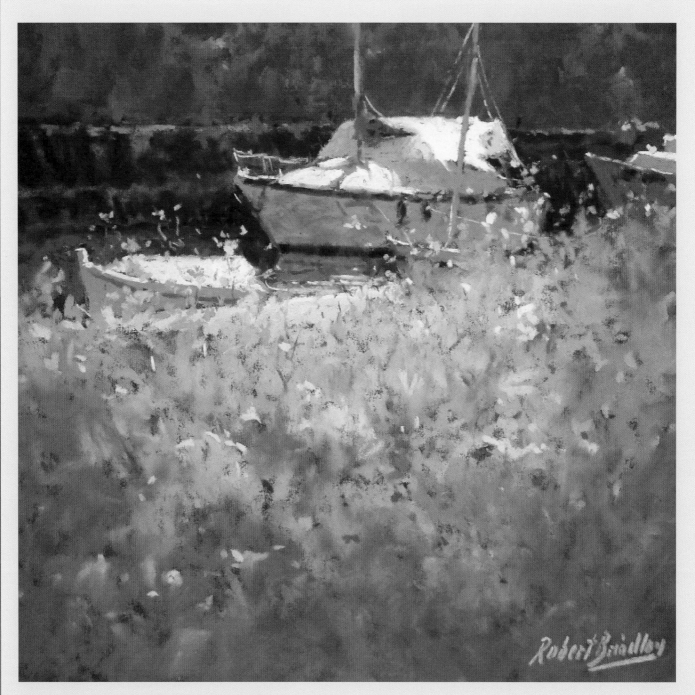

Boats/Corfu Old Town Harbour, 20 × 20cm (8 × 8in).

The painting *Boats/Corfu Old Town Harbour* was painted in the studio from sketches and photographic reference. It was decided to crop the photograph fairly drastically to give the boat more importance and at the same time to create a better balanced painting with regard to composition. (This painting was also referred to in Chapter 2 where counterchange was discussed.)

Evaluation

The honest evaluation of any piece of work, whether done immediately on completion or several years later, is always recommended. On some occasions you will be fairly satisfied with the work and feel that you would not have changed anything at all. On other occasions, you may find that painting fails for a variety of reasons and no adjustments are possible. However, most of the time, only minor faults will be noted which may only require simple adjustments. The evaluation of a painting several months or even years after it was completed is nearly always extremely interesting and rewarding. You may be quite surprised by the number of changes you would like to make if you were to tackle the same subject matter again. The passing of time and looking at the subject with new eyes seems to open up many more options.

The evaluation of this painting led to the following observations.

Composition
The diagonal lead-in, from the bottom left-hand corner is understated and needs strengthening slightly to fulfil its purpose more effectively. This could be achieved by using a wider range of tones to increase the contrast. A feeling of depth and perspective could be increased by using larger pastel marks in the immediate foreground and progressively smaller marks as the foreground recedes.

The small boat moored on the left-hand side of the painting is probably surplus to requirements and competes too much with the main yacht. This would be omitted if the painting was repainted.

Tone
There are not too many errors with regard to tone, only the contrast in the foreground as discussed above.

Photographic reference for *Boats/Corfu Old Town Harbour.*

Mark-making
Once again, the marks made in the top section of the painting work fairly well and the only changes made would be to the foreground area, also discussed above.

Comments

Never feel downhearted after any evaluation. After all it was carried out as a learning experience, and by using constructively all the points that came to light you can't fail to improve as an artist. Be open minded with regard to your own work, and real progress will be made. Remember, there is no such thing as a perfect painting. All good painters, past and present, accept this and use this fact as the driving force in their efforts to improve.

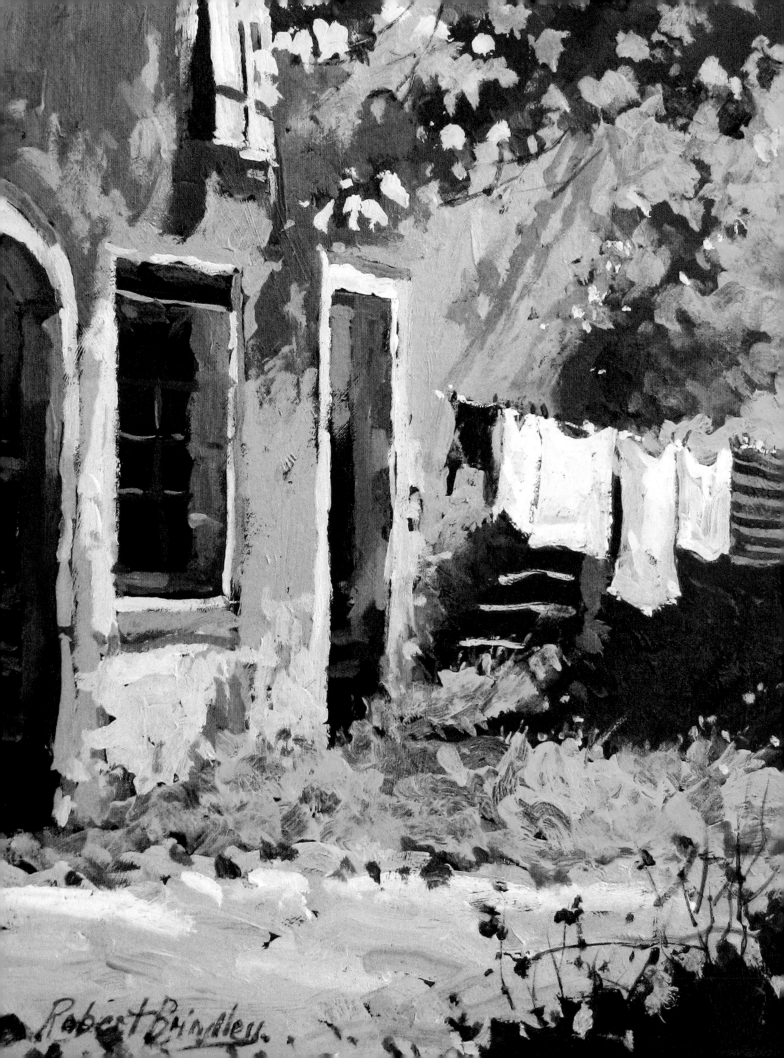

OTHER OUTDOOR SUBJECTS

It is almost impossible to come up with a list covering the vast variety of subject matter that you might wish to paint. However, the following suggested subjects, not covered previously, may give you some ideas for consideration.

Animals/Wildlife

Animal and bird life of all kinds surrounds us all, ranging from everyday domestic pets such as cats and dogs through to farm animals, cows and sheep, and finally to wild animals such as badgers and foxes. In addition to these, you may decide to widen the field even more by painting animals or birds from other countries; lions, tigers, elephants and birds of prey all make wonderful subjects.

There is never too much of a problem in obtaining reference material for pets or local wildlife; however, not everyone gets the opportunity to travel far and wide to gather suitable images from overseas. If this is the case a visit to a zoo or safari park is to be recommended, where a wealth of material can be found. Although the fences and enclosures may be a hindrance, small sketches can be made using a selection of pastel pencils. Take your time with a chosen subject and, if possible, consider various viewpoints. The zoom facility on your camera is a wonderful aid for composing a close-up of your subject matter. Don't be too concerned with the background; if it's not right for you it can be changed slightly, cropped out or ignored completely.

The lion was painted from photographic reference. The original photograph was much larger in size and the background extremely busy. It was therefore decided to crop the image quite drastically. By doing this the completed painting achieved a far greater impact than the source material.

OPPOSITE PAGE:
The WashingLine/Burgundy,
(pastel and gouache),
15 x 20cm (6 x 8in).

The Lion, 35 × 23cm (14 × 9in).

DEMONSTRATION *Ben's Bee*

Reference photograph for *Ben's Bee*.

This demonstration illustrates how even the simplest of subjects can be developed into a small painting.

The reference photograph of a bee was taken by a friend and proved to be an ideal subject for a small step-by-step demonstration.

Materials

Board:
Raw Sienna Rembrant pastel board.

Pastels
The following Rowney soft pastels were used: a mid and light-toned red, a mid and light-toned green, a mid and light-toned yellow, two mid-toned purples, a mid and light-toned blue/violet, three tones of grey, burnt umber and burnt sienna. A mid-grey Conte pastel pencil was used for the drawing.

Step 1.

Step 1: Drawing out

Only a simple drawing will be required for this painting. When complete, use a dark grey pastel to begin the background block-in.

Step 2.

Step 2: Continue the background block-in

Continue to develop the background by using a mid and light-toned blue/violet, together with a mid-toned green. Make a variety of marks applied with only a light pressure. This will ensure that sufficient tooth remains for later applications of pastel.

Step 3.

Step 5. *Ben's Bee*, 14 × 14cm (5½ × 5½in).

Step 3: Continue the block-in

Develop the block-in further by working on the bee and flower. For this use a light and mid-toned yellow, burnt umber, burnt sienna and a red orange. Once again pay particular attention not to over-develop the painting at this stage.

Step 5: Complete the painting

Now is the time to consider how much blending you want to carry out. For this demonstration, blending was carried out to the background and the flower. The resultant diffused backdrop ensures that the bee becomes the focal point of the painting without any competition from other elements.

Finally, add all the details and highlights to complete the painting using light greys and the blue/violet.

Step 4.

Applying the final details and highlights.

Step 4: Develop the bee and flowers

Continue to paint the bee and flowers using the two reds, purple/greys, blue/violets, burnt umber and burnt sienna. Avoid overdetailing at this stage.

Racehorses, 48 × 18cm (19 × 7in).

Insects

Butterflies, moths, bees and dragonflies all make interesting and unusual subject matter where colour, texture and design can be explored (see the step-by-step demonstration painting *Ben's Bee*). Pastel, if applied with little pressure, can work extremely well for painting the delicate texture found on the wings of insects.

Visit the Races

Whether you like horse racing or not, a day out at the races can be very productive in many ways. Apart from the horses and jockeys, the race goers and their attire provide wonderful, colourful subject matter, ideal for pastel paintings. Unfortunately, without obtaining permission from the course management, painting a large piece of work may not be possible. However, working in a small sketchbook using a few pastel pencils could be beneficial. Once again, use the camera zoom lens and consider groups of figures from all angles. Close-ups and cropped studies of ladies in splendid hats and dresses, or jockeys in their colourful silks are just a few suggestions.

The painting *Racehorses* illustrates how a photograph taken with a zoom lens has been cropped and simplified to produce a colourful painting of unusual proportions.

Studies: Texture, Form, Colour

There are numerous objects to be found which would make excellent small studies of texture, form or colour. The following suggestions may give you a few ideas that will hopefully encourage you to find your own special subjects.

- A good starting place could be your own garden where you may have an old potting shed with peeling paintwork or wheelbarrows, rusty buckets and tired garden implements, all of which could make interesting subject matter. Pastels applied to a variety of textured boards would be ideal for this type of subject matter.
- Going further afield, but along the same lines, many old farmyards may offer similar subject matter, although on a larger scale.
- Harbours and boatyards often abound with boats in various states of repair, and there is always the usual flotsam and jetsam to be found lying around.
- A final suggestion is to seek out weathered architectural features which are easily found in many old towns and cities throughout the world. The painting *Venetian Texture* is a good example of this type of subject matter.

IN THE SPOTLIGHT

Photographic reference for *Venetian Texture*.

The painting *Venetian Texture* was painted from photographic reference in response to the texture and colour which seemed to capture the essence of Venice.

The textural effect was reproduced by working on a piece of MDF board, heavily overlaid by texture paste applied with a 25mm hog brush. In places the texture paste was applied to a depth of 2–3mm and drawn into using the end of a brush handle to produce the necessary relief around the panels and figures. This drawing work, together with further texturing using a fairly coarse sponge, was executed rapidly before the texture paste dried. When perfectly dry the board was primed using two coats of Daler-Rowney acrylic white primer. At this stage the subject was underpainted using acrylic paints to produce a basic foundation upon which to work.

The close-up shows the variety of texture achieved in the painting. The pastel was fixed at regular intervals to ensure adequate adhesion.

Evaluation

This painting is a fairly recent experimental piece of work. One of the problems encountered was the loss of tooth; the acrylic painted surface would not hold successive layers of pastel. In order to achieve the desired textural effects the board was laid flat. Pastel was applied by using the stick in the normal way and by repeatedly sprinkling coarse grains or dust into certain areas where a build-up of texture and colour was required. Layers of pastel were applied; each layer being fixed using an aerosol fixative. This method of applying pastel, although experimental, produced a fairly satisfactory result.

On reflection, further experimentation would be needed regarding the use of pastel on heavily textured surfaces.

The tone, colour and the variety of edges achieved proved to be satisfactory.

Venetian Texture, 25 × 30cm (10 × 12in).

Close-up *Venetian Texture*.

INTERIORS AND STILL LIFE

Colin's Window was painted from photographs taken when visiting a friend. The collection of well-arranged objects demonstrates how by being observant you may be able to source excellent, readymade still life subjects.

What we see depends mainly on what we look for.

John Lubbock

Interiors

The painting *Boat Building Shed/Whitby* is an ideal subject for anyone wanting to paint an interior. The subject offers a combination of interesting shapes and objects, texture and colour. In addition to this the lighting creates a wonderful atmosphere and a wide variety of tone. When using pastels to paint an interior such as this, you should bear in mind the degree of detail present that could pose problems if only a small painting is envisioned. A large board may seem daunting; however, by painting to a larger scale the edges and points on the pastel sticks need not be so fine. You will also find that because the marks can be made with more freedom, the less fussy the final painting will be.

Painting interiors could be likened to an intimate indoor landscape. One of the many advantages associated with painting interiors is that you will have complete control over the subject matter, being able to decide exactly what to include in your painting. You may decide to include a figure or two, either working or relaxing. On the other hand the interior itself may have all the qualities that you are looking for without including any human interest.

The type of interior you paint is a very personal choice. You may prefer the domestic situation and decide to paint the surroundings that you are familiar with around your home. Whichever subject you choose, the nature of pastels, being a relatively fast medium to use with such a wide choice of immediate colour and tone available, make them an ideal medium for painting interiors.

What to Paint?

The following suggestions are just a few of the numerous possibilities out there for the more adventurous:
- *Old barns, boatsheds and other agricultural/industrial buildings*: Look for those offering a good quality of light, mood and atmosphere, together with an artistic clutter of associated items which will provide interest for future viewers.

OPPOSITE PAGE:
Colin's Window,
20 × 25cm (8 × 10in).

RIGHT:
Boat Building Shed/Whitby,
36 × 30cm (14 × 12in).

- *Public houses, cafes, shops, museums and art galleries*: These subjects will almost always include figures, so be selective and imaginative with the figurative content and composition. For instance, the people that you may decide to use in cafes and bars should relate to and engage with each other to create a convincing atmosphere. However it is quite possible for you to observe one solitary figure, studying a painting or display in an art gallery or museum for example.
- *Country houses, National Trust and English Heritage properties*: These interiors make wonderful paintings as they offer the artist such diversity. There is often a special quality of light to be found in properties such as this: dramatic rays of sunlight cast across rooms from huge windows; dark corners and recesses filled with colour, texture and reflected light. Add to this the sheer scale and grandeur of the rooms, together with their contents, and you can't go far wrong. The only problem that you may have is in obtaining permission either to work on-site or to take photographs. This at times can be difficult; however you will find that some properties are very helpful in this respect.
- *Railway stations, airports and other bustling public places*: Railway stations and platforms, especially the larger ones to be found in any major city, make wonderful subjects. They always abound with human activity, and often the quality of light is magical. In some of the older railway stations you will find that architectural features will provide added interest to your paintings. If you are in any doubt about setting up your easel and painting on-site in any of these locations, you should always get permission. Otherwise, consider tucking yourself away in a corner and work on sketches using pastel pencils. The sketches can then be developed, together with any photographic reference, back in the studio.

Qualities to Look For

When evaluating the merits of any interior you should look for the qualities that will engage the viewer, such as:
- The quality of light and atmosphere.
- The interior/space itself must contain the essential elements for you to create a workable composition. You will need to create a convincing lead-in and focal point. The presence of a workable mixture of vertical, horizontal and diagonal features will be necessary to provide you with compositional flexibility.
- The furniture, objects and figures to be included should be interesting and well positioned.

Invariably an interior may need slight adjustments made with regard to composition and lighting. In these situations you will need to use your imagination and in some instances a little artist's licence to re arrange things or to adjust the light source.

Still Life

Although the selection of subject matter is very much a personal choice, it seems strange that painting the still life has, over the years, been overlooked by many artists.

The still life has always been used by tutors and art colleges for teaching the basics, such as composition and drawing. However, it seems that after this learning stage only a relatively small number of artists continue to work on them. This is surprising as there must be thousands of artists working indoors, desperately searching for good subject matter without realizing that within every household wonderful subjects abound.

There are many practical advantages to painting the still life. With a little imagination they are relatively easy to set up, the timescale is not relevant as the light and weather conditions are obviously not a consideration. In fact you are in complete control of every aspect of the painting process.

You become so familiar with your home and everyday surroundings that it may take time to evaluate all the possibilities around you; however, even the most insignificant of household objects, when used imaginatively, can make wonderful subjects.

Objects and Composition

The following advice may assist you when setting up your own still life arrangement.
- Because a still life is composed of a collection of static objects, your challenge will be to compose an arrangement which is well balanced, full of implied movement and an interesting variety of shapes, colour and texture.
- You should therefore give careful consideration not only to the objects selected but also to their relationship to one another, with special regard to shape, colour and placement.
- Select a range of objects that give a variety of shape and height. This will provide you with the opportunity to position the objects overlapping one another, maybe using the tallest object at the back, placed on or around the golden third to provide compositional balance (see the painting *Colin's Window*).
- Try to use the edge of a draped cloth, or a linear shaped object laid on the surface, as a directional device to lead the eye into the painting. The positioning of the objects themselves can be arranged to take the eye into the painting.
- Try to be imaginative with your lighting and composition.
- Use different viewpoints, a variety of backdrops, some simple and others coloured, texture or patterned to complement your arrangement.

DEMONSTRATION *Venetian Mask*

This demonstration illustrates how a single object placed against a simple, black background can be developed into a small still life painting.

Materials

Support:

Black Hermes fine sandpaper, mounted on stiff card; excellent paper for bold, expressive mark-making.

Pastels

The following Unison soft pastels were used: reds, red earths, browns, brown earths, yellows, blue/violets and greys. A light Burnt Umber Conte pastel pencil was used for the drawing.

Step 1: Drawing out

Draw in a simple outline using the Conte pastel pencil.

Step 2.

Step 3: Continue the block-in and complete the painting

Complete the block-in and add the final highlights and details. Be careful not to add any of the highlights until the latter stages. Carry out a small amount of blending where you decide soft transitions are required. Soften any edges that you feel hold too much importance.

Step 1.

Step 2: Begin the block-in

Begin the block-in using a variety of marks applied with only a light pressure. This will ensure that sufficient tooth remains for later applications of pastel. Use a dark grey pastel for the background together with mid-toned red and brown earths for the mask.

Step 3. *Venetian Mask*, 25 × 30cm (10 × 12in).

Pastels can be a quite difficult medium to work with if you are painting a complex compositional arrangement, full of interesting, overlapping objects. Consequently, for anyone who may be fairly inexperienced, try to select a simple, maybe single, object to begin with; an apple, banana or a favourite ornament, placed against a plain, black background may be advisable. As your confidence grows, select two or three objects, placed in a simple compositional arrangement.

Remember, if you are struggling to come up with a satisfactory arrangement, return to the basic compositional devices discussed in Chapter 2; after all the still life is only a miniature, indoor landscape.

Flowers

Flower painting, when undertaken as a still life subject, often requires a little more consideration than the more general subject matter discussed previously.

Although you may have been able to arrange a satisfactory composition of found objects, it is a little more difficult to compose a successful arrangement of flowers. If you find this aspect difficult, work from a simple bunch of flowers, or even a single bloom. Try to arrange the flowers so that they fall naturally, carrying out small adjustments to achieve different head heights and angles.

Before finally settling on an arrangement make a series of small pastel or pastel pencil sketches of the subject. Use loosely applied marks made by the sides of the pastel, bearing in mind the usual criteria necessary for creating a successful composition: a sound focal point, lead-in, and a pleasing pattern of colour, shapes and tonal masses. To achieve this you will have to use a little artist's licence and imagination.

If you still have no success, look for an arrangement that someone else has put together (see the step-by-step demonstration *Flowers/Venetian Hotel Reception*).

Your first impressions are always important, especially so when painting flowers. It may have been a combination of pure, bright colours and shapes that attracted you to the subject; if so, pastels are the ideal medium for capturing these qualities, having a wide range of immediately useable colours available.

Flowers are ideal for those artists interested in producing a more abstract interpretation of the chosen subject. By squinting the eyes, concentrating purely on colour, shape and tone, a simple abstract design can often be created.

DEMONSTRATION
Flowers/Venetian Hotel Reception

Materials

Support:
Black Hermes fine sandpaper, mounted on stiff card; excellent paper for bold, expressive mark-making.

Pastels
The following Unison soft pastels were used: reds, red earths, browns, brown earths, yellows and greys. Light burnt umber and mid-red Conte pastel pencils were used for the drawing.

Additional items
• A bottle of black Rowney acrylic ink.
• An old No.10 watercolour brush.

Board preparation
In order to produce a far richer, darker black to work on, the board was painted with one coat of undiluted black Rowney acrylic ink.

This demonstration illustrates how a single object placed against a black background can be developed into a striking still life painting. Only two types of simple mark were used to make this painting: small, flat strokes made with the side of the pastel (for the petals) and linear, drawn strokes made with a sharp edge (for the stems, details and highlights). The original reference photograph was digitally edited to remove the distracting shapes in the background.

Original photograph for *Flowers/Venetian Hotel Reception*.

Digitally edited photograph for *Flowers/Venetian Hotel Reception*.

Step 1.

Step 1: Drawing out

Draw in a simple outline using the Conte pastel pencils.

Step 2.

Step 2: Begin the block-in

Begin to block in the flowers using a variety of simple marks (see close-up).

Dark tones of red earth and brown earth were used to hint at the vase. Apply only a small amount of the pastel in this area.

Close-up showing simple marks.

Step 3: Continue the block-in and complete the painting

Complete the block-in and add the final highlights and details. Be careful not to add any of the highlights until the latter stages. Carry out a small amount of blending where you decide soft transitions are required. Soften any edges that you feel hold too much importance.

Step 3. *Flowers/Venetian Hotel Reception*,
25 × 33cm (10 × 13in).

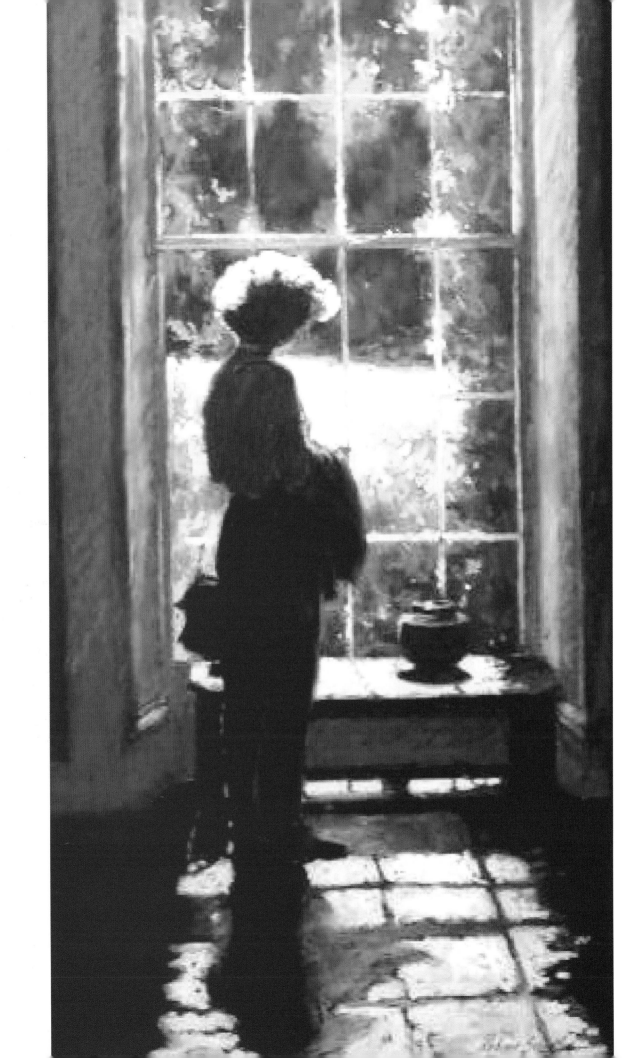

THE FIGURE

Linda at Castlegate Gallery was inspired by the light pouring through the gallery window, reducing the figure into a simple silhouette. Photographic reference was used to paint this studio piece. The painting was carried out on black Hermes sandpaper using a relatively warm palette of colours. The dark and mid tones were applied very lightly, only just colouring the paper. The lights were painted using confident, firmly applied pastel strokes.

The human figure can be used in many ways, either as the primary subject or in a more supporting role in order to introduce life and interest to your paintings.

Working from a Model

There can be no better way of improving your drawing skills and powers of observation than regular painting directly from a model. Most art societies or painting groups at some time or another offer their members the opportunity to draw or paint from a live model.

It is usual to commence with several speed studies of between five and twenty minutes, which help to sharpen your observational skills and get you into the flow. Pastels are ideally suited for rapid sketches/studies as they are quick to use, can be used for drawing or shading and they come in a wide range of ready-to-use colours and tones. Even though you may not feel comfortable about structured studies such as this, by making the effort you will inevitably be rewarded for your endeavours.

Painting from the model on a regular basis will help to keep your eye and hand well trained. In addition, many other facets of your work will be developed such as: sighting (the ability to see widths and heights accurately), sensitivity to how edges are handled, and the assessment of value and tonal relationships. Be aware of these factors whenever you are drawing or painting.

OPPOSITE PAGE:
Linda at Castlegate Gallery, 30 × 50cm (12 × 20in).

Consider carefully the positioning of the model, the lighting and the importance of colour choices; all are essential and determine the strength and aesthetics of the finished painting. The model can be clothed or unclothed and positioned in many ways, either formal or informal. Paint the model in as many positions as possible – standing, sitting, reclining or lying down; there is much to be learnt from every pose.

No matter what pose is struck, how the model is lit can make

If you want to learn to draw, work from the human form; for colour, go to the landscape.

Anonymous

an enormous difference to the outcome of the painting. The light can be soft or harsh, warm or cool, direct or indirect. All of these lighting conditions will create paintings of a variety of moods and impact.

The above quotation can be qualified by the fact that no one notices if a tree is drawn a little wider or a mountain a little taller. However, the slightest mistake when drawing the human form is immediately noticed by everyone.

The distances involved in painting the human form or portrait are relatively small. To deal successfully with this aspect you will have to manipulate drawing, colour and value more imaginatively to achieve depth in your paintings.

Using Figures as the Primary Subject

The painting *Farmers/Egton Show* uses two figures as the primary subject. The use of figures creates interest in any painting. A figure or group of figures may be engaged in the workplace, at leisure or walking along the beach; the choice is endless.

DEMONSTRATION *Deep in Conversation/Egton Show*

Photographic reference for *Deep in Conversation/Egton Show.*

This painting illustrates a group of figures observed at a local agricultural show. The deep red trailer was immediately attractive and provides an interesting, colourful backdrop to the figures. The painting was developed from on site pencil sketches and photographic reference.

Materials

Board:
Terracotta Art Spectrum Colourfix textured board

Pastels
The following Unison colours were selected using at least three tones of each: reds, red earths, greens, green earths, blue/greens, brown earths, greys and blues. A light grey pastel pencil by Conte was used for drawing out. Should you decide to follow this demonstration, try selecting your own coloured ground and a slightly different range of colours. A variety of results can be achieved by ringing the changes, some successful and others which may fall short of your expectations. .

Step 1.

Step 2.

Step 1: Drawing out
Draw out the composition using a pencil or pastel pencil, whichever you prefer. On this occasion a fairly detailed drawing will be required, especially for the two figures.

Step 2: Begin the block-in
Begin to paint the figures and the horsebox using mid-toned grey and green earth pastels. Apply these first applications of colour lightly, ensuring that sufficient tooth is retained for subsequent layering of colour.

Step 3: Continue painting the figures and trailer
Continue to paint the figures using the following colours: mid and light-toned brown earth, light and dark grey, dark green earth and light and mid blue. Use a red and red earth for the trailer. Pay particular attention not to over-develop any one section of the painting at this stage. A far more controlled, balanced painting will be produced by bringing all the elements together in a controlled manner.

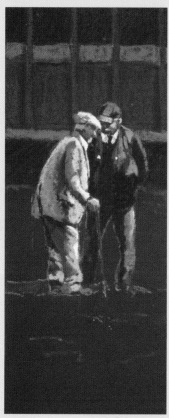

Squint your eyes to evaluate and simplify the tonal changes present. By doing this you will be able to reproduce the folds in their clothes and at the same time produce a convincing rendering of the three-dimensional qualities of the figures.

Step 4: Complete the painting

Paint the grass by using a selection of greens, green earths, blue/greens and brown earths. Use a variety of pastel marks to reproduce the textural quality of the grass (see close-up showing textural marks). Remember to leave enough of the Terracotta ground showing through. This will ensure harmony throughout the painting.

Step 3.

Close-up showing textural marks.

Finally, add all the final details and highlights to complete the painting. Before you undertake any framing, take time out for the usual careful evaluation of your painting.

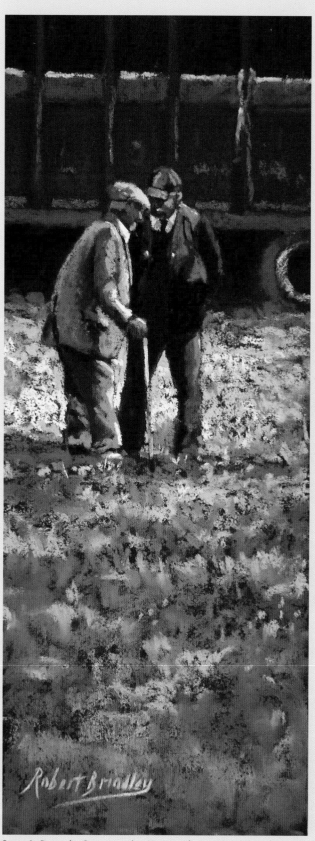

Step 4. *Deep in Conversation/Egton Show*, 12 × 30cm (5 × 12in).

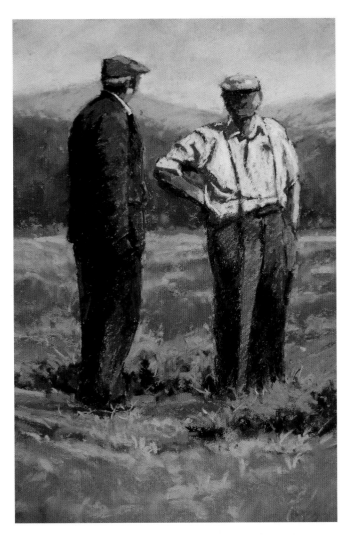

Farmers/Egton Show, 19 × 30cm (7½ × 12in).

The Gondoliers, 25 × 30cm (10 × 12in).

You will soon become aware of the importance of accurate observation with regard to capturing movement. As stated earlier, the process of making frequent, rapid sketches is invaluable, not only for reference but also a means of capturing movement, rhythm and realism in your figures.

The direction of the marks used is also an extremely important factor when trying to create movement and rhythm. For instance, for a rapidly moving figure, loosely rendered strokes in the same direction of the movement should be incorporated. For a figure walking in the surf on the water's edge, directional strokes similar to the ones used in the water itself could be used.

Although a single figure may work better on some occasions, well-composed groups of figures more often than not make a more interesting and engaging subject. The successful portrayal of the relationship of one figure to the next, with regard to size, proximity and composition, will ensure that the viewer will be engaged in the story-telling element of the painting.

On some occasions you will come across an interesting group of figures where cropping and the simplification of the background could be used to both strengthen the composition and increase the impact or drama of the final painting.

The painting *The Gondoliers* illustrates how the process of cropping and the simplification of the background has been used effectively to produce a simple image with strong focus and impact.

Portraits

The painting *The Violinist* was painted from a very blurred photograph taken from some distance in very poor light at a concert many years ago. However, having to work from substandard reference material proved to be a blessing in disguise, as the painting convincingly captured the movement and feel of this subject.

You may decide to try working from less than perfect images yourself. This apparent handicap, in actual fact, may force you interpret the image based on recollection, and in conjunction with a certain degree of flying by the seat of your pants you may occasionally produce a piece of work that has something extra special.

Painting from photographs is sometimes referred to as cheating. However, many people these days don't have the time to sit for their portrait to be painted. In situations such as this, providing that the reference material is of suitable quality and you are confident with your ability to draw and use paint and colour imaginatively, working from photographs is perfectly acceptable. With good reference material, bearing in mind that you will not have to translate from three dimensions to two, the painting process can be far easier.

RIGHT:
The Violinist,
55 × 50cm (22 × 20in).

Wherever possible, though, you should try to work from life. Although the process is far more difficult, you may find that the final painting somehow has more life and captures the sitter's character and personality more successfully.

Portrait painting has been described by many as the highest form of art. For the fortunate few this special ability comes almost naturally. For others, many hours of study and practice will be needed to develop any ability in this, the most demanding of subjects. There is surely nothing more satisfying than achieving a likeness and, more importantly, capturing the character and personality of the sitter.

The portrait of a baby or child undoubtedly holds the biggest challenge to a portrait painter of little experience; the subtlety of colour and tone and the many soft transitions demand accurate observation and skills that only come with much practice. An example of a child portrait, *Holly* is shown as a step-by-step demonstration later in this chapter.

To begin with you may consider working on studies of older people with faces full of character. The demonstration painting *Jimmy* illustrates this point well. An aged, weather-beaten, heavily lined face assists the artist in capturing the sitter's character and at the same time often conjures up imaginative tales for the viewer. Glasses and beards can also quite often be of assistance in disguising, or in the case of glasses, diffusing part of the face.

Making a Start

Underpainting was discussed in some depth earlier in this book, dealing with its merits for building a sound framework upon which to base your painting. Although, more often than not, underpainting is used in landscape painting, it can be used to far greater effect when painting the portrait, not only to unify the painting in terms of colour but also to establish form, masses and tone at an early stage.

Before you begin to paint a portrait you may find the following considerations of use.

The Composition

For portrait work, the composition is all-important. Consideration should be given to the comfort of the sitter, as this is an essential ingredient to achieving a natural and relaxed pose where a rapport can be developed.

When this pose has been decided, you will need to give consideration to the lighting of the subject which often determines how the viewer will respond to the completed work. Strong side-lighting for instance will result in a dramatic portrait, often far easier to paint, especially if used for an older face, full of character. Softer lighting may be more suitable for a younger person, to emphasize the delicacy of skin tone.

Bear in mind that most indoor environments have too many light sources. Windows and a variety of lights combine to create multiple and often confusing highlights and shadows, making it almost impossible to render form convincingly. A single, strong light can be the most successful and can be achieved artificially, using a spotlight, or naturally by blocking off all but one of the sources of light. North light is the best and most constant of natural light sources.

DEMONSTRATION *Jimmy*

Cropped photographic reference for *Jimmy*.

Jimmy, the brother of a good friend, was painted to illustrate how a well-composed, cropped photograph of an older person's face can be used to produce a painting full of character.

Materials

Board:
Elephant Art Spectrum Colourfix textured board

Pastels
A minimum of three tones of the following colours by Unison, Rembrandt and Rowney were selected: red, red earth, brown, brown earth, orange, yellow, blue, blue/green, green and grey. A mid-toned grey pastel pencil by Conte was used for drawing out.

Step 1.

Step 1: Drawing out
Draw a simple outline using a pencil or pastel pencil.

Step 2.

Step 2: Begin the block-in
Begin the block-in using lightly applied pastel strokes to the shadow masses. To establish a benchmark for the flesh colour and

Step 3. Step 4. Step 5.

tonal sequence, you may decide to select a mid-toned orange. Select a number of mid-toned reds, blues and brown earths for the head scarf and denim jacket.

Step 3: Continue the block-in
Continue as Step 2, using the above colours plus a darker orange and a dark brown earth.

Step 4: Develop the head
Develop the head and shirt by introducing two lighter tones of orange and yellow. Select a mid and a dark-toned grey for the background. Should you wish, you can now carry out a limited amount of blending using either your finger, a paper blending stump (tortillon), an old hog oil painting brush or plasticized colour blender (a softer effect will be achieved by either the finger or a plasticized blender).

Step 5: Develop the headscarf and clothing
Develop the headscarf and clothing using the full range of colours with the exception of the very lightest tones, which should be reserved for the final stage.

Step 6: Complete the painting
Complete the block-in before placing all the final details and highlights. Reserve the sharpest edges and the greatest contrast for the light-struck areas of the face.

Carry out any final blending, making sure that there are no distracting edges, contrasts or over-use of colour, away from the focal point.

View your painting through a mirror. This will reveal any smaller errors in the drawing, tonal sequence or use of colour.

Step 6. *Jimmy*, 25 × 35cm (10 × 14in).

DEMONSTRATION *Holly*

Original photographic reference for *Holly*.

Digitally altered photographic reference for *Holly*.

This demonstration of my granddaughter, Holly, illustrates how photographic reference can be used to produce a soft focus painting. The original photograph was digitally manipulated to simplify the background.

Materials

Board:
Black Hermes fine sandpaper, mounted on stiff board.

Pastels
A minimum of three tones of the following colours by Unison, Rembrandt and Rowney were selected: red, red earth, brown, brown earth, orange and yellow. A mid-toned pink pastel pencil by Conte was used for drawing out.

Step 1.

Step 1: Drawing out

Draw a simple outline using a pencil or pastel pencil, whichever you prefer.

At this stage a light spray of fixative can be used if required. This will stabilize your drawing whilst working on the first applications of pastel.

Step 2.

Step 2: Begin the block-in

Begin the block–in by using pastel strokes lightly applied to the background and to the darker tonal masses of the hair.

To establish a benchmark for the flesh colour and tonal sequence, you may decide to place a mid-toned orange alongside the dark-toned pastel used for the hair.

Select your colours from the following: two dark tones of red earth for the hair, a mid-toned red earth and a mid-toned yellow for the background, and finally a mid-toned orange for the flesh.

Step 3.

Step 3: Continue the block-in

This step is a continuation of Step 2, using exactly the same selection of colours. Take care not to apply too much pastel to the board at this time.

Step 4.

Step 4: Blending

Carry out a limited amount of blending using either your finger, a paper blending stump (tortillon), an old hog oil painting brush or plasticized colour blender (softer effect will be achieved by either the finger or a plasticized blender).

Step 5.

Step 5: Develop the face

This is probably the most important step. It is imperative to select a range of suitable flesh colours to achieve an accurate tonal sequence, together with not only a convincing likeness but also a feeling of the sitter's character and personality. For this step select mid and light toned colours from the reds, oranges and yellows. Pay particular attention to the highlights, which should be placed towards the end of the painting, using an extremely light , warm red or yellow.

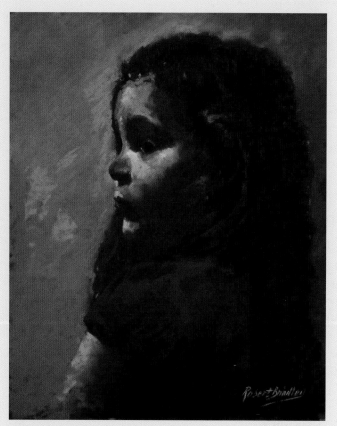

Step 6. *Holly*, 25 × 30cm (10 × 12in).

Step 6: Complete the painting and take time for evaluation

Complete the painting using combinations of all the previously applied colours.

After you have completed the block-in, and before you apply the final touches, spend a little time deciding whether you need to use further blending. Remember, never over-blend around the focal point as you will risk losing the impact. Generally speaking, look for hard edges that are too insistent, that may draw the viewer's attention away from the focal point. In this demonstration the extremities of the hair, dress and arm have been softened.

When you are satisfied, place all the final touches to the hair and the highlights on the face.

Take the usual time for evaluation and reflection. For portraits, pay further attention to all edges. A combination of lost and found edges should be apparent. It may sometimes be easier to evaluate your painting by viewing it through a mirror. By laterally inverting the image, any problems should be immediately apparent.

The Background

The background is an extremely important element. It can be used in several different ways, playing a greater part in the overall design and content of the painting by relating directly to the sitter's home environment/interests, or a lesser role where it acts merely as a support to the portrait itself.

Whatever background is chosen, it should always play a secondary role and must never dominate. Pay particular attention to colour tone and edges, which should be played down.

Shadow Shapes and Patterns

Learn to look carefully at the shapes and patterns created by the shadows. The accurate placement of these shapes is vital to the success of the painting and second only in importance to posing the subject correctly in order to tell your story. As an artist you deal with painting the illusion of light and shadow. By identifying and reproducing the shadows that are interesting and at the same time descriptive of form, you will be more assured of the success of the finished work.

The Drawing

A sound drawing is vital for many artists as it forms the skeleton around which colour, tone and texture can be developed. Some artists prefer to keep drawing to an absolute minimum, or in some instances not to draw at all. This depends largely on the individual and their ability to paint without the framework that a drawing provides. Should you be in any doubt about your ability to work this way, always draw first.

It may help you to begin with the rough shape and size of the head, drawing a horizontal line halfway down it. This line will enable you to position the eyes with a fair degree of accuracy, as they are positioned approximately halfway between the top of the head and the bottom of the chin. Many people think the eyes are positioned much higher than that, but careful observation reveals that they are not. The gap between the eyes is critical; however, as a general starting point, there is usually room for a third eye between a person's real eyes.

The positioning and length of the nose always seems to present problems. The actual features of the nose (the nostrils or shadows underneath) are so far from the eyes that you may be tempted to guess where to place them. Never do this; always find and relate other features and value changes in between, measure them correctly and place them correctly.

As you draw, look back and forth from the painting to the face. Hold the pencil up to take a measurement and to get an accurate proportion.

Every few seconds you should squint; by doing so you will be able to reduce what you are seeing to one level of light and one level of dark. It will help you identify the bigger shapes more successfully. Through squinting, anything that is remotely in shadow becomes completely dark, a general shape, which helps to reduce a face to its basic elements.

Don't be concerned with a high degree of detail at this early stage. You should concentrate on plotting the position of all the features as accurately as possible, even if you only use small marks, dots and dashes, where these features lie. Think of the drawing or painting as merely putting down something to start with, to be corrected progressively, gaining more accuracy throughout the completion of the painting.

The Importance of Edges

During the painting process pay constant attention to the edges created. An edge is found wherever one value meets another value.

There are four kinds of edge regularly found in most paintings: hard, firm, soft, and lost.

- A hard edge is where one value butts against another, like a dark jacket against a white shirt. A sharper, more defined edge can be made by painting the darker element thinly and the adjacent, lighter area with a much firmer application of the pastel, creating an impasto effect similar to oil painting.
- A firm edge is a highlight or shadow that is easy to see, like value changes around the bony areas around the bridge of the nose or cheekbones; this edge appears to be fairly abrupt but has a little softness.
- Soft edges could be described as localized transitions, like those found across a forehead or down a round cheek.
- Lost edges must be used where, no matter how long you look at them, you can't tell exactly where the edge is. Lost edges are the magic ingredient, vital for creating added interest and engaging the viewer to use their own imagination.

Flesh Tones and Colour

Flesh tones have always proved to be a major stumbling block for most beginners. Remember that skin comes in a variety of colours and textures, so there is no specific formula for mixing flesh tones in portrait painting. You will have to experiment and practise until you find the right colour mixtures for any particular subject. Resist the temptation to purchase any pre-mixed flesh

colour, as they tend to be lifeless and bland. When mixing your colours be careful not to over-mix, which can deaden a colour.

Try to introduce the colours and values used in some areas of your painting into other areas, even if they are not there in reality. This practice will add to the harmony and balance of your finished work.

When painting hair, don't try to paint every individual strand. Remember to squint when looking at the hair; consider it to be one object and then paint the lights and darks. More convincing results are achieved by painting the hair in the direction it lies on the head.

Another helpful tip is to compare the colour temperature of the flesh in the space between the nose and mouth. The flesh in this area is generally slightly cooler than in other areas.

Add touches of colour where the shadow meets the light in your portraits.

Fleshier parts of the face are generally warmer in colour, and bonier parts of the face, the chin for instance, are generally cooler in colour.

The white of the eye is not white. To accurately assess the colour for the white in the eye, you can take the subject's basic flesh colour and then lighten it slightly by using a light grey.

Even though you may have a passion for painting the landscape, an occasional venture into portrait painting can be a very useful exercise with respect to your sensitivity as an artist and at the same time offers the opportunity to hone drawing skills and your powers of observation. As a painter, you can only benefit from the experience.

IN THE SPOTLIGHT

The painting *Outside the Restaurant Giglio/Venice* was painted from photographic reference after a Venetian holiday some years ago. The couple were smoking, and it seemed very natural and acceptable at the time to show this in the painting. The painting took some time to find a buyer, and eventually the cigarettes were painted out. Amazingly it sold almost immediately. It could just have been a coincidence, however, often the slightest thing can prevent the sale of a painting!

Evaluation

This painting is a very early work, painted with little knowledge of pastel and its techniques. It was painted with an extremely limited choice of colours, and consequently the darks in the background lack variety in tone and colour.

Composition
At the time it was decided to crop the centre section out of a much larger photograph to create a balanced composition with the girl sitting on the well-head forming the main vertical, positioned around the golden section. If this subject was to be painted again, no compositional changes would be made.

Tone
The distribution and balance of tone appears to work well.

RIGHT:
Outside the Restaurant Giglio/Venice,
25 × 38cm (10 × 15in).

OBSERVATIONS AND CONCLUSIONS

Painting Abstracts

The genre of abstract art is broad and contains many art forms. Essentially, any art that doesn't try to realistically portray something, and instead uses texture, colours, shapes or space to represent that thing, is considered abstract. This departure from accurate representation can be either slight, partial or complete.

In theory, even art that aims for the highest degree of accuracy can be said to be abstract since perfect representation is almost impossible to achieve.

Artwork which makes noticeable alterations to colour and form can be said to be partially abstract. Total abstraction however, bears no resemblance to anything recognizable.

The abstract artists that I admire were grounded in drawing, composition and design and it shows in their work.

Jennifer Bellinger

Completing Unfinished Work

There are numerous reasons why you may not have completed a particular painting. It may have been that changing light interrupted a *plein air* piece, or purely that the inspiration was lost. In some instances a break just before completion can prove to be fortuitous, taking you away from the temptation to overwork the painting without due consideration. However, for the paintings that require considerably more work to bring them to completion, it may prove far more difficult to regain your initial enthusiasm.

The following suggestions may be of use to you when considering whether or not to resume work.

OPPOSITE PAGE:
Evening/Tall Ships/Whitby, 28 x 40cm (11 x 16in).

Remember Your Initial Inspiration

Ask yourself a few simple questions. Why did you start the painting in the first place and how did you visualize the finished piece of work? What inspired you at the time? Does the uncompleted painting still inspire you and does it in any way meet your initial expectations? If not, why not? The answers to simple questions like these often pinpoint the reason why you abandoned the painting in the first place. If you find that you have deviated from your original concept in any way, this could be why you have lost direction. It is essential to stay on track throughout the execution of any piece of work. By doing so, you know when you are approaching a finish. If the direction is lost, there is no finishing post in sight and inspiration may be lost.

Recall Your Mood

Try to recall your mood at the time you started the painting, as this always has a great bearing on both the work selected and the results obtained. We all have ups and downs, and it could have been that you were feeling enthusiastic and full of the joys of spring when you first started the work and you may now be in a more subdued frame of mind. If this is the case, return to the painting when you are in a similar mood.

Revisit the Subject Matter

It may be helpful to revisit the subject matter of the painting. If the location is nearby, go and spend some more time there. It's always better if the conditions are similar; however this is not essential. Should you be using photographic reference it may be beneficial to look at other images taken at the same time. This will assist you in re-living the day.

DEMONSTRATION *The Grand Canal*

Reference photograph for *The Grand Canal*.

Digitally edited photograph for *The Grand Canal*.

Materials

Board:
Elephant Art Spectrum Colourfix textured board

Pastels
The following Unison soft pastels were used: a mid and light-toned orange, a light-toned yellow, two mid-toned blue/violets and a red for the outline and drawing.

This short demonstration painting of *The Grand Canal* could be interpreted as abstract by the fact that it makes noticeable changes with regard to colour and form. It illustrates how a detailed, fairly complicated subject can be simplified by using digital software and a limited tonal range of basic complementary colours to produce quite a large, visually exciting painting. The reference photograph was digitally edited to produce a simple tonal image. A complementary palette of blues, oranges and yellows was decided upon.

The reference photograph was taken from the Academia bridge in Venice. The photograph was digitally edited to simplify detail and tone.

Step 1: Drawing out

Draw out a simple outline using the red pastel.

Step 1.

Step 2: Start the block-in

Start the block-in using the two blues and two oranges. Apply the pastel with broad, flat strokes, being careful not to place too much colour on the board at this time.

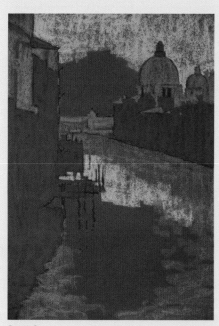

Step 2.

Step 3: Continue the block-in and complete the painting

Develop the block-in using the above colours plus the light-toned yellow in the bottom of the sky.

You can now carefully hatch one colour over the other until you feel that you have produced the required texture. Should you decide to blend any of the colours, be aware that you could lose some of the texture and energy in the painting. As usual it comes down to personal taste.

Finally, if you decide it is necessary, restate the outline using the red pastel.

Take the time for evaluation and reflection.

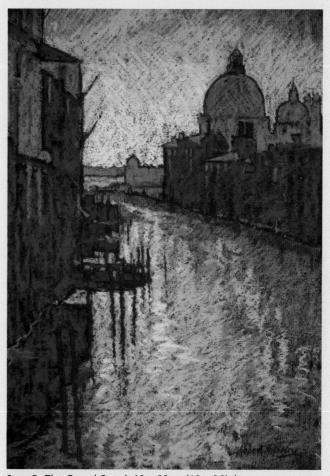

Step 3. *The Grand Canal*, 46 × 66cm (18 × 26in).

Stimulate Your Senses

Finally, stimulate your senses and imagination by looking through your art books or watching an instructional DVD. You may come up with some fresh ideas with regard to colour, composition, mood and atmosphere that will assist in solving some of your problems.

If these suggestions don't help, put the painting aside for another time when you can repeat the process. Never start working on the painting without enthusiasm and a clear plan of action.

Brilliant colour that does not yellow with time, a velvety, matte surface unlike any other medium, dry colour that is capable of a range of effects…

The Pastel Society of America

Storage and Framing

The above characteristics are distinctive to pastel and result from the medium's composition: a blend of finely ground pigment and extender coalesced with a small amount of binder. It is this powdery property that accounts for the delicate surface of the finished work, and underlies the following issues that must be taken into consideration.

A lined, double-mounted, framed painting.

Fixing

On completion, the painting should be suitably protected for storage, or framed immediately.

The inherent attraction of a pastel painting is undoubtedly the strength of colour, and its weakness lies with its powdery composition. These factors have provided a constant debate among artists as to how to stabilize their works and which fixing substances to be used, if any. Although fixatives are used by some artists, the results are not always favourable.

The general opinion remains that there is no ideal fixative available. When a liquid fixative is applied to a pastel it penetrates the spaces between the fine particles and causes some of the colours to become dull or darkened, thereby diminishing the light scattering characteristics of the medium. The fixative can also alter the colour/tone of the ground used. These factors should be remembered when considering whether to fix or not. Experimentation in advance is strongly recommended, thus avoiding any undesired results. As a result of these shortcomings in order to preserve the brilliance of colour and tone many artists never use a fixative.

Storing Unframed Pastels

Unframed works should be protected by a sheet of archival paper. A smooth, hard-surfaced, non-fibrous paper should be used between each piece of work and taped securely to avoid any movement. Silicone release paper works well; however, avoid all papers and films that hold a static charge.

The paintings can then be stacked in drawers or archival boxes. Ensure that no pressure is applied to the stack of pastels and that they do not slip or slide against each other.

Another consideration when storing work is the environment in which they are to be kept. High levels of humidity will almost certainly affect both the pastel and the ground. A temperature range of 68–72°F together with a relative humidity of 50% should ensure that the paintings remain in perfect condition.

Framing

By framing and glazing your completed pastels the surface will be well protected. When framing your work ensure that the surface of the painting is at least 4mm from the inside face of the glass. This minimum dimension goes some way towards ensuring that the work is protected from any rubbing, condensation and the subsequent staining that may occur in any rapid falls in temperature. This space can be created by double-mounting the work and using a hidden spacer mount between the artwork and the outer mount. This method of

Corner detail showing a typical pastel mount.

Corner detail showing the rear of a typical pastel mount.

mounting also provides a useful gap for any loose pastel dust to fall out of sight should the work be knocked during transit or any subsequent handling.

Paintings undertaken on paper or non-rigid boards should be taped on all edges to avoid cockling. All mount boards and tapes should ideally be conservation quality to avoid any future discolouration due to acidity.

Should you decide to protect the work further, a high quality picture glass can be used to give protection against ultraviolet rays.

Conclusion

Pastels have a unique quality of their own. They allow the painter to express themselves in numerous different ways, probably more than any other medium. To take advantage of the versatility of the medium, it is suggested that you use the pastels in as many ways as you can; work on a large or small scale, on a variety of coloured, textured surfaces using the many different ways of applying colour. Most important of all is not to be afraid to experiment.

Pastel: the creative manipulation of coloured dust.

Byron Howard

It is vitally important for you to be enthusiastic about painting, and there are many ways of ensuring that this enthusiasm is maintained through all the low periods that every artist encounters from time to time.

You may consider joining an art society or painting group where ideas and any problems you may have can be shared with like minds.

Showing your work in as many exhibitions as possible is also recommended as it is beneficial in several ways. There is nothing like working towards deadlines to keep you on your toes. By careful and honest assessment you will also benefit by evaluating your work against other artists' work.

The most important factor of all is to enjoy the creative process. With a love of painting, coupled with the desire to paint on a regular basis, nothing else should really matter.

Pastel dust: Pure pigment in a Venetian art shop window.

FURTHER INFORMATION

Further Reading

Aggett, Lionel *Capturing the Light in Pastel*, David and Charles.
Martin, Judy *Pastels Masterclass*, Harper Collins.
Mowry, Elizabeth *The Pastelist's Year*, Watson-Guptill.
Savage, Ernest *Painting Landscapes in Pastel*, Pitman (out of print).

DVDS

There are many excellent instructional DVDs available; the following are recommended:

APV Films (www.apvfilms.com)

Coates, Tom *Figures in Pastel*,
Watkin, Barry *Pastel Landscapes*, *Progressing with Pastel* and *Pastel Techniques*
Wilks, Maxwell *Colour and Light in Pastel*

Town House Films (www.townhousefilms.com)

Tookey, John *Taking Risks With Pastels*

Materials and Suppliers

Pastels

Rembrandt, Unison, Rowney, Sennelier, Art Spectrum, Schminke.

Supports/Boards and Papers

Hermes fine Grey or Black glasspaper, in a roll or board mounted (from Youdells Art Shop)
Fisher 400 Art Paper.
Art Spectrum Colourfix boards and papers.
Sennelier pastel card.
Colourfix Primers, available in several colours for you to make your own boards.

Other Items

Rowney Texture paste
Golden Fine tooth pastel ground
Fixative
Acrylic white primer
a limited range of acrylic paints or inks
Pro Arte blending stump or plasticized colour applicator
Easels.
All the above materials can be sourced from most good art shops or the following on-line suppliers:
Jacksons Art Supplies (www.jacksonart.co.uk)
Ken Bromley Art Supplies (www.artsupplies.co.uk)
Society for All Artists (SAA) (www.saa.co.uk)
Youdells Art Shop, Kendall, Cumbria (www.youdells.co.uk)

Framing

Frinton Frames (www.frintonframes.co.uk, tel: 01255 673707) for high quality, handmade frames for all mediums, including pastels.

INDEX

OTHER ART BOOKS
FROM CROWOOD

Ball, Emily *Drawing and Painting People*

Beer, Nicholas *Sight-size Portraiture*

Brindley, Robert *Painting Boats and Coastal Scenery*

Eyre, Doug *Drawing Cartoons*

Freeman, John T. *Portrait Drawing*

Hollands, Lesley E. *Painting Still Life in Watercolour*

Hughes, Alan *Interior Design Drawing*

Lloyd, David *The Colour Book*

Lowry, John *Painting and Understanding Abstract Art*

Newey, Jonathan *Drawing and Painting Buildings*

Osada, Ryuta *Creating Manga*

Oxley, Valerie *Botanical Illustration*

Shelbourn, Colin *Drawing Cartoons*

Simpson, Peter M. *Practical Anatomy for Artists*

Talbot-Greaves *Painting Landscapes in Watercolour*

Woods, Bridget *Life Drawing*

BOCA RATON PUBLIC LIBRARY, FLORIDA

3 3656 0556043 0

741.235 Bri
Brindley, Robert,
Painting in pastels

JUN 2012